P9-DTM-036

"As fans of Perry's writing—and they are legion—know, Perry's expertise is in spinning the sometimes-literal straw of everyday small-town family life into writing that can gild even the most commonplace moments with wit and a bit of poetry. . . . *Visiting Tom* is more than just a whimsical portrait of a unique character. It's a meditation on modernity and self-reliance that sneaks up on you with its unexpected depth."

—*Capital Times* (Madison, Wisconsin)

"Charming and humorous." —*Booklist*

"In *Visiting Tom*, a story that melds Perry's unique humor with notes of Garrison Keillor and Bill Bryson, the elderly man's tenderness and character jump off the page as he shares his thoughts on life and love." —*Express Milwaukee*

"Warmhearted. . . . Engaging. . . . Down-to-earth and genuine."
—*Kirkus Reviews*

"Funnier than Keillor." —*MinnPost*

"Michael Perry writes the words that create the memoirs that make so many of us want to raise chickens and pigs, plant a few rows of corn, or otherwise just make hay. Mostly, though, he makes us want to get to know our neighbors better—no matter where we live."

—*Experience Wisconsin* magazine

"It's part memoir, part character piece. There's a bit of the poetic to it. It's about fighting bureaucracy, Foxfire-ish self-sustenance, life the 'old timer's' way, and male-bonding foolishness. It's about fatherhood, marriage, and love. And it's just about one of the sweetest books you'll ever read."

—*Daily Sparks Tribune* (Sparks, Nevada)

VISITING
TOM

Also by MICHAEL PERRY

BOOKS

Coop: A Year of Poultry, Pigs, and Parenting

Truck: A Love Story

*Population: 485: Meeting Your Neighbors One Siren at
a Time*

*Off Main Street: Barnstormers, Prophets &
Gatemouth's Gator*

AUDIO

The Clodhopper Monologues

Never Stand Behind a Sneezing Cow

MUSIC

Headwinded (Michael Perry and the Long Beds)

Tiny Pilot (Michael Perry and the Long Beds)

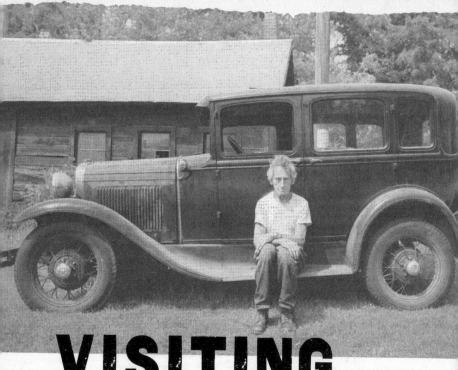

VISITING TOM

A MAN, A HIGHWAY, AND THE
ROAD TO ROUGHNECK GRACE

MICHAEL PERRY

HARPER PERENNIAL

NEW YORK • LONDON • TORONTO • SYDNEY • NEW DELHI • AUCKLAND

HARPER ● PERENNIAL

A hardcover edition of this book was published in 2012 by HarperCollins Publishers.

P.S.™ is a trademark of HarperCollins Publishers.

HarperCollins books may be purchased for educational, business, or sales promotional use. For information please e-mail the Special Markets Department at SPsales@harpercollins.com.

FIRST HARPER PERENNIAL EDITION PUBLISHED 2013.

Designed by William Ruoto
Photographs copyright © J. Shimon & J. Lindemann

The Library of Congress has catalogued the hardcover edition as follows:
Perry, Michael.
Visiting Tom : a man, a highway, and the road to roughneck grace / Michael Perry.—1st ed.
p. cm.
ISBN 978-0-06-189444-2
1. Hartwig, Tom. 2. Perry, Michael. 3. Perry, Michael—Friends and associates. 4. Farm life—Wisconsin. 5. Farmers—Wisconsin—Biography. 6. Wisconsin—Biography. I. Title.
CT275.H388P47 2012
977.5'043092—dc23[B] 2012001356

ISBN 978-0-06-189446-6 (pbk.)

13 14 15 16 17 OV/RRD 10 9 8 7 6 5 4 3 2 1

To Tom and Arlene and all who
keep an open kitchen . . .

RULES OF THE ROAD

OPERATING AS I DO UNDER the rubric of nonfiction, and with an eye to the various critical permutations of the term, I believe I owe my readers certain specifics: I strive to keep the facts straight. If I fail in this and a reader graciously notifies me, I post a correction in public. That said, you should know that in the book you are about to read, some names have been changed, and in some cases time has been compressed and oft-told tales synthesized to preserve ink and eye strain. Beyond that, I'm doing my best to give you things as they were, and for reading what I write you have my solemn gratitude.

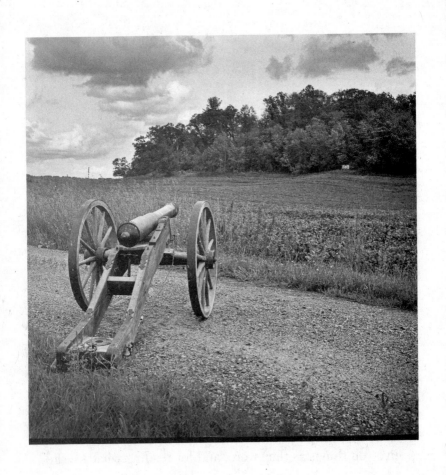

PROLOGUE

IF YOU'RE GOING TO VISIT Tom Hartwig, you will have to drive past the cannon. Not just past it, but *before* it. The muzzle surveils you through the open door of his galvanized tin pole shed, poking from between a pair of manure spreaders and a homemade portable welder the size of a chest freezer. You'll be about fifty yards out when you first glimpse the artillery, and will thus have time to consider whether or not you wish to proceed directly into the field of fire.

The cannon is not a lawn ornament. If you look to your left, well across the field and halfway up the hill to the treeline two hundred yards distant, you will see a 4×8 sheet of white plywood with a red bull's-eye painted dead center.

Upon closer study you will note a pair of perforations in the plywood—one within the first ring of the bull's-eye, the other just outside it. The cannon is only moderately accurate (as evidenced by the number of significant divots and frayed saplings surrounding the plywood backstop), but if you care to stand up there and test the matter, you may first wish to note that when the cannonballs do hit their mark, they leave a ragged puncture through which an NFL lineman could easily stuff his fist.

Tom never leaves the cannon loaded, but newcomers will nonetheless find it daunting to motor between the target and the menacing hollow eye. "It's tough," a salesman once told Tom, "to come up your driveway with that thing parked there."

"Oh," said Tom, "I never shoot at anyone coming *up* the driveway . . ."

The Hartwig residence—a classic twin-porched Wisconsin farmhouse, clad in white clapboards and capped with a silvered standing-seam steel roof—sits central to a cluster of outbuildings arranged at the base of a semicircling ridge. If you open the kitchen door and cast your gaze out beyond the red peg-and-tenon barn (framed with nary a nail, and still standing square well into its second century), you

will note how the fall-away slope of the land terminates in an abrupt cut, beyond which lies fertile bottomland and a rambling thread of water we call Cotter Creek.

It was Cotter Creek that drew the original white settlers to this spot, as well as those who came to the country prior—Tom will tell you the local Ojibwe tribes preferred to camp the eastern bank, so as to keep a protective band of water between them and the prevailing west winds in the event of a wildfire. Tom's immediate predecessors arrived in the 1860s, when his grandfather, a German immigrant employed by a local farmer, followed the creek while searching for a stray batch of cows and took a liking to the area. Looking into the matter, he found out the property was being held for sale by a land agent in New York, and in the mid-1870s he took ownership. After a final trip to Germany to sell his remaining homeland possessions, he returned and began to establish the homestead in earnest.

Tom doesn't know for certain when the house and barn were built, but he has his ideas. "Weaaahhll," he told me once, prefacing the sentence with a drawled-out "well" the way he so often does, "when we remodeled the house we found square nails. Square nails went out of use about the turn of the century. So you *know* it was built before 1900." He is prone to that sort of statement. Of sharing arcane knowledge as if he is confirming something you surely knew.

Other buildings followed over time—a pumphouse, a milkhouse, a chicken coop, a pig hutch, a machine shed, a granary, and in more contemporary times, two steel pole sheds. Tom arrived in 1929. Born at a hospital in nearby Eau Claire, he spent his first night at the farmhouse swaddled in a crib upstairs. He has lived beneath the same roof for every one of his eighty-two years since.

He'll smile when he describes his childhood, how he'd snatch up his schoolbooks, go slamming out the screen door, trot past the barn, and drop down the cutback bank to the footbridge spanning Cotter Creek, then on to a second bridge that served as a natural meeting place for the local farm kids making the two-mile trek to the old one-room school. Stealing a few moments from the morning, Tom, his brother, and the neighbor boys would gather up shale rocks and drop them *plonk* into the water. Some days Tom lingered even longer, searching for stone flakes left streamside by the Ojibwe as they knapped arrowheads and skinning tools. By the time he was in high school, he had a sackful.

He graduated in 1947. Blessed with a natural understanding of animals and preternaturally adept at mechanics, he elected to stay at home and farm with his father. Still, even a good young man gets restless, and evenings when the chores were done, he would head for town on his brand-new 1948 Harley-Davidson. To ensure the ladies

noticed him, Tom wove decorative green and red lights through the front wheel spokes, and then—rigging a pair of generator brushes so they contacted a copper band soldered to the brake drum—he wired a switch that drew power from the low-beam headlight. When he hit that switch he says the bike lit up like a rolling Christmas tree.

The lights were wasted on Arlene Knutson, as she wasn't the kind of girl to be on the street at night. In fact, it was full daylight on a hot Sunday morning the first time Tom caught her eye—or ear. Arlene was sitting in a church pew beside her mother. The church doors were open to circulate the air, and Tom Hartwig raced that Harley through at full throttle—on the sidewalk. All that noise, and during worship. It didn't set well, Arlene says, and when Tom asked her out after services, her mother forbade it. Furthermore, Arlene said she wasn't riding on any motorcycle.

Sensing he was at a disadvantage on two wheels, Tom tried four. Got himself a white '49 Chevy convertible and a red shirt. Arlene was at work in a second-story office building when she saw him coming this time—rolling downtown with the top down, that scarlet shirt playing off the white car—and when she tells the story now her eyes glint as if she's seeing him coming up the street for the first time. There followed a successful courtship, and right around the time Dwight D. Eisenhower was moving in to the White

House, the young couple married and set up housekeeping in the same upstairs bedroom where baby Tom first slept in his crib.

In 1958, Tom's father stepped aside, moving with his wife to a small cottage the family built just thirty yards uphill from the original farmhouse. Tom and Arlene moved downstairs and assumed daily operation of the farm. Tom was just shy of thirty years old, and it was good, he'll tell you, to greet the morning in this place, to step out on that screen porch and see treetops poking through the bottomland mists, the only hint of a world outside their own two-track driveway curving out of sight around the corncrib. In the stillness he walked the bird-songed dawn down the footpath to the barn, where the cows were waiting.

The first official letter arrived right around the time Tom and Arlene took charge of the farm. President Eisenhower had signed the Federal-Aid Highway Act, designed to create the interstate highway system that would transform a nation. Somewhere in Washington someone drew a line, and that line passed directly between the Hartwigs' house and Cotter Creek. There were delays and skirmishes, but in 1965 the United States government—that is to say,

we—sent bulldozers smack through the middle of Tom's farm.

The first earth was shifted that winter, when a construction crew bulldozed a crooked ravine straight, then used a crane to install a 360-foot concrete culvert intended to redirect the water headed for Cotter Creek. The foreman asked if it would be okay if the cement trucks used Tom's driveway, and Tom agreed. All winter long the trucks tore the driveway apart, but the foreman promised that they'd grade everything up shipshape when the job was done.

In spring, the rumbling commenced in earnest, led by twin-engine Caterpillar bulldozers and giant earth scrapers called Tournapulls. Fitted with engines fore and aft, the Tournapulls were equipped with a bladed jaw that dropped open to scrape up a layer of earth that then accumulated in the low-slung belly of the machine to be carried off and dumped elsewhere. When the going got tough, the twin-engine Caterpillar dozers would pull in behind the twin-engine Tournapulls and give them a push. You had four huge diesel engines roaring in monstrous harmony then, and Tom says that up in the house the dishes rattled in the cupboards and down in the barn the cows stood wide-eyed and trembling.

The interstate opened on November 9, 1967. A series of seven ribbon-cutting ceremonies was scheduled, one at each

interchange from Eau Claire to Black River Falls. According to an archived copy of that day's *Eau Claire Leader*, the first was held sixteen miles northwest of Tom's farm and began under blue skies at 9:30 a.m. sharp when a local high school band marched forth before a crowd of some four hundred bystanders to play "On Wisconsin" beneath a banner proclaiming A SALUTE TO HIGHWAY PROGRESS. A local pastor then offered a prayer in which he asked that motorists be thankful for the new highway but also "use sound judgment when driving it," from which we can infer the pastor may have lapsed from prayer mode into sermon mode. After the introduction of dignitaries, the lieutenant governor gave a short speech and, exactly twenty-two minutes after the ceremony began, produced a pair of small black-handled scissors and cut the ribbon. Moments later the official party (consisting, according to the *Leader*, of fifty cars "from Volkswagens to Cadillacs") curled around and down the on-ramp, followed by a "cavalcade" of average motoring citizens. The first accident was reported at 10:15 a.m., exactly twenty-three minutes after the ribbon fell. Somewhere you had to figure the pastor was holding his head in his hands.

The ribbon-cutting ceremonies continued apace, the politicians working their way ever southward. At the Northfield stop they were greeted by square-dancers. At another, the lieutenant governor was presented with an ar-

cher's bow and arrows. From atop one dais a local mayor reportedly got a laugh when he turned the tables on the assembled dignitaries and instead designated the accumulated citizens as "the most distinguished guests" because "I can assure you they're going to be paying for it." At various stops the lieutenant governor was assisted in his scissoring by a Strawberry Queen, a 4-H Queen, an Indianhead Princess, and a petite girl of ten known as "the Christmas tree girl." In some cases the phrase "ribbon-cutting" was euphemistic: In Hixton suspense was high as a "bevy of beauties" presented the lieutenant governor with a series of keys, only one of which opened the lock on a fence across the roadway; at Northfield he "took a half a dozen whacks with a mighty wire clipper" before the barricade dropped.

The final ceremony was held in Black River Falls. Here the *Leader* reports the lieutenant governor was "decked out in a crimson wool hunting shirt" and greeted with "a first class pow-wow." As he approached the final fluttering barrier, "Winnebago Indians danced to the thump of the tom-tom and chant of the singers while around 2,000 persons happily chomped on venisonburgers." *Snip*, and at 3:48 p.m. the last ribbon fluttered earthward. It would be another year before the interstate was open border to border, but Tom Hartwig's farm was now officially cloven.

It could have been worse: In the original plan, the 'doz-

ers were aimed directly at the barn. At this Tom pitched his most resolute fit, and the bureaucrats rerouted the destruction, if only by a few feet. It was Tom's only victory, really. He nicked them in the ankles now and then, gummed the works some, wangled a few loads of free sand, and still has an old push broom one of the state crews left behind, but when the final piece of heavy equipment clanked from view and the last politician tootled through en route home from the ribbon-cutting, well, then, without apology America came pouring down the meadow in a tin-and-windows blur of rubber-borne hurry running ceaseless to this very instant.

I can make no special claim on Tom Hartwig. The path to his door was well worn by a parade of feet other than my own before I first crossed his threshold, and so it is right through the present. I visit him whenever I need a piece of iron cut, bent, or welded. Sometimes I visit in the company of my wife and two daughters; we bring food and stay for supper. Sometimes I visit to drop off a dozen eggs. Sometimes I visit just to visit. I rarely come to Tom *seeking* anything more than ten minutes of his time and a size-sixty-eleven welding rod. He is not my mentor, I am not his

acolyte, we are simply neighbors. And yet with each visit I accrue certain clues to comportment—as a husband, as a father, as a citizen. (I also accrue certain clues regarding the fabrication of cannons, the rebuilding of Farmall tractors, and how to run a sawmill, although due to my profound mechanical ineptitude, any observations I might make in these areas should be regarded as anecdotal rather than instructional.)

During any visit with Tom, there is no ignoring the roaring four-lane that splits his lifelong home. A man could go sour for the mortal duration after suffering an intrusion of this magnitude. And truth is, you won't have to prime the pump much to get an earful of Tom's abiding disdain for the government and its bulldozers. But then just as quickly he will shift gears and happily update you on this year's wild grape harvest ("Thirty-eight pounds, destemmed!") or spring from his chair to show you the heron his father shot and stuffed in 1920. He is not one to forget; neither is he one to fruitlessly linger.

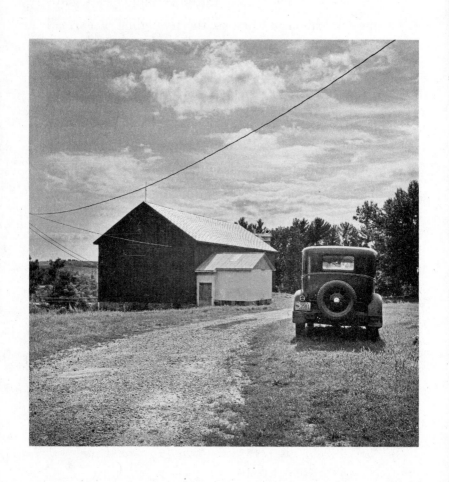

CHAPTER ONE

The camera is a Deardorff, built in 1967 but pretty much unchanged from the first models out of Chicago in the 1920s. It is loaded with a single piece of film roughly the size of a magazine. To frame and focus you have to hunker down beneath the black cape, just like you've seen in the old movies. There are two photographers, a man and a woman. The man is under the cape. The woman is aiming the strobe and reminding Tom to look straight into the lens. He gazes directly into the Deardorff's monocle eye.

The photographers arrived in a black Rambler wagon. A Cross Country model, fresh off the line in 1961. The photographers are dressed in clothes the same vintage as their car and camera, and their eyeglasses the same. This is not a special occasion; this is their everyday. You watch them tinkering with that Deardorff and you understand they have a yen for operating in the present using the tools of the past.

They started with Tom on the Model A, because he had

pulled it from the garage for a tune-up. I think it's a 1930 model, he says, 'cause it's got a '29 dash. Granddad died in 1953 and Grandma gave it to me. Back then you could get them for fifty to seventy-five dollars. Run the tar out of it, take it to the junkyard, get another one. But I hung on to this one. It's got 73,000 miles on it.

Do you mind sitting on the running board, Tom? The female photographer often attends the subject while the man fiddles with the setup and pulls the trigger on the shot.

That must have been old Henry's signature, says Tom, pointing to the script on the blue logo just below the silver radiator cap. He folds the hood flaps back so the photographers can see the engine.

There are visitors here today. A young girl, blond and tall for her age, peers into the engine compartment. She is standing beside her young aunt. You can see the relation in the light of their blue eyes and the way they are standing hands on hips. Tom reaches in through the driver's-side window, presses the horn button. A-oogah. He chuckles when everyone jumps.

I was real happy Ford wasn't dumb enough to take any of that bailout money, he says. Anything the government does has strings attached.

Now the photographers have lugged the Deardorff and its tripod across the yard to the tin lean-to between the

chicken coop and the machine shed. Space is tight, and made tighter by a wall of barbwire, some rolled in tight reams, some rolled big and loose, some wadded in a barbarous scrunch. Also along the wall, a few smooth spools of electric fencing, three post-hole diggers, a shovel, and a tamping rod. Some of the wire is stacked on a plank supported at both ends by fifty-five-gallon steel drums. In and among it all, an additional miscellany: fiberglass fence posts, wooden stakes rolled in string, empty plastic jugs, dangling hoses, a pie tin. In the back, an oxcart. Tom is balancing a yoke on the singletree. This yoke weighs fifty-seven pounds, he says. It's a five-footer. He wrestles it around so the photographers can get a better look at it.

Yah, when my granddad came here in the 1870s he had a pair of white oxen. And back about 1980 I had a pair of white bull calves born and we raised'em up and trained'em and we named them Chester and Lester. Over a period of five years we went to over twenty-five parades with them. At first they were afraid of manhole covers. What's important with oxen is to keep talking to them. The first time it took two minutes. They stood there with their yoke around their ears, lookin' it over. I kept talkin to'em. Finally I said, "Okay, boys, now giddap." And they went. One year we were in Loyal at Corn Fest and the world champion stilt walker Eddy Wolf was down there on real tall stilts and yel-

low pants, and from four blocks away Chester and Lester saw 'im and stopped. I just talked to 'em and they went on by.

We always used to weigh 'em at Augusta Bean and Bacon Days. One of the early years they each gained 700 pounds. I had ladies tell me, "I could do that if I tried!" He cackles and shakes his head. They got to be 2,700 pounds. We had to go to a six-foot yoke.

I got my ideas for making yokes from reading those Foxfire books. This one's white pine. You see the knots in it. Knots, you don't get drying cracks like you do in straight-grain wood. The way I made these, I cut a cardboard pattern that was folded in half so it was equal. Then you get, oooh, probably about a 10×12 timber, maybe 10×14. You drill your holes first, so you stay square with the world. Then you mark everything according to your pattern and take the chain saw and rough it out. I'd boil the oxbow sticks in a big hog kettle for a couple of hours, then bend 'em. The first bend goes pretty good, but the second one tends to kink on ya. You want a pair of oxbows, you better have at least half a dozen sticks, because they don't all turn out.

A phalanx of cycles rolls through, their tailpipes obliterating his story. He stops talking. Stands. Waits. The photographers are shooting digital snapshots for reference. You want to make sure you know how things frame before you burn up the 8×10 rectangle of film in that Deardorff. No do-overs.

The cycles recede and he takes up where he left off. We had a third ox: Otis. We called him Odie. He didn't pull. He was just a pet. Six feet tall at the shoulder. One morning we loaded him up and took him to the sale barn and put him on the scale. He weighed 3,000 pounds. I'd be welding and I'd feel a nudge on my shoulder, and it'd be Odie. I'd scratch him and talk to him and then he'd go over to the porch and rattle the doorknob so Arlene would come out and feed him a loaf of bread. She got the bread up there at the Plank Street bakery. The lady had a shopping cart in the back full of bread and doughnuts and a sign on it that said "Otis."

Beneath the dust the cart is painted red and green. Tom built it from the back half of a hundred-year-old buckboard. The wooden-spoke wheels stand as tall as his chest. The seat sits on leaf springs. *Eleva Broiler Fest was the biggest crowd,* he says. *People lining the streets eight deep. Arlene and the girls would be in there and these big lugs would spot'em every time, and stop and beller at'em. Among all those faces they recognized their own people.*

This is a tough space for the photographers, cramped and oddly lit. While they experiment with the angles, Tom keeps talking. *Yah, very few people know where the term "acre" for measurement of land came from, and that was the amount of land an average man and a team of oxen could plow in one day. This country was built more with oxen*

than it was with horses because ordinary people couldn't afford horses. Oxen, you could raise'em from any cattle.

The photographers are satisfied and the flash pops. The cannon is right around the corner there, but there is a tacit agreement to save it for last. Will you shoot it for us? asks the female photographer. Sure, says Tom, real offhand, like it's something he just might get around to.

Sure, we can pop a shot.

IT'S BEEN DRY HERE LATELY. Way too dry. In the fields alongside the county road the corn leaves are twisting up tight. Going all "pineappled," as I heard someone put it. Robins pant and the chicken run is hardpan. You think of drought, you think of a bleached-bone dome and nothing to scrim the sun, but throughout this desiccant stretch the skies have been oddly busy, popcorned with cloudlets small and scattered as spooked sheep, each trailing a smear of precipitation that drapes into dissipation just above the earth. They commute the heavens west to east, giving the topsoil nothing more than a brief breath of coolness before their shadows slide on. My brother Jed, who farms forty miles northwest of here, says he's seen the phantom rain streamers do a slow-motion swerve around his tilled fields,

shrugged aside, he presumes, by thermal updrafts rising from the baking dirt. They come and go, these faux roving rainstorms, sliding here and there but never really getting it together to form up a meaningful front.

The heat has helped blanch the oats from milky green to bleached tan and they're ready for harvest. Actually, they've been golden for a while now, but whenever I get the itch to get at them I remember old Art Carlson telling my dad, "When you think it's time to cut the oats, go fishing for a week. *Then* they'll be ready."

I take an old scythe down from where it is hooked over a rafter, tip it butt end down, and run a damp whetstone along the curve of the blade. The heavy sliding door of the granary is open to a full view of the valley below. We've lived here a handful of years now, and as a longtime flat-lander I still marvel at the swoop of the vista. Through a split in the hills two miles distant I can see a segment of the interstate, the cars and big rigs shuttling to and fro. If I shift to the east a bit I can just see Tom Hartwig's steel shed, the one where he stores the cannon. The rest of his buildings are obscured by the ridge.

Decades have passed since this granary was a granary. The cupolas designed to admit the auger spout were re-moved and shingled over years ago, the only evidence of their existence the two lighter squares of roof boards up at

the peak that have not faded to gray like the originals. The bins themselves are gated with store-bought lumber and hardware that suggests someone converted them to horse stalls in the 1970s or '80s. Over there by the double doors, the year 1946 was scratched into the foundation before the concrete dried. The wall inside our garage is dated 1947. Tom told me once that buildings like these came about because of money the government made available after World War II. Two years ago we covered the south-facing shingles with a bank of twenty-four photovoltaic panels. The roof is just a few degrees short of perfect for catching the sun and, depending on the weather, we can scrub away up to half of the electric bill, although on average it runs closer to a shy third. The payoff on this project is decades distant, but the electric cooperative just announced another rate increase, bad news that nonetheless accelerates the return on our investment.

I use three whetstones to sharpen my scythe. Each is a slender oval that fits nicely to my palm. They vary in grit from coarse to fine. One was quarried in Austria. When I'm in the field I carry the whetstones on my belt in a repurposed plastic pop bottle half filled with water. In addition to providing lubrication and keeping the grain of the stone from becoming clogged, the water makes a slurry of the stone and steel particles, thus enhancing the sharpening action. It's calming to work in the old granary with the sunshine

angling in and a cross-breeze pushing through. I spend a lot of time on the road, and sometimes it seems as if this country is either sadly slumping or hyperactively rising and no in-between. It's a solid comfort, then, to stand here on this concrete floor with that date etched in the foundation behind me, watching other people run the distant interstate. Sometimes I think maybe the only thing I've learned in this life is to simply inhabit moments like these. To feel the sun, see the valley, hear the stone rasping on steel.

My wife, Anneliese, and I live with our daughters in an old farmhouse at the far end of a dead-end township road that rises on a grade so steep the local cross-country coaches truck their high schoolers out here for interval training. Every year they use colored chalk to inscribe the asphalt with yard markers and inspirational slogans. NO PAIN, NO GAIN, it says, halfway up. Three-quarters of the way, YOU CAN DO IT! Then, just short of the crest: *POP THE TOP!* I do some running now and then, and every time I slog across *POP THE TOP!*, my inner voice says, *Son, that happened about a mile ago.*

Starkey Road, it's called. Nothing but hill, top to bottom. It's only two tenths of a mile long, but the pitch is such

that if you're headed uphill and more than an inch of snow blankets the blacktop, you need a full head of steam upon approach or you'll ascend three-quarters of the way and then slide down backward—a bracing experience if you are hauling several thousand pounds of milk or a vanful of family. You really haven't butt-clenched the seat covers until you've surrendered a hill mid-blizzard, in the dark, in reverse, with the wheels locked and no point of reference but a pair of obscured mirrors.

To picture the logistics, imagine a line bent at a 90-degree angle, with the point of the bend softened into a curve. This is the county road. When we come home from town we approach the Starkey Road intersection on the county road from the north and make a left-hand turn to go up the hill. However, anyone who has ever lived up this hill quickly learns that making the standard left-hand turn in snowy conditions is futile. Instead, if there is any accumulation on Starkey, we continue through the curve of the county road a half mile or so and then—after turning around in Fitzger's driveway—approach from the west. This approach—and the fact that a wide patch of black-top aligns the right-hand lane of Starkey Road with the right-hand lane of the county road—allows us to build the hammer-down momentum required to make the crest. For decades everyone—including each and every milk truck

driver, school bus driver, delivery truck, and mail carrier—
has relied on the straight-and-speedy approach.

There is a turnaround where Starkey Road terminates
atop the hill, and I am told that over time it has been a popu-
lar spot for drinking and necking, although in our few years
here it has collected only a scattering of beer cans and scant
evidence of love. One spring I did find a backpack contain-
ing schoolbooks and a blister pack half full of unidentifiable
pills. The whole works was slung deep into the brush, as if
it had been ditched at the sight of approaching headlights.
The pills had turned to mush, stymieing my detective work. I
also discovered a detached license plate, which I intended to
have a sheriff's deputy pal run through the system, but while
verifying the ethics of that request I put the plate in the pole
barn and have only just now remembered it.

Two driveways can be found atop the dead end. One de-
parts at a right angle and leads to the home of a neighbor. The
other—ours—runs straight off the terminus before curving
out of sight through a patch of oaks. Where the right-angle
driveway is a smooth asphalt beauty, ours is a heaved and
honeycombed jumble of busted-up blacktop and beweeded
potholes. Point being, if you make it more than twenty yards
down the ruts and don't realize you've left the public road,
well then either you're not paying attention, or yer snoopin'.
And if you make it all the way to the end of the driveway,

which describes three curves and runs a couple tenths of a mile, well then you've definitely intruded.

After we moved here, it was not unusual for unfamiliar vehicles to come nosing in, pull around in front of the garage, perform a rubbernecking Y-turn, and then ooze on out back the drive. My in-laws lived here nine years previously and had the same issue. It didn't seem like a real big deal, although it was more unsettling when my wife and daughters were home alone, or when we arrived after being away to find tracks in the snow, or—more than once—when we came upon someone in our yard simply having an unabashed look around.

I have a writing space in a room over the garage. My folding-table desk faces a set of windows positioned directly above the garage doors. The vantage point is such that I can see the granary, the pigpen, a distant hill, and a good swath of the yard. I also have a direct view to the asphalt pad in front of the garage doors. This is parentally strategic, as the children and their playmates tend to congregate there with their bikes and trikes, and since I keep the windows open and they forget about me, I am able to gather reams of actionable intelligence. When spats break out and I magically materialize (the door to my office exits at the rear, allowing me to circle the building and appear out of nowhere), armed with a veritable transcript of the preceding events, they gape

at my omniscience. The other option is to deploy the Voice of God technique, which is to say I go all stentorian on them through the screen, with the effect that they momentarily freeze like African dik-diks before a lion's roar. And regarding uninvited pilgrims, I can also report that if you sneak around the garage and park yourself right at a trespassing driver's left elbow, a declarative "How *you* doin'!" is usually sufficient to bounce them headfirst into the dome light.

As a bachelor of thirty-nine years, I was late out of the gate on the dad thing. My elder daughter, Amy, was three when I met her, and four when her mother, Anneliese, and I married after a chance meeting in the Fall Creek Public Library (In *Six-Word Memoirs on Love & Heartbreak*, I told the story thus: "Bachelor visits library. Books wife [nonfiction]." I have offered to license that quote to the American Library Association for use in all of their promotional materials; so far, nothing.) Amy is now as tall as my shoulder, and last year as I watched from the dark at a ballet recital she moved so graceful-ghostly through the blue light in her white costume that I was reduced to the usual parental mist. This had something to do with Art, but even more to do with Time. Then again, I am Adam's-apple

deep in the middle-aged maudlins and the same poignant pang recurred a week later when Amy dragged the garden hose into the pigpen and refreshed the wallow while dancing barefoot in her swimsuit as the hogs flopped about like giddy mud-rassling walruses.

Jane, our younger daughter, was born in the upstairs hallway of our old farmhouse and is these days roughly the same age as Amy was when we met. Jane is predominantly a delight, although given to fits of comporting herself as the emotional equivalent of a D8 Caterpillar bulldozer: Viewing life as a big pile of dirt, she drops her blade and plows through. We are regularly reminding her to use her "tiny voice," and once when she was still in diapers I found myself telling her she was behaving like a "ruinous termagant." Sadly for me, she is lately supplementing blunt force with more intellectually based weaponry, including linguistic lawyering. The first time I caught her sticking out her tongue behind Mom's back, I issued the usual interdictions. A day later, after instructing her to pick up her socks, I whirled and caught her mid-stick. Rather than retract her tongue, she flattened it, stuck it out even farther, and let her mouth gape open. "I hope you're not sticking your tongue out," I said. "I'b dot!" she said, brightly. "I'm saying *aaahh* so you can *check* my tongue, and that's a *good* thing!"

Then last winter, after fruitlessly fighting a stubborn

infection, she went on a course of oral antibiotics. They were allegedly cherry-flavored although the way she fought them they might have been skunk oil cut with maraschino bitters. Every dose went down with storm and stress. One evening, despite having internally sworn never to do so, I broke down and defaulted to the old leveraged standby: "Can't you drink your medicine like a *big* girl?"

Glug. Straight down the ol' hatch.

Night two: "Can't you drink your medicine like a *big* girl?"

Glug.

Night three: "Can't you drink your medicine like a *big* girl?"

The blue eyes were cool as shaved ice, the gaze steady. "When *you* are a big girl, *you* can drink it."

I am going with the theory that this level of sustained intellectual engagement will keep the old man young. This line of thinking suffered a severe setback at five o'clock this morning when the tot thundered into our bedroom to stand six inches from my ear while doing jumping jacks and gleefully hollering, "WE ARE GOING FOR A NIGHTTIME WALK!"

We live on a farm, but I am not a farmer. I feel compelled to make the distinction right up front because for the sake

of promotional shorthand I am sometimes represented as such. We raise fifty or sixty meat chickens every year, we have another sixty or so layers, and, depending on whether or not you know the location of the secret refrigerator, we may or may not generate a little feed money by selling brown eggs on the black market. The pork in our freezer spent its time on the hoof snuffling around within sight of the yard, and whatever they didn't root from the ground, I lugged to them. Out there on the ridge you will find a modest stand of corn, and downslope from the garden are plots of oats and wheat. Occasionally I travel down the road and help one of my neighbors bale hay; in return he chugs up here with his John Deere 620 and three-bottom plow and flops enough sod to give me a new corn patch. So I spend some time in barn boots. But when it comes to making a living, I do it mostly by typing. Books and magazine articles, the occasional poem. Another eighty to a hundred days per year, I hit the road to give talks, perform at small theaters, and play music with my band. You may have pigs, chickens, and a spotty half acre of corn, but if you are absent from the operation upwards of one hundred days per annum, you dare not designate yourself a *farmer.* Should I return from one of these excursions to discover my pigs are all hooves-up and the chickens have molted and bolted, well, that's a bad weekend. But it doesn't mean I'm gonna be entering

desperate negotiations with the banker. Real farmers have something on the line. In short, they bet the farm.

Full-scale or not, it feels good to walk from the granary into the oats and set to swinging that old scythe. I'm sure my technique is suspect, and having spent some time in online scythe forums I realize lighter European scythes are all the rage these days, but I don't care because with each ungainly swing I'm remembering the day I strode across the freshly tilled dirt with my little shoulder-strapped seed broadcaster, sowing seeds in hope . . . and now, here I am, *reaping*. I learn pretty quickly that the key is to keep the blade low and flat to the ground, and to swing *through* the oats rather than at them. Sometimes I get lazy and the tip of the blade scubs the turf like a poorly played pitching wedge, and sand spatters the dry oat stalks. Other times I angle the blade up too much and it flattens the plants rather than cuts them. Mostly, though, I get a good, clean cut and how satisfying it is to hear the severing crackle, to see the plants laid out in a flat bouquet, the stubble neatly shaven. I go for a long while beneath the sun, the sweat pouring from me, but my body coming into its own. When it's warmed up and humming like this, all the accumulated impingements of middle age seem to disappear.

Anneliese and Amy have gone on an errand, so Jane has joined me out at the edge of the field. The sun is rotisserie-

hot, so I have fashioned a lean-to tent using an old rain poncho, a piece of pipe, and some steel fence posts. For reasons not quite clear Jane specifically but pleasantly requested her car seat rather than a lawn chair, and she is reclined in it now, eating a green windfall apple beneath her square of shade. She is two-handing the apple, gnawing her way around the equator. When circumnavigation is complete, she chucks the fruit to the weeds and announces, "Daddy, I'm going to get another apple."

Our standard family frugality rules forbid wasteful food practices, but the farm is profuse with apples and littered with windfalls. We feed the things to the pigs and chickens by the bucketful, so I can't see forcing my daughter to eat them down to the core. The nearest apple tree is back across the far side of the yard, and I make a big deal of the distance. "Oh, I don't know, Jane . . . that's a long way . . . are you sure you can get the apple all by yourself?"

"I can, Daddy!" she says, and takes off at a short-legged trot. In minutes she is back, taking her seat and rotating the apple into place.

I settle into the groove of the work then, dropping the stalks in rough rows. Come winter, I'll fork them into the chicken coop. The birds will eat the oats and some of the weed seeds, and the straw will make fresh bedding. They'll poop in it and scratch at it and break the stalks down, and

by spring we'll have a rich pile of compostables. When all is said and done I'm not sure I want to do the math on how this all works out financially. The truth is, I'd likely lend the family more stability if I just bought bags of feed and bales of straw and spent more time in my writing space finishing the next book, or pitching the next magazine article, or putting words to a song. But there is something at work here that goes beyond financials. It nibbles at the edge of self-sufficiency, but that's just a fraction of the impetus. It is also in part tied to the idea of putting my soft palms to the worn handles and imagining the hands placed there before mine, how much rougher they must have been, how many countless hours their owners must have toiled to lay the smoothness in the grain. There are also the contemplative aesthetics: Even as the heart thuds and the sweat falls I am appreciating the graceful curve of the wooden shaft. Its very shape is a sculptural implication of patience and craft, and the anatomical terms of the scythe—the nib, the heel, the tang, the snath—are the poetics of another age. But this is all peripheral. What really puts me out here in the field is the fact that I was raised by farmers and loggers and have never shed the atavistic sense that the worthiest work is accomplished through force applied via the body. The cutting and the gathering play counterbalance to weightless electronic letters or stories told into thin air.

I am feeling what Matthew Crawford, in his book *Shop Class as Soulcraft*, describes as the sense of "agency and competence" associated with manual labor.

This whole philosophical angle has its limits. One day Tom and I are rummaging in his machine shed for a piece of steel when I spy a scythe hooked in the rafters, just the same as mine. I start telling Tom about my scythe and how I've been using it. I tell him about how I sharpen it, using the three stones in sequence, keeping them wet, how I follow the arc of the blade.

"Yah, sounds like you're doin' that about right," he says, and inside I glow a little. There are certain skills a man ought to have, and putting an edge on a blade is prime among them; to have Tom's imprimatur in this instance is doubly meaningful. I tell him how I've been refining the way I swing the scythe, hoping he might give me some advice on how to better handle the thing, but he just says, "Yah, that's pretty much how you do it."

I am feeling expansive now, not just because of his approval, but because I am imagining it must be heartening for him—the old-timer—to know that some of us in the trailing generations are taking up the old ways again, studying them, doing our best to preserve fundamental traditions in the face of an uncertain future. The scythe is a cultural baton, and we are passing it down the generations.

"Y'know what really works good?" asks Tom.

I give him my full attention, determined to keep my scatterbrain in focus so that whatever secret he is about to share I will be able to carry it forward, hand it to my own children, be a living link.

"One'a them gas-powered weed-whackers!"

In addition to the heat, we have lately suffered under a profusion of gnats. Normally we have just enough breeze up here on the ridge to push them clear, but today is baking-oven still and the bugs orbit my head like erratic electrons. They loop wildly, seemingly with only the barest navigational control. One has just now careened into my left eyeball, and as I lower the scythe and straighten to blink it out, I see that Jane's car seat is empty beneath the makeshift tent.

"Jane?" I say, my voice only half raised.

Nothing.

Louder: "*Jane?*" If you're a parent, you know how it goes. There is every reason to believe she is giggling behind the nearest tree, and every reason to fear far worse. I let the scythe drop to the stubble and jog uphill, calling her name again, more loudly. Absolute silence, and suddenly the air seems to thicken and close in on me, muffling everything. I run to the yard, cover it corner to corner. Into

the house then and back out, zigzagging to every structure or place in and among the buildings I can think of where there might be danger, some place to fall, or get hung up, or trap an ankle. Even as I lurch about, my internal voice is saying I am overreacting, that she couldn't possibly have disappeared, but reflex quickly outstrips rationality. I am crossing the blacktopped skirt of the garage—hollering her name now—and wondering where to sprint next when I register the tiny chime of a voice—not a word, not *daddy*, but just a sound I recognize by the pitch of it.

I find her just over the lip of the hill, down by the old barnyard where the berry bushes bristle among the railroad-tie posts. She is splotch-fingered and wearing a smeary maroon grin. "I'm picking *berries*, Daddy!"

It's been a decent year for berries. No bumper clusters, but handfuls of black caps and velvety raspberries if you're willing to reach in and suffer a scratch or two. It's been fun introducing Jane to the idea that treats grow on bushes, and now here she is, purple palm outstretched, a half-smashed black cap balanced at the center. I take the berry and eat it. Then I hold her close and tell her how very, very, very important it is to answer Daddy when he calls.

"I was picking *berries*, Daddy," she says again, as if that explains everything. Then a look of concern crosses her face. She points to my forehead. "What is that, Daddy?" I

swipe at my forehead, and when I bring my hand away the edge of my palm is covered with sweat-logged gnats. Apparently the combination of my perspiration and all those insects has turned me into human flypaper. I explain to Jane what gnats are, wipe them off in the grass, and then we pick and eat berries. When we have had enough, we walk back to the oat patch, stained hand in stained hand. The heat is still oppressive, and Jane asks me to fill her wading pool. "How about if we go swimming in Cotter Creek?" I ask. "Yes! Yes! Yes!" she says, one pogo per exclamation point. I retrieve the scythe from the oat stubble, hang it from the granary rafters, and we head for the house to change into our swimming suits.

We have access to the creek through the property of some friends a short drive down the road. They're not home, and all is quiet as we park the car and I unbuckle Jane from her seat. We make our way around behind the house and down a footpath through the trees and into a patch of canary grass taller than my head. Forcing my way through the grass toward the gurgling sound of the creek, I find a spot where a log projects out over a sandbar and we step into the shallows. "Huh, huh, huh!" Jane says at the first cold shock of the water on her feet, but she acclimates quickly, stomping and splashing. The creek is barely ten feet wide, but the current is swift and the sand bar drops

off darkly, so I grip her hand at all times. "Let's dance and twirl, Dad!" she says, and I know from our many living room ballet sessions that what she really wants me to do is sweep her in wide circles so her feet skim in and out of the water. Then I wade off into a belly-deep hole and swish her back and forth while she giggles and giggles. Then we slosh back up to the sandbar and dance, she rising on her tippy-toes and fanning her fingers, me stomping around white-leggedly.

We take a break then, sitting side by side on the log. The stream is deeply canopied here, the scorching day shut out, the air mud-cool. Jane leans in tight and shivers against me, elbows tucked to the sides of her belly, wrists crossed over her chest, teeth chattering. Now the mosquitoes show, whining around our ears and settling on our bare shoulders, where I feel the first itchy-sweet bite. But she doesn't want to go just yet. She just wants to sit there huddled next to her old dad, and I can't find it in me to budge. The love I feel is nearly overcoming, and as always in these moments the joy is crowded by a breathless realization of how fleeting this moment is, a desperate desire to burn it deep in some crease of the brain so that you might call upon it even as you let go this world.

It is no good to overthink these things and I am spared the sentimental whirlpool when I feel a hard lump between

my butt and the log and realize it is my cell phone. "Rat-tafrat!" I say, managing to maintain a G rating.

Jane straightens. "What, Daddy?"

"I got my cell phone wet!"

She shakes her head with her eyebrows raised. "Well, *that's* a problem."

The skeeters are really digging in now. I wrap Jane tight in a towel and carry her up the path. When we reach the yard, she asks me to put her down. When her feet touch the ground she runs up the lawn and around the house toward the car, and in a beautiful bit of mangled syntax, hollers back over her shoulder, "I will win you, Daddy! I will win you!"

A man once told me I didn't so much have a family as a sorority. When I shared this joke with Tom, he chuckled in recognition, having shared the same census (as well as living in the same house or across the yard from his mother for over seven decades) for many years. In light of his experience, I once asked him what advice he could give me about raising daughters.

"Weeaaahhll . . . one time my youngest daughter came home and told me some boy was teasing her at school. I

said, you tell him he may think he's a smart feller, but he's just a fart smeller!"

I guess I was looking for something a tad more Robert Fulghum.

"Then I told her if that don't work, tell'im he looks like a goat sucked'im!"

You will understand I did not scribble any of this right down. But over time I have learned something about Tom: The best stuff emerges when you skip the interrogatories and just visit. Or better yet, just wait. After the joke, he sat quiet for a moment, then said, "Ah, but you shouldn't tease a kid. And sarcasm is wasted on'em, 'cause they'll take it literally. When I was a kid the neighbor died, and someone said he dug his grave with his teeth. I puzzled on that one for years.

"Nah, you just play it day to day. You do what you can for your kids, and don't go overboard. When the girls would ask me for something and I hadn't made up my mind, I'd just go, *Hmmmm* . . . That wasn't a yes or a no. Once my oldest daughter wanted to get her ears pierced and I said, Nope, if you get your ears pierced, you have to get your nose pierced, too."

Now we were veering a little more in the realm of practical application, although that last bit loses a little steam in this perforated age.

Arlene was sitting beside Tom, and at this point she in-

terjected. "One thing Tom and I never did was go anyplace without the kids."

"Yah, we never left the kids with anybody," said Tom. "Except sometimes Grandma, since she lived right here." He paused, looking at the table. Then he raised a hand. "One of the things that does make you feel bad, when you get later in life, why, in the early years you're always hard up for money. You wish you'd have had a little more when the kids were little, so you could have done more with'em, or for'em."

As a frequently absent dad, this last line of talk hits close to home. My absences are driven by work and opportunity, and they feed the family, but still. You don't know until it's over how the math will work out.

I have never met Tom's daughters. They are long grown, and the youngest is my age. I don't know how they would characterize their dad. I can only go on certain clues, one a 1970s-era Arctic Cat minibike in the grass outside his shop. The last time I was over there, Tom stepped over the bike on his way to get a piece of pipe and said, "I'm tryin' to find a set of rings for that thing, because that's all that ails it." I noticed that the minibike had a decidedly nonstock trailer hitch welded to the frame.

"What's the deal with the hitch, Tom?"

"Oh, my younger daughter Emmy used to get the mail with that scooter, and she'd bring water to us in the hay

field. She had a little dog named Buffy. That dog was an ideal dog for a little girl, because Em used to put her in her baby buggy and put her bonnet on her and put lipstick on her! But she was always complainin', 'If I had a trailer, Buffy could go with me.' So I put a hitch on there, and I had one of those little garden trailers with no springs, and poor Buffy would set in that trailer, bouncin' on that shale driveway or across the fields, the exhaust blowin' all over her face. Why she didn't just bail out, I don't know."

He stopped then, for a moment, then spoke. "Once a parent, you're a parent always. But the kids . . . the kids are like visitors."

Although I cannot speak definitively regarding Tom as a father, I *can* speak definitively to what it might have been to approach him when he was occupying the role. My wife did not have a blithe childhood. Her parents divorced when she was a toddler, and when she was seven years old, her mother married a man who owned a farm just down the road from the Hartwigs'. Things were not easy, and perhaps Tom and Arlene knew this, because Anneliese recalls Arlene stopping on her way home from the bakery to share from her trunkful of Otis treats: bread that was expired but just fine, and maybe powdered doughnuts (Otis didn't care for the way they clung to his tongue), but Anneliese remembers especially peeling the sticky cinnamon rolls from their flattened

packets. When Anneliese was fifteen her mother divorced the farmer and moved the girls to town some six miles away. Despite the distance, Anneliese and her sister spent even more time with the Hartwigs in the ensuing years, mowing the lawn, washing windows, picking crab apples, and loading hay wagons in the summer. Although it was never spoken, Anneliese says the Hartwigs were clearly aware that she and her sister were hungry for elements of stability and refuge. There was reciprocity: While the girls were paid for their "official" work, they and their mother often responded in kind by bringing homemade meals or pitching in to paint the kitchen or hang new wallpaper. After Anneliese went away to college, she made it a point to visit Tom and Arlene whenever she returned home. When she met me—and after I had survived a vetting process I hadn't even known was under way—we naturally found our way out to the farm.

Very early on—perhaps the third or fourth time Anneliese and I visited the Hartwigs—Tom must have seen hearts in my eyes, because while Arlene and Anneliese were in the other room, he had a word with me.

"That girl there," he said, indicating Anneliese. "You know she was on my hay crew."

"Yes, sir," I said.

"Outworked any boy I ever hired," said Tom, and nothing more said.

Later, upon reflection, I realized this was intended less as a testament to Anneliese's character than as a challenge to my own.

When the oats have lain in the sun two days so the green weeds can dry, I take the pickup to the field and fork them into the bed until the heap is higher than the cab. Then I back up to the granary and fork them into the old horse stall. It doesn't take long for the stack to build to a satisfying size. I do five loads today, and Amy and Jane ride back and forth with me. While I work in the sun, they stay in the cab, singing songs and talking nonsense. When I rake the final forkful from the stubble and pitch it to the top of the pile, I pull my new cell phone from my pocket and snap their photo. They are hugging cheek to cheek, their blond hair straw-bright in the low-angle afternoon sun. Somewhere down the road in some motel room I am going to flip the phone open to that photo and it will hit me like a tanning light.

I don't know if Tom Hartwig can make me a better dad. That's incumbent upon me, not him. There are moments like the one the other day when Jane asked me to fill her wading pool and my first inclination was to demur, because

there is always work to be done. That day it was the oats still standing, today it is a magazine deadline, tomorrow a compelling Twitter exchange, the day after that, something else. And more often than not, the work wins out. But sometimes, just as I'm drawing the heavy mantle of toiling martyrdom over my shoulders, I think of that Arctic Cat with the trailer hitch, drop the flimsy cape, and off we go to Cotter Creek.

For the first year up there on our farm off the Starkey Road dead end, the uninvited yard traffic came and went, and we mostly just observed. Someone suggested I post a Keep Out sign at the entrance to the drive, but I resisted. Back when my folks moved to the farm up north of New Auburn, Wisconsin, the general procedure was that if you bought a piece of land, the neighbors hunted on it the first year just like always. The second year you maybe had a quiet word with them. By the third year, you had the property to yourself. Lately, though, the first thing folks seem to do the minute the ink dries on the real estate forms is slap up No Trespassing signs every forty feet. We took this as a sign of greenhornery, and so I didn't want to go that route. I have also been taking into account Seneca the Younger and his belief that "things sealed up invite a thief: the housebreaker passes by open doors." You put up a nice Keep

Out sign, and maybe people start thinking you've got nice things. We have no complaints, but the truth is we live in a drafty-windowed farmhouse with mismatched doors, and while there are a few goodies in the pole barn, my favorite possessions are either worthlessly esoteric or heavy and hard to move. Regarding the rest of our stuff in general, you'd get a poor return on your thievery.

But here at the terminus of our driveway the cars kept coming, and one day after rising from the dinner table at the sound of yet another unfamiliar motor only to observe yet another carload of strangers helping themselves to a leisurely tour, I turned to Anneliese and said, "I'm puttin' up a sign."

In hopes of counteracting Seneca's dictum, and believing in this case that the medium most definitely affects the message, I headed down to the aforementioned pole barn and rummaged through the scrap lumber pile until I located two mismatched boards of sufficient length to carry the lettering. Using a jackknife-sharpened pencil, I sketched the word *PRIVATE* on the first board, and the word *DRIVE* on the second. Next I sorted through my collection of half-used cans of wasp killer and WD-40 until I found a canister of bloodred spray paint. I shook it until the rattle ball went silent, then purposely oversprayed the pencil tracings so that here and there the excess paint

ran in exsanguinous streaks. Then, being a stickler for detail, I fetched and loaded my Ruger Super Redhawk .44 Magnum, leaned the boards against a box elder stump, and from a civilized ten paces, drew down the seven-inch barrel and blew six 240-grain slugs through the signage.

I hope I'm not putting you off. I was operating under the auspices of art, not violence. Certain respected craftsmen take strategic hammer and tongs to their high-end cherrywood credenzas in pursuit of the "distressed" look. I placed every bullet with the same judicious intent. Anyone who would judge these as incidental bullet holes would likewise impugn Jackson Pollock as a random drizzler. Furthermore, I was raised in a township where no road sign was fully christened until someone blew lead through it, and in fact I long suspected the town board kept a well-armed man on retainer for that very purpose. With every round punched through *PRIVATE* and *DRIVE*, I was establishing veracity. What you had here was what the art department refers to as a *vernacular* piece.

Jane and I hung the sign together. She gabbled happily from her safety seat as we bounced out the driveway in my beat-up and beloved 1951 International Harvester pickup truck, and kept it up through the open window while I mounted the signboards on a popple tree just a few yards past the mailbox. I attached the sign using drywall screws

and a cordless drill. (Flagrant misuse of drywall screws is a hallmark of slapdash craftsmanship: I buy'em by the case.) It was nice there beneath the leafy canopy, standing among shifting blots of sunlight. In the spaces between the sound of the drill and Jane's jabbering, I could hear the faint traffic over on the interstate. It's two miles as the crow flies from here to Tom's yard, and yet on heavy-weather mornings it sounds as if the big rigs are fogging through our garden. Even on the quieter days the hollow howl of tires reaches us—softened a bit, but held at an unbroken sustain as if someone capable of circular breathing was piping a jug— and it is tough to imagine what it is to have all that traffic just off the porch. When I sunk the last screw and caught the sound of those incessant wheels, it occurred to me to count it a blessing that our intrusions could be stopped so simply.

For a week or two, I came and went, and admired the sign. The scrap-wood look, the drywall screws, the scrub tree mount, the dripping red letters, the .44-caliber perforations, everything combined to send the perfect message: There's nothing back here worth taking, and furthermore, do you really want to meet the guy responsible for posting the message?

But a thing is worth doing only if you do it well, and I shortly realized that for all my effort, I had fallen short by a single critical degree. The piece was passable, yes. Ac-

ceptably assembled, perhaps, to the undiscriminating eye. But one little detail—a missed opportunity, frankly—kept niggling me. And so came the day when, like a painter returning to the museum to retouch his own masterpiece, I unscrewed the topmost board and returned with it to my pole barn studio.

Today if you sneak down my driveway, you'll see a sign pretty much identical to the one I mounted initially—with one critical difference, and although the critics have yet to weigh in, it is my opinion that this final tweak, this *nuance*, equips the piece to succeed on every level. The new sign— composed in the same fashion (cruddy lumber, runny red letters, and fusillade included)—reads as follows:

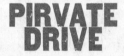

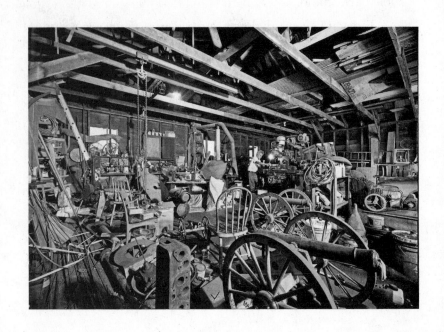

CHAPTER TWO

In conjuring Tom Hartwig's workshop you could do worse than to imagine an antique store stocked by Rube Goldberg, curated by Hunter Thompson, and rearranged by a small earthquake. The tangle is all wood, rubber, and iron. Wood-spoke chair backs, wood-spoke wheels, sawdust, and odd boards leaned about. Coiled air hoses. A stripped straight-six engine block. A large galvanized oil funnel upside down on the floor, as if the Tin Man fell feetfirst down a manhole. A steel-rail engine hoist bolted to the rafters. Two belly-high cannons, each dust-covered and stuffed with socks. Another cannon, the wheels maybe a foot high, Lilliputian but fully functional. A canister of gun bluing, a gallon of WD-40, a sprung tape measure lying in bright yellow zigzags across the floor. A torpedo heater, plastic buckets of Mystik grease, various teetering heaps, a deflated inner tube, a selection of squirrel-cage blowers. An overlapping cascade of adjustable wrenches, ordered by size and draped in the vertical from a

rough-cut stud. On the wall adjacent, a single row of open-end/box wrenches hung neatly on nails. On the windowsill, a bristle of twenty-one screwdrivers jammed blade-first into a Styrofoam packing block.

This is not the comprehensive catalogue. This is just the first glance. The photographers have gone to rummage in the Rambler for a wide-angle lens. When they return, Tom leads them first to a John Deere engine. The ol' one-lunger, he calls it, in light of its single piston. Dating from 1930, it is mounted on cast-iron wheels and fitted with a drawbar on the order of a toy wagon. This pumped water around here for thirteen years, he says. I'll start'er for ya. He fiddles with the spark and throttle, spins the flywheel. After several spins, it refuses to fire. Ach, he says, I flooded it already. You open the gas too much, it floods.

This is our cannon business, he says, moving along. There are three cannons in immediate evidence, each mounted in its caisson and apparently ready to fire. Two have barrels the size of a short length of sewer pipe. The third stands just shin-high and its barrel is the length and circumference of Tom's forearm. Scattered on the floor are parts for other unassembled cannons. This is an elevating screw, he says, picking up what might be the knob for an antique water faucet. You heat this a dull red and you drop it in oil and it turns black. You don't even have to paint it.

I got interested in these cannons and stuff because my great-grandfather was in the Civil War and he was with the 7th Wisconsin, Company G, which was part of that famous Iron Brigade. Most of 'em wound up getting killed. Then one year my ma got me a book. Title was Round Shot and Rammers. *And they had sketches in there of cannons. And first, I started out, I was gonna make a lawn ornament. And then I got to thinkin', well, I got black powder around for stump blasting and whatnot, I might as well make it so it shoots. And I just kept goin' from there.*

These two bigger ones, I had a copy of the blueprints from the United States Land Artillery for a Model 1849. I made everything half of what the blueprints had. The muzzle called for an eighteen-inch radius, I used a nine-inch radius. He pats one of the barrels. This is five pieces welded together. In an original it'd be either forged or cast. You make do. I gotta drill the touchhole in this one yet. He looks at the cannons a little longer. Yah, I should get busy and finish these up.

He leaves the cannons, moves to the very definition of a contraption: a homemade tangle of roller chains wound up down and around a conglomeration of sprockets, all hooked to a spring-loaded saw blade and powered by a repurposed electric motor. This is a shaper, he says. They had these already in the 1700s for makin' gun stocks. On a lathe you can cut something round but you can't cut any-

thing odd-shaped. *He shows you how the machine works back and forth, the roller tracing the shape of a hammer handle, causing the spring-loaded blade to shave a square stick of wood into the duplicate shape.* I got it figured so it goes ten turns per inch, *he says.* They come out a little rough, but all you gotta do is take a spoke-shave and smooth 'em up. I built this to save time on making spokes for my cannon wheels.

He talked to the Amish to learn how to build wooden wheels. They tend to a straight wheel, *Tom says, but he cuts the spoke holes at an angle so the wheel has a "dish" to it.* They're sturdier that way, *he says, and they have some give when you shrink the steel tread around them. All the while he is turning the spokes and wheels over in his hands.*

He moves deeper into the shop, the darkest corner. He reaches up and pulls a string, and a fluorescent light quivers to life. Yah, and back here is my lathe and my milling machine. They're old. This milling machine, the last patent on it is 1916.

The machines are squat, and ornate, and impossibly solid. The lathe alone is over three tons of steel and cast iron. One of the photographers asks, Why such a big lathe, Tom? *He smiles and replies,* Because you can do a little job on a big lathe, but you can't do a big job on a little lathe.

In the works and on the floor, you catch glints and,

looking closer, see oily coils of shiny steel shavings. Here's a deal I just made, he says, picking a silvery steel shaft from the lathe bed and holding it to the light. A guy brought me some shafts he wanted O-ring grooves cut in. But he didn't tell me how deep, so I cut these fifty-thousandths of an inch. If they're not deep enough I can easily set'em up and cut'em deeper. And this is a boring bar holder I made for the lathe here, like when you ream out the inside of a tube. I made it out of a broken tractor axle. It takes a while, but you work on it in degrees.

He holds the boring bar holder up for closer inspection. The surface is crosshatched with fine lines. This is what you call knurling, he says. Now he holds up another lathe tool fitted with three rotating wheels, each scribed with diagonal lines. This is a knurling tool, he says. You put it in your tool host and put pressure against it and it leaves a design like that. A lot of time knobs and stuff have knurling for gripping. He holds up the boring bar holder again, rolls it in his palm to show off the cross-hatching. No need of it on this, he says, it just looks neater.

One of the photographers studies the O-ring grooves. Did someone teach you these things, Tom? No, he says. No, you get good books and read'em. Understand what you're reading. I've got a lot of books in the house. The lathe is the king of tools, because if you need something, you can make it.

Can you hold the knurling tool up, Tom? He does, and offers it to the lens. You back away now, so as not to block the limited light. Also to position yourself at the next stop on the tour. You have been on the tour before. You know how it will go. You know there is a specific choreography and timing. You know which jokes go with which stations. You know, for instance, that right now he is hoping someone will ask about the hole cut in the wall at the far end of the lathe, so he can tell the story of how it came to be, and you know if no one takes the bait, he'll wedge the segue in there. Sometimes, out of courtesy, you play the straight man, feed him the line that leads to the story.

For now, though, you backtrack through the maze and simply run your eyes around the place. You wonder what calculus might quantify the cumulative toil represented by every hand-worn tool, every besmudged Folgers can brimmed with bolts, every belt and pulley, every project set aside for the moment how many years ago. And this is only what is visible and tangible—what of every project in and out of here over the decades right through today? Somewhere right this instant a hand-turned axle bears the weight of a loaded hay wagon, a refurbished bushing vibrates in the bowels of a quarter-million-dollar combine, the weld bead on a corn picker slowly rusts in the blackberry canes out behind some barn somewhere. In stillness, the place echoes with work.

The photographers are done at the lathe now and starting to eye other corners, so you take your cue, do it like you can't remember: Tom, what was the story again with the hole in the wall there? And he tells it then, the one about the farmer who showed up with a fifteen-foot shaft off a manure spreader, and Tom with only fourteen feet of workspace. That lathe wasn't going anywhere, so they jigsawed a hole in the wall and threaded the shaft through from the outside. Y'do what y'gotta do, he says, grinning at the payoff.

Inch by inch the photographers cover the shop. There are stories every step of the way. Leaving the lathe, he stops by the forge, six sets of tongs and a ladle for pouring lead all resting on dead coals beneath a chimney hood fashioned from the sheet metal of some long-gone machine. Beside the forge is a wood-burning furnace made of two fifty-five-gallon drums. On now to the hand-operated drill press his daddy installed before electricity was available and that Tom wired up to an electric motor after the juice finally did arrive. Once lightning struck and fried the wiring, and he'll happily show you the scorch.

At the twenty-ton press, he pauses and says, I was pickin' something up at Hanson's machine shop and they

were showing me their brand-new hydraulic press. I said, Whaddya gonna do with the old one? Hanson said, I wanna sell it. I said how much you want for it, he says, Hunnerd bucks. I didn't say anything. Came home and mentioned it to Arlene. Couple weeks later it's my birthday and the neighbor drove in the yard with it in his pickup. Here she went and bought it for me and never said nothing.

You're tickled with the story, because that one you hadn't heard before. But you'd stake your pending heartbeat on what's coming next. You can see he's taken the photographers on the complete circuit. He's easing them toward the door. But he's also angling for the corner, the corner leaned with an impossible cluster of rakes and pipes and shovels and posts and handles, essentially a tangle of parallels. But if you know what you're looking for, you'll see there's a freak in there. A wooden-handled spade, just your standard shovel, except that after the handle rises from the blade for about two feet it turns completely back on itself and heads back down to form an inverted U. And right when it seems you are about to exit, he reaches in and he pulls the shovel out, holds it up, asks, Ever seen one of these? He waits a beat, then: This is a shovel we found in the ditch after the county boys got done leanin' it to death!

You wonder, briefly, if in the hands of famed prop

comedian Carrot Top that one would play in Vegas, and because you've been in on the joke for a few years you know it's not a shovel handle at all but rather a failed oxbow, but even knowing the joke, you still enjoy the idea of him taking the time from the work of the farm to construct a gag shovel. You think of him at the workbench on a rainy day when he couldn't get into the fields, shaving that oxbow down so it fit the receiver of the spade, you think of him smiling when he first held it up for inspection, you think of him leaning it there in the corner and anticipating his first victim, and you figure the world could relieve itself of a lot of pressure if more of us were willing to break toil for the sake of a harmless dumb joke.

RARE IS THE JOY THAT transports a country boy like a summertime pickup truck ride in the company of a sweet country girl. You will understand, therefore, that my heart is light right now, bombing along as I am down a tore-up dusty road with a blue-eyed beauty belted in beside me. I smile at her, and she smiles back. Then she repositions her blankie and stuffs a thumb in her mouth.

Jane and I are on our way to visit Tom. I've hatched a plan for a movable chicken pen that requires a series of

five-foot-long steel stakes bent at a right angle five inches
from one end (the bend serves as a handle), and to that
end I have purchased a bundle of ten-foot rebar (a type
of ribbed rod commonly used to reinforce concrete). Tom
has agreed to cut and bend the rebar for me, and it's jan-
gling behind us in the truck bed. Normally we would be
rolling on smooth blacktop, but crews are resurfacing and
reshaping the curves along this stretch of county road,
so they have chomped and removed the asphalt. Gravel
rattles in the wheel wells, and a whorl of dust spins from
beneath the back bumper to drift in our wake. It's good
to drive a dirt road, especially in a pickup truck. You get a
whole different feel coming up through the wheel. There's
a little give, a little float to the curves. You feel like maybe
life is more livable when everything doesn't have to be all
double-yellow perfect. Given time and good spirits in the
company of a child, I believe you should converse with
that child, but right now Jane's thumb is well planted,
and furthermore I can cultivate in her worse habits than
the love of watching farm fields slide past an open truck
window to the tune of yesteryear's country music legends,
so I punch the radio button and dial up Moose Country
106.7. I do my best to raise my children right, but some
lessons are best imparted by ladies, specifically among
them Patsy, Tammy, Loretta, and even—*especially*—

Dolly. (Later, when the boys start showing up, there will be supplements of Neko Case, Kathleen Edwards, and judicious applications of Koko Taylor.)

I slow to turn up the Hartwigs' driveway. It's a dirt two-track, and long ago recovered from the cement truck ruts—although, forty-five years on, Arlene still grumps about that foreman who promised to fix the driveway and never did. The drive is a good half-mile long, cut through a cornfield. Wavering bicycle tracks are visible in the sandier patches; in fair weather, Tom pedals out to fetch the mail. Recognizing where we are, Jane raises her gaze and uncorks her thumb. "I can feed Cassidy a bone?"

Cassidy is the Hartwigs' three-legged dog. Took me a while to figure that one. For the longest time I thought the name an unusual choice. Tom and Arlene, the type of people they are, you think they'd go for something more in the vein of "Shep," or "Buster," or even "Ol' Hound." (My brothers Jed and John, in their own way younger versions of Tom, have named their dogs Jack, Frank, Leroy, and Sven.) You will get a sense of how my brain floats when I admit that it took two years and a quiet moment alone before the epiphany struck: *Cassidy . . . Hopalong Cassidy!* I was alone at the time, but I said "Ha!" right out loud.

"I can feed Cassidy a bone?" It's Jane again. Young as she is, she is used to Daddy's aimless mind.

"Yep," I say. "When Mr. Hartwig and I finish our work, you can feed Cassidy a bone."

She smiles, then recorks her thumb. We roll happily past the cannon and round the bend beside the barn. A gigantic sleepered semi pulling a fifty-three-foot refrigerated trailer shoots out from behind the whitewashed silo at 70 miles per hour, blasting past so close I can see the IFTA stickers over the fuel tanks.

I park the pickup over by the shop.

When my father needed something welded he drove around the three-mile block to see Oscar Knipfer, who stored his torch in the peeled-paint remains of a one-room schoolhouse, wore his overalls without a shirt, and built indestructible hay wagons composed of bridge beams and old Buicks. By the time I was in grade school Dad got his own welder, so the images I retain of Oscar and his shop are knee-high and indistinct: the driveway winding through mounds of steel heaped above man-tall weeds; a big dog; a dark garage-door-sized hole sawn in the side of the schoolhouse to admit larger projects; Oscar's face a smudge of dirty whiskers. The work zone was a haphazard radius of tools, cables, wooden jack blocks, rags, wads of wire, fifty-five-gallon drums, scrap-

metal castoffs, cast-iron oddments, and cannibalized cars doubling as storage lockers, all of it distributed as if the schoolhouse had gaped its black mouth and coughed.

Surely somewhere inside the schoolhouse there must have been a workbench and vises, but the door was perennially blocked by industrial clutter and yet another partially completed hay wagon, so Oscar worked out in the open, sometimes atop a stack of tire rims, sometimes right on the dirt. He'd mark and clamp the pieces as needed, then kneel to lay the bead or make the cut. When he straightened from his work the knees of his overalls were dark with a mix of soil, waste oil, and slag ash, and his hands were stained the same. Odd, I think, to remember a man's work so clearly, but not the way he talked or anything other than his overalls and an impressionistic visage.

Before he'd let you take your wagon, Oscar insisted on painting the running gear (nonfarmers might call it the undercarriage: essentially the steel and wheels) green and yellow. I suspect he obtained the paint at discount, as it came off a tad too lemon-limey to attract the attention of the John Deere trademark attorneys who were anyway not necessarily roaming the sketchier corners of Sampson Township. Apart from their two-tone coloration and in addition to being built to carry more hay than five men might stack, Oscar's wagons were renowned by farmers all around

for their ability to run smoothly down the road. Whereas most factory-built wagons juked back and forth if you got above ten miles per hour, you could draw Oscar's wagons at highway speeds and they tracked dead true. Dad said it had to do with the Buick parts and Oscar's seasoned eye.

Tom is my latter-day Oscar Knipfer, I think, as the screen door opens and the man steps out. The first time I met Tom, he struck me as resembling someone, but I couldn't quite put my finger on it until one day I happened upon a portrait of the Irish playwright Samuel Beckett. The brushy shock of hair, the fatless cheeks, the deep-seamed skin, the nose like a flint broadhead; the basics are the same, although Tom's is a less hawkish visage, and he tends to rest his features a few creases nearer a grin. The lines in Tom's face do not convey worry. They seem more a product of curing and mirth. Today as in all seasonable weather he is wearing plain brown work boots, a dirty white T-shirt, and jeans. The T-shirt collar is lightly frayed, and the jeans are cinched across his flat belly with a black leather belt. As he crosses the yard toward us, he walks bent forward at the waist, his elbows back and slightly splayed.

"Whaddya got?" he says.

"Pretty simple, Tom," I say. "Gotta cut some rebar and then put a bend in them about five inches from one end. I was gonna hacksaw them, but I figured it'd be a lot quicker with your torch."

Tom nods. "Yah, that'll be nothin'."

"I tried to bend 'em cold, but I just about twisted the vise off the bench." Tom chuckles, and then stumps off into the steel shed that doubles as his shop and garage. His bicycle is leaning against the Crown Victoria he and Arlene use for grocery runs. The bike is of fairly recent vintage, equipped with hand brakes and knobby tires and fitted with a basket for the mail. Back in the darker recesses, bumpered up snoot to snoot with the Crown Vic, is his Model A. He re-emerges now, pushing a dolly cradling two cylindrical steel tanks—one containing oxygen, the other acetylene—and begins unlooping the red and green hoses that carry the gases to the torch. "Bought these tanks new in 1964," he says, apropos of nothing.

"Year I was born, Tom." He grins.

I've positioned the truck so that Jane can observe from her car seat. Normally I'd turn her loose on the sod—she has always loved to crawl on the earth and even her size-two jumpers had dirty knees—but I don't want to risk her grabbing hot steel or being spattered with slag. Kicking around in the weeds beside the shop, I locate a length of treated 4x4 post and prop the lengths of rebar on it so the cut points are held clear of the ground. The traffic noise flows as usual, but I am near enough to Tom that I also hear the scratch of the striker and the *puhp!* of the gas igniting, then the fluctuating pitch of the hiss as

he fine-tunes the oxygen-acetylene mix. At first the flame is a wavering orange ribbon shedding feathery strips of ash, but as Tom alternately twists the twin brass knobs of the regulator, the ribbon stiffens and retracts into a pale yellow cone, the base of which surrounds a circle of minuscule flamelets, each one a sharp blue dart. Kneeling, Tom applies the torch to the first rod. As the flame splays out across the surface he swabs it slowly back and forth. Shortly a half-inch section of the rod begins to glow deep red, then—quickly, because this is not a big chunk of steel—incandescent orange. Now Tom presses his thumb on the cutting valve, releasing a blast of pure oxygen, and a shower of sparks spits from the suddenly molten iron. As Tom advances the torch, beads of slag drip from the kerf and drop glowing to the ground until the cut is complete and the rod falls in two. The glow fades almost immediately, but the steel sizzles in the grass, the green blades blackening even as Tom turns his attention to the next bar.

As Tom begins the second cut, Jane calls out from her seat in the pickup truck. "Pyre-crapper, Daddy! Pyre-crapper!" I look at her blankly. "Pyre-crapper!" she repeats, pointing toward Tom as another blast of sparks erupts, and now I get it. A few nights ago on our way home from a family get-together, we stopped to watch fireworks. We thought the big booms might scare Jane, but it turned out quite the opposite: After each thunderous retort, she cried out, "More!" Of course the

amateurs always have to throw their stuff, and throughout the evening the snapping of firecrackers was constant.

Tom's torch hisses and the sparks fly. "Pyre-crapper!" says Jane, pointing again.

"It *is* like a firecracker," I say, and wonder about the microscopic flashes happening down there in her brain, how the nascent neurons arc to make such an abstract connection.

When the last rod is severed, Tom snuffs the torch and hangs it from a hook on the dolly handles. "Now, you want a right-angle bend? About five inches off the end?"

"Yep."

Tom studies the rods a moment. "Y'know . . ." he says, then heads over to the opposite end of the shop, reaches into another patch of weeds, and begins to tug at something. I move to lend a hand and we yank out a length of steel tubing roughly six feet long and bent in a broad arc. Five-inch pipe stubs are welded at intervals along one side of the tube perpendicular to the flat axis.

"Trampoline frame!" says Tom triumphantly. He lets the semicircle pipe flop flat so the open-ended stubs—which I now see are collars positioned to receive the legs of the trampoline—point skyward. "Stick one of those rods in there," says Tom, lighting the torch again. I grab a rod and stand it on end inside one of the collars. Tom kneels and

puts the flame to the rebar just at the lip of the short pipe section. This time when the rod glows orange, he stays off the cutting valve, saying instead, "Awright, go ahead and bend'er." I apply sideways pressure and feel the rebar give at the luminous joint. I continue to press the upper portion of the rod downward and it bends smooth as twisting taffy until it is parallel to the ground. When I lift it clear of the collar the rebar has formed a perfect 90-degree bend. "I knew I was savin' that thing for a reason!" Tom says, beaming the triumphant grin of the vindicated hoarder.

The trampoline frame serves as a perfect jig, and in minutes we have the whole batch bent. Tom snuffs the torch, and immediately the sound of traffic pushes in.

While Tom coils his hoses and the rebar cools on the ground, I poke my head inside the truck cab to check Jane and immediately discern that she has loaded her shorts. I grab the diaper bag from atop the drivetrain hump and the truck seat becomes a changing table. Pyre-crappers, indeed, I think. When do the nascent no-more-pooping-in-my-pants neurons fuse?

When I called Tom earlier to make sure he was home and available, I asked him what I'd owe him for this proj-

ect, and—as he often does—he said *nothin'*. So I told him I'd pay him with a packet of homegrown pork chops, and he said, Well, I figure that would cover it. Now after snapping Jane's onesie back over a fresh diaper, I start rummaging through the cab for the chops, but they are nowhere to be found. I distinctly recall taking them from the freezer before we left, and slowly realize I managed to leave them on the lid after I closed it. If forgetfulness were a sport, I'd have a shoe contract.

Tom and I have known each other long enough now that trust isn't an issue, but there is a singular psychological gap between handing over payment in the moment as opposed to days or even hours later. There's also an anticipatory cringe because I know what's about to happen: First, he'll tell me not to worry about it. Then he'll launch into a stream of stories about every deadbeat and no-account grifter who ever skinned or stiffed him over the years.

"Tom, I'm a little embarrassed," I say when he emerges from the shop.

"Yah?" he says.

"I promised you pork chops, and I forgot to bring'em."

"Aw, don't worry about it."

"Well, I'll bring'em, I just feel like a deadbeat."

"Nah, I know you're good for it." There is a brief pause. "Now, that Frank Thurston, every time he came here he'd

forgot his wallet and his checkbook. Minute I'd shut off the welder, he'd start slappin' his pockets . . ." Tom pantomimes patting at his shirt and pants with a look of exaggerated surprise.

I manage a tepid, "Heh-heh."

"Yah, and then once one'a them Buford boys come over here, lookin' for a one-inch bolt. He spied one layin' on my lathe, and he said, 'That's just what I want,' and he picked it up and took off. I thought, 'Well you S.O.B.!' Later that fall, he calls me up, he had a gravity box fulla corn, he was just pullin' up on Mackey Road, and the hind axle broke. He wanted me to come and weld a new one in. So I take that portable unit I got, and a torch, and I cut it out, welded a new one in, and normally at that time I used to charge twenty bucks. I charged that boy thirty, and to this day he didn't know the difference! And then ol' Fredericks over there . . ."

It's a detailed rundown, extending over several minutes and featuring a cast of every character who ever cut Tom short or didn't drop cash on the barrelhead. Herb Vinson, the neighbor who reliably produced his wallet but invariably found it empty. Turk Jackson, whose checks bounced like a red rubber kickball. The guy who wanted to borrow five gallons of gas on a credit card. You know the end is near when he circles back to Frank Thurston. "Yah, that Frank was so tight, we used to say he squeezed a dollar till the eagle shit."

"Heh."

" . . . and a nickel till the buffalo gave milk!"

I just stand there, toes curled tight.

"Nah," says Tom, apparently in conclusion. "I'm not worried about you payin' up."

I muster a wan smile.

"I can feed Cassidy a bone?" It's Jane, and I could kiss her for the diversion.

In the house, Arlene is seated at the kitchen table, her chair angled to face the front door. She has only recently returned from the hospital where she spent the better part of two weeks in a coma related to numerous health issues culminating in profound pneumonia. Her forearms rest on a wheeled aluminum walker, the rear legs of which are fitted with tennis-ball skids. Transparent oxygen tubing coils at her feet and trails off into the dining room, where it attaches to a green oxygen cylinder, the miniature medical equivalent of the one Tom has just used to fuel his torch. A wire basket attached to the front of her walker is filled with miscellany: pill bottles, Kleenex, a portable phone, and a plant mister set to "stream." Today when I step through the door she doesn't greet me, but rather snatches up the sprayer, hollers, "Mis-

ter Bigshot!" and starts pumping the trigger, shooting thin jets of water all around my feet. Startling as this is, I am not the target. Rather, the sprayer is her means of preventing a ponderous black-and-white angora cat—the aforementioned Mister Bigshot—from escaping through the screen door, as he is attempting to do now. "Mister Bigshot!" says Arlene again, finally getting zeroed in and spritzing the cat in the snoot. He shakes his whiskers and retreats, but within three steps has regained the air of languorous insouciance so central to the feline nature and pads off to nap in a sunbeam. Tom closes the door behind us and circles around to take his customary seat on a wooden chair in a corner between the cluttered table and a countertop teetering with books and periodicals: *A Civil War Treasury of Tales, The Iron Brigade, Kursk, Tricks & Secrets of Old Time Machinists, Navajo Code Talkers, Winds of Freedom, The Complete Modern Blacksmith, Car & Driver.* And that's just half the stack.

The Hartwig kitchen is small and close, dominated by the bulwark of a cast-iron wood range dating to 1893. Add to that the encroaching cupboards, the kitchen sink and dish-stacked countertops, a refrigerator, a modern electrical stove, a small wall-mounted porcelain utility sink, and an overloaded coatrack, and there's not a lot of room to maneuver. The wooden floors are dark brown and unpolished, but worn to smoothness by over a century of boot soles. The

table is always happily cluttered with mail and pens and notepads and cookies and saltines and—always—a Skippy jar filled with peanut M&Ms.

The worn floor, the dim corners, the bacon-grease undertones . . . this is the same kitchen I've known from clear back to my Jane-sized days when we went to visit our neighbors in Sampson Township. These are not the kitchens of slick magazines and stainless-steel appliances. These are kitchens of clutter and stack, of the dishrag hung and the pans piled. Of the countertop ice cream bucket spilling onion husks and potato peels. Company is happily received with no preemptive clearing of the decks. Just clomp right in, boots and all. Your chair is waiting, more often than not left at an open angle, ready to receive the next visitor. This kitchen feels like the one in which Dad and my brother John and I would take our bologna and rhubarb sauce lunches when we helped our second-generation Czech immigrant neighbor put up hay. It was in a kitchen like this that we sat around a table with the Baalruds after their anniversary shivaree, when we all snuck up the drive and made a ruckus beneath their windows in the dark. This is the kitchen of Art and Clarence, the Norwegian bachelor brothers who farmed just north of us and who before sitting down to visit would set their obese dog Tootsie up with a heaping bowl of crumbled bread soaked in milk. When we

visited our neighbors in those days we just naturally sat in the kitchen. In fact, it would have felt stiff and strange to sit in the parlor. What I'm saying is, the first time I walked through the Hartwigs' door and into that kitchen, I knew exactly where I was.

Today I take the open chair facing Arlene, lower Jane to the floor, and ask what I always ask: "What's Mister Bigshot weigh these days?"

"Seventeen pounds," says Arlene. In his prime, the cat weighed nineteen. The Hartwigs' other cat, Oscar Underfoot, goes thirteen.

Jane is tight to my knee, giggling and squirming as she tries to avoid Cassidy's lapping affections. A frantically happy sausage of a mutt, she whips her tail with a vigor that pitches her butt back and forth in an odd dip-and-swoop accentuated by the missing hind leg. Circumnavigating the dog, Jane toddles away into the pantry just off the kitchen. "I know what *she's* after," says Arlene, eyes sparkling. I follow Jane and find her up to her elbows in a box of Milk-Bones. When she withdraws her hands, each fist clutches three biscuits. A seventh biscuit falls to the floor and she tries to pick it up, but with her teensy fingers full, she only manages to push it

around, and while she is doing so, another biscuit drops from her hand. This frees up space in her fist and she snags the original dropped biscuit. Then she starts scrabbling around after the most recently rogue treat. And drops another. And picks up the one previously dropped. And keeps repeating the process. I'm expecting her to pitch a fit, but she remains inexplicably placid, dropping and retrieving biscuits one after the other, until finally I give in and grab the current loose biscuit myself. Back in the kitchen chair, she stands at my knee, doling out the bones one at a time as Cassidy twists herself into knots of slobbering joy.

Arlene pushes a plasticine tray of lemon crème sandwich cookies my way. She and Tom buy them at Stockman Farm Supply in Osseo when they make their weekly grocery trip in the Crown Vic.

"So what brought you here today, Mr. Mike?"

"I'm workin' on a chicken project, Arlene."

"I'll tell you a story about a chicken," says Arlene. "One day this hen came up here, trying to get in the house, and I wouldn't open the door . . ."

"Yah, it was one of those Black Polish Crested hens," says Tom, cutting in.

Arlene picks up where she left off. " . . . she went up to Grandma's house and Grandma let her in, and the cupboard door was open . . ."

Tom jumps back in. " . . . first the hen walked all around the house."

From here on in they talk in tandem, like two musicians trading licks.

" . . . and there was an electric frying pan filled with papers, and she set her little butt in there and she . . ."

" . . . laid an egg . . ."

" . . . laid an egg . . ."

" . . . in the frying pan . . ."

" . . . in the frying pan . . . and Grandma'd let'er out every day to go do her duties and come back in . . ."

" . . . she wouldn't mess . . ."

" . . . and she'd spend her time in that pan . . . and she laid how many eggs, Dad?"

" . . . she laid thirteen eggs . . ."

" . . . and hatched'em."

" . . . all thirteen of'em, in the frying pan."

" . . . in the fryin' pan!"

In the kitchen, the traffic noise recedes, but it does not disappear, audible instead as a faint nautical wash. More than the noise you sense the motion: the peripheral flicker of the vehicles beyond the barnyard, the sublimated sense of something coming and going but never gone.

It is easy to focus on the vehicles and forget about the

occupants. In the years after the interstate opened, Tom and Arlene became used to strangers showing up in the barn or on the porch looking for gas, or radiator water, or to borrow pliers, or wanting to use the phone. If they wanted gas or tools, Tom got cash up front, or held the supplicant's driver's license as collateral. ("People are about eighty-five percent honest," he told me once.) In the early 1970s a man knocked on the door and asked for five gallons of gas. Tom was suspicious right away because a gallon was plenty to get to the nearest station. "Why do you need so much?" Tom asked. "Well, I gotta get to Rice Lake," said the man, naming a city sixty-five miles north. Then the man said he had no money but would return the next day with cash. "Nope," said Tom. "I need something for a deposit, like your driver's license." The man got spooked then, and walked off, only to return shortly with two quarts of Pennzoil and the spare tire from a '73 Buick. Tom figured it for a fair trade and got the five gallons of gas. Later, Tom says, he figured out the man was driving a stolen car. But his favorite part of the story comes a year later: two girls showed up in the yard because they'd had a flat tire on their '73 Buick.

More than once Tom turned on the barn lights in the morning to find someone sleeping in the hay. Or he'd be knelt down welding and someone would tap him on the shoulder and ask for directions to St. Paul after going two

hours in the wrong direction. Once—Arlene shakes her head when she tells this one—a young couple whose car stalled showed up shivering desperately, having set out in 20-below weather wearing sweatpants and T-shirts. Arlene brought them in and sat them beside the stove. The record, Tom says, was five people in one day. The visits diminished when CB radios became popular, and now in the age of the cell phone they have dropped to nearly nothing. These days his visitors are more likely to arrive in the fashion of the young fellow driving from New Jersey to Alaska who departed the roadway in a snowstorm and drove right through the fence and 150 feet into Tom's cornfield before realizing the GPS could not get him out of this one.

Still, it's the noise that makes me wonder how they abide. This year I read Sarah Bakewell's *How to Live*, and when I got to the part describing how French essayist Michel de Montaigne often slept in a bedroom located beneath an attic containing a large bell that rang out the Ave Maria every morning and evening, I immediately thought of Tom and Arlene and the highway. "The noise shakes my very tower," wrote Montaigne, "and at first seemed insupportable to me; but I am so used to it, that I hear it without any manner of offence, and often without awaking at it." Tom will tell you that after forty-odd years, he is used to the nonstop sound, and that it doesn't get to him the way it did in the early days.

At work, in conversation, and in sleep, he and Arlene have grown accustomed to it the same way some people do the surf, or the subway, or a regular freight train.

More problematic, he says, are the little things: Once the highway opened Tom could no longer stand at the milkhouse and hear what Arlene was saying when she called to him from the porch. And he suddenly found himself overfilling his Farmall because he could no longer hear the gasoline approaching the lip of the tank.

When the last crumb of Milk-Bone is licked from the floor, I gather up Jane and we begin the slow process of our leave-taking, which unfolds in the usual segments, with stops for conversation every four feet or so, sometimes right through the driver's-side window and up to the time the vehicle begins to move. Today, with Arlene tethered to her oxygen, the overtime conversation extends only to the edge of the porch, but it still consumes another ten minutes.

"You tell Anneliese hello," calls Arlene from the kitchen, where she's once again avidly hosing down Mister Bigshot. "I'll do that," I say. "And I'll be back soon . . . with the pork chops."

"Oh, we're not worried about that," says Arlene. "Now, back when Tommy used to do work for Frank Thurston . . ."

Outside, the traffic noise swells back in a sleek rush. As I strap Jane into her seat I have time to parse the sound more closely. The linear hiss of tires predominates, but I hear also the fluttering whip-crack snap of flatbed tarps, the ribbony pop of tie-down straps, the *psssssss* of air-brake tanks relieving themselves, and the tidal *whoosh* of minivans and smaller vehicles. Now and then you get a whistling antennae, the tub-thumping sound of a loosening cartop cargo box, or the *wocka-wocka-wocka* of a trailer tire gone flat. Although the stretch is level, unexpected shifts in traffic often cause some highballing trucker to flip the Jake brake, and the longitudinal *bla-a-a-a-a-p!* drowns every other sound. Tom will tell you things were actually louder in the old days, especially back when a lot of the trucks ran the old two-cycle GMC diesel engine known as the "Screamin' Jimmy." "You'd hear'em bellerin' a half mile up the road and a half mile after they went by," Tom says, and the way he shakes his head you're pretty sure he's glad they're gone, but in his eye you detect the glint of the enthusiast, and you figure maybe he wouldn't mind hearing that beller one more time, and in fact would straighten right up just to watch the black smoke roll.

I strap Jane securely in her seat, turn the truck around, and then pause a moment to observe the vehicular river. I imagine little Tommy, running right across this very

ground, off to steal a few moments on the footbridge be-
fore school. The one-room school is gone to the ages now,
but the bridges remain, and you can still see a riffle where
water passes over the miniature dam left by all the rocks
those boys dropped. The creek is as close as ever, but you'll
have to travel some to see it, because to cross the interstate
is to trespass. You'll have to go a roundabout mile by road,
and then hike a half mile more. As Jane and I motor slowly
around the corncrib and pass before the cannon on our way
out the drive, a posse of fresh-leather motorcyclists blasts
past, the reverberations of their exhaust splattering off the
barn siding like a fusillade of angry whale farts.

Jane is back at her thumb as we rumble over the gravel, and
I wonder how much of this day will snag in those emerging
neurons of hers. If she'll remember the *pyre-crapper* blow-
torch, if she'll carry a vision of a cat more than half as big as
she, if the scent of a Milk-Bone will forever conjure an eye-
to-eye vision of a salivating three-legged dog. And I wonder
if she'll absorb the atmosphere of that kitchen. I hope so,
because someday her daddy is going to tell her how that sim-
ple room played a key role in her very existence. Thirty-nine
years a bachelor, I'll tell her, and then I met your mother,

and one day she took me to meet her friends Tom and Arlene Hartwig. I can't recall how she introduced me. I don't recall any conversational specifics, or if we shared a meal. What I do remember is the sense of gut-level comfort I felt the moment I crossed the threshold and into the close confines of that kitchen. How the sensory familiarity was such that the moment I tucked my knees beneath the table I was immediately at my ease, skipping right past the getting-to-know-you stage and straight to shooting the breeze like I'd been there before, which in essence I had.

Garden-variety nostalgia was in play, sure. But when Anneliese and I left that night, and after I had dropped her off and was headed back to my very bachelor home, there had been a key change within me. As I watched her laugh and trade stories I saw signs of an old soul. A person who paid her respects, and paid them to the sort of people much of the world passes by at top speed. Prior to our night in the Hartwigs' kitchen I saw Anneliese as beautiful, desirable, smart, and strong. More than enough, in other words, and easily more than I had earned. But as I watched how she honored Tom and Arlene with nothing fancier than honest talk and clear laughter, I began to realize I had found a person perfectly and unpretentiously matched to the roughneck kitchen of my dreams.

Rounding the final turn for home, I can see the road

equipment working at the base of Starkey Hill. As we draw nearer, I slow and pull wide around the crew. Jane is jabbering and pointing at the equipment when I realize they aren't working on the county road, but are rather marking up the intersection that links the county road to our town road. Taking a closer look as we pass, I am taken back. If I'm reading the situation right, the intersection at the base of the hill is going to be completely reconfigured. The straight shot—the essential straight shot—is being recut and hooked, bent in the shape of a J so it meets the county road at the apex of the curve.

I feel a twinge in my gut. Something between worry and resentment. If we lose the straight shot, we'll never be able to climb the hill in a snowstorm. This being Wisconsin, it seems a fair consideration. And I'm thinking about all those days I'm away, when Anneliese is alone here with the girls. I'm seeing them stuck down here on the curve, the snow swirling down, and me off telling cow jokes in Oskaloosa. Now the scales are tipping toward resentment. As we climb the hill in the fading light Jane has pulled her thumb and is chattering away. I maintain my end of the conversation but I'm wondering who I have to call to keep this road straight.

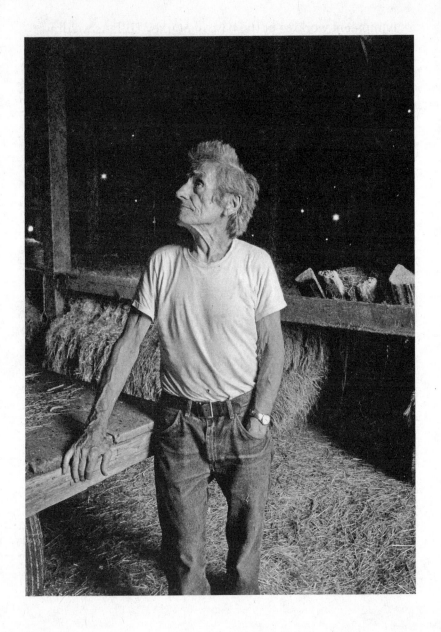

CHAPTER THREE

Portraits in the barn now. The haymow. The barn is built into a hillside, so you can walk right into the mow. There must have been bats in here, he says, pointing to the hay wagon. It is covered with dry particles of black guano, like someone let loose with a pepper grinder in the rafters. The hay wagon hasn't been moved in a long time. The chaff littering the floor is settled and dingy. A small stack of bales remains, all of them leached of color. At the south end of the barn nickel-sized bursts of sunlight pop through the knotholed siding. Tom says, See the mortise and tenon? Not a nail in this barn. All held together with wooden pegs.

The bones of the barn are dead solid, the ridgeline dead straight. Over there at Stube's mill, Tom says, back in the 1800s, they used to saw with power from a little log dam. That must have been slow sawin'. He runs his hand over an anchor beam. Here now, this, they must have

had a steam engine, because you can see the marks where the saw went and they were using a feed of about a half inch per revolution. That'd be about a fifteen-, maybe an eighteen-horsepower steam engine. They'd float this lumber down and pitch it out where the D bridge is.

We quit milkin' in 1991. Arlene didn't feel able anymore. I kept the cattle around for company.

He smiles sheepishly at that. Then, brushing his hand in the air like he's dismissing a fly, says, Weaaahhll, I liked in the summertime to look out and see my cattle in the fields. But then when I was seventy-seven I decided if I got laid up there was nobody to take care of them cattle. So I sold'em.

The photographers are positioning the camera. Through vertical gaps in the barn siding you can see the interstate traffic passing: blip-blip-blip. From misty morning solitude to 23,200 vehicles through the pasture daily. He knows the numbers because a couple of years back the state put a counter out there. Eight-point-five million a year. Sometimes winter evenings when the air was still he would climb up to throw hay down and the diesel exhaust would be acrid in the air and he could see it hung in the space between the bales and the roof.

While he waits for them to set the shot he stands with one hand stuffed in his pocket, the other on the hay wagon. He was explaining how a pulley system ran the hay hooks,

but he's quiet now, gazing up where the rigging used to be. His head is tipped back and quartered away, his profile caught in the light from the wide-open door. You don't know what he is thinking. You do know he put up hay in this space for the better part of seventy years.

I met a guy once, he says. Had the same last name as me. He asked me: Hartwig—what does that mean? I don't know, I told him. I think it's German for "hard work"!

IF YOU DRIVE THE BYWAYS around these parts, take note of the names: Frayzee Road, Goost Road, Hartzgraff Road, Shoemaker Road. Next, cross-reference them with the local phone book (while it still exists) and you will find the matches quickly run to double figures. Tom Hartwig—not coincidentally at all—lives on Hartwig Road. Our little road, the dead end, is named Starkey Road, after the family who farmed our acreage up through the 1970s. A Starkey cousin still farms in the valley below us, and others are scattered all around the area. And although I grew up some forty miles north of here, my own ancestry is represented on the local plat by Peterson Avenue, named after my great-grandfather, whose red barn still stands just eight miles from the Starkey Road intersection.

Even when we can't claim a road by name, we claim it mile by mile, drive by drive, trip by trip. The way a road unfolds before us becomes imprinted. It frames our geographic perceptions, gives the horizon context. The turns, the contours, even the potholes become part of the familiar rhythm of passing through our day. Of simply knowing we're headed into familiar territory, and at the end of the day that is what the heart seeks: familiar territory. It quite naturally follows, then, that we become proprietary about our roads, even unreasonably so. I believe I have legitimate concerns about the changes planned for our intersection, but there is no question I am also reacting to something more visceral. Every time I hit that straight stretch and was lifted toward home, I laid another layer of emotional lacquer on my mythology of this place. You know better, but you come to believe the road is yours, no matter whose name is on the street sign, that it is an untouchable element of the landscape. And once we memorize that landscape we don't want it to change. Of course it is not *our* road in anything other than the taxpaying collective sense, but we let ourselves slip into that mode of feeling and there is always a bit of the old rug being tugged from beneath our feet when changes come. For instance, when my neighbor Denny—he lives at the base of the hill—told me recently that the township plans to cut back the trees along Starkey Road this winter, my first reaction was a heartfelt *awww*. Over

time, the tree lines on either side of the road have encroached well into the ditches, with several large maples extending their limbs to touch branches above the centerline. It is soothing, on sunbaked summer days, to exit the scorching main road and ascend beneath the leafy green arch. In autumn, at peak color, it is like motoring directly into the September page of a bank calendar. Our attachments develop despite the fact that the laws of right-of-way are clearly stated and you can tack your own tape measure to the centerline and figure out exactly which trees the chain saws will take. Emotion really shouldn't come into it. And yet I feel a twinge. Could be worse: When it came time to trim the white pines along Hartwig Road a few years back, one of the neighbors put up such a stink the crew had to pack a sheriff's deputy along with the chain saws.

After I saw the crews preparing to reconfigure our intersection, I placed a few phone calls. Because the intersection involves both a county and a township road, there was some confusion over exactly where to properly register my concern, but ultimately I was directed to the office of the county highway commissioner. The woman who answered the phone said I should attend the next meeting of the highway committee. There would be a "citizen input" segment, she

said, during which I would be allowed five minutes to speak my mind. I immediately began putting together notes. I also began to find myself rehearsing impassioned speeches while jogging or collecting eggs. More than once I caught myself standing in the coop actually waving my hands and raising my eyebrows for emphasis. And then on a Friday morning before dawn (the highway committee meeting convenes at 6:15 a.m.) I drove down Starkey Road and off to the county highway department building in nearby Altoona.

When I arrive, the committee members are already sitting elbow to elbow around two conference tables, most with Styrofoam cups of coffee, a few with doughnuts. Surveying the group, I see men who could pass for my dad and my brother John, both of whom have served on their respective town boards and have endured all the public hectoring and second-guessing such positions incur. The complaint box overflows and the thank-you cards are sparse. In short, the look of these folks makes me feel like I have a shot at making my case.

The commissioner—whom I have never met in person but immediately identify by his position at the head of the table—is wearing silver-bowed glasses with dress shoes and a tie, and he looks a shade more deskbound than the

rest of the crew. I figure he and I would be neck and neck for the softest hands in the room. I choose a seat against the wall in one of a handful of chairs provided for the public. The room is so small that when the commissioner leans back, my knees nearly brush the Naugahyde of his chair.

Only one other citizen is present to comment. He has the beefy hands and sausagey fingers of a lifelong farmer and is clutching a packet of snapshots.

The meeting comes to order. The previous month's meeting minutes are approved, and the bills audited. Then the public session opens and the recording secretary invites me to take the empty chair at the commissioner's right hand.

Without warning, I go completely cotton-mouthed. My heart begins triphammering to the point I fear my shirt is visibly vibrating. You'd think I was being dragged before the International Court of Justice. I can get up in front of a thousand people in a theater and let'er rip. I have clambered atop a piece of plywood on a pool table in a health food store to read my not-so-hot poetry with nary a knock in the knees. But there are two unfamiliar elements in play here. The first is the element of confrontation, and I have no stomach for it, even in this the most civilized of circumstances. I am basically present to tell the highway commissioner that I don't agree with his decision and want him to not only reconsider it but reverse it.

The second element is the level of formality. Sure, it's an elbows-on-the-table session in a cramped cinder-block room with a quorum of men sharing gas station doughnuts, but I have this awareness—and this may sound silly, but I mean it—that I am participating in *democracy*. I am being allowed my say. I feel the spirit of Norman Rockwell's *Freedom of Speech* hovering in the room, although unlike the subject of that painting, I don't have to stand, and a good thing, too, as there is no bench back to grab, and I'd have to splint both legs with rebar to keep my knees from folding. If I am ever called to testify before Congress they will have to pour me from a water pitcher.

I begin by making it clear that I understand why the change is being proposed. That I recognize it as a common reconfiguration designed to prevent accidents by forcing traffic from secondary roads to enter at the apex of a curve, which among other things discourages high-speed merging or lane crossings and improves visibility.

At this point, the farmer with the snapshots breaks in. "You live off Starkey Road?"

"Yep."

"Well, you'll never make it up that hill without havin' a run at it!"

"Yah, that's my poi—"

"That's what the school bus always had to do, and the

milk truck. They'd go past and turn around down there by Fitzger's, then come at it that way."

I have never spoken to this man prior to this moment, but as the newcomer I am grateful to have him at my back, and surely the citation of historical precedent by a seasoned resident will help bolster my case.

I have my prepared notes and stick pretty closely to them. I explain how the straight shot is essential if we are to make the hill under snowfall. I draw a little diagram illustrating how a vehicle forced to slow in order to navigate the proposed chicane will lose vital momentum. I explain how we learned this the hard way when we first moved to the farm and, trying to climb the hill without taking a run at it, had gone down backward with the van and the kids. I explain that I am especially concerned in light of the fact that my wife is home alone with the children so often. Not only does she face the prospect of sliding off the hill, but there is the additional hazard of unloading the kids along the shoulder, leaving the van as its own roadside hazard, and then hiking up through a snowstorm—the worst of times to be afoot along a roadway.

Throughout this entire disquisition, my heart continues to fibrillate as though I were a high-strung gerbil keynoting a convention of raptors. I believe I am keeping my countenance fairly in order, but there is the dread prickle of emerging dew-

drops across my balding melon-head, and now and then my voice is choked off by an involuntary gulp. Throughout, the highway commissioner regards me with a polite, bland gaze.

When I was a child, I lived beside a dirt road. Of all the vivid memory clips I retain from those days, few match the turbulent beauty of Bob Bohl's Plymouth Fury III streaking from between the pine trees and into the open on the road paralleling our meadow, the car a carbureted white rocket disgorging an oblong dust twister that hung to drift slowly over the corn. Bob was running two operations in those days, milking cows on his own farm southwest of us and also over on the Acey Fortner place to the northeast, so he ran that Fury hard. No going out by the road until Bob Bohl has gone by, Mom told us, but we'd get out there early and as close as we could for just that one moment when Beaver Creek Road became the Bonneville Salt Flats.

Dust production was a big deal. My brother John and I pedaled our banana-seat bikes frantically in an attempt to raise just one visible puff, which we associated with grown-up vehicles and grown-up velocity. We'd aim for "sifty" patches where the sand was extra-fine and pump our pedals extra hard, looking back over our shoulders. We were thrilled when the thinnest wisp rose in our wake; we had broken the speed of *dust*. In that spirit, this summer I have

enjoyed the fact that our county road has been temporarily left in gravel so it can settle before the paving. To celebrate I run a tad hot (even in the family van) on the way to Tom's place, in an attempt to produce a classic Bob Bohl plume. How I smiled the day the girls and I ran a dozen eggs to Tom and Arlene and Amy spoke up from the passenger seat to say, "Go faster, Dad, make it fly higher!"

One morning, instead of Bob Bohl shooting from the trees like a moon rocket gone sideways, a lumbering parade of bulldozers and Tournapulls crawled into view. They arrived early, because I remember seeing them first from an upstairs bedroom window and me still in my pajamas. You can bet we dressed fast, and for the next few weeks there was no end to the entertainment as the dark green earthmovers bellered and wallered up and down the road, black exhaust boiling at the sky. The Tournapulls were my favorite. There was something dinosauric in their articulation and the way they lumbered over the uneven terrain, the operator seated in a cab that jutted into the air ahead of the front axle and waggled about like the head of a monitor lizard scanning the bushes for food. When I recall how the operators jounced at their controls I assume it had to be a vertebral horror, but from our vantage point it was a carnival ride. When a dozer put its blade to the Tournapull's rump it was like a bull boosting a hippo, and the two would snarl and rumble until

the earth came mounding up and toppled over the sides of the catch box, at which point the Tournapull would snap shut its scraper jaw and roar off to the dump point. Once a Tournapull got stuck down by where the new culvert was going in. As the giant industrial tire spun down to the axle it flung sheets of soil like an angry rhino pawing dirt.

The road crew used a corner of our hayfield as a staging area, and at night when all the workers had gone home, we would hustle down to where the equipment was parked, climb into the seats, and imagine we were reshaping the world. It seemed the work went on all summer, although it was likely a matter of days or weeks. In time the paver came, laying down blacktop flat as a sheet of oily brownies. First chance, we zoomed out there on our bikes. No dust, but we never felt faster.

I still retain that little boy's fascination with road crews and their equipment. (Naturally one fantasizes only in terms of safe and sunny days. Real road work is conducted in mud and dust and cold rain and boiling heat, and all too often within the kill zone of high-speed texting ninnies.) When I saw the road crews staging their equipment early this summer, I looked forward to observing them in their work. I looked forward to the dust and the evident progress. I looked forward to letting my daughters investigate the fresh culverts and even clamber on the equipment, although vandalism

prevention and the culture of liability have impinged that experience. Funny, then, how my feelings changed when I saw what they intended for our intersection.

When I finish speaking my piece, the commissioner calmly and clearly lays out the reasoning for, as he puts it, *improving* the intersection. There have been numerous complaints of vehicles coming down the hill and entering the county road at high speed, he says. This is curious as there are only two residences and a total of three driver's licenses at the top of the hill, and apart from the occasional wanderer or teenager seeking refuge for beer and nookie, the term *numerous* strikes me as a tad robust and perhaps even pre-emptively positional. When I ask exactly how many complaints the commissioner has received, he becomes vague.

As a follow-up, I ask, "If the goal is to slow traffic coming off the hill, how about changing the sign at the intersection from a yield to a stop?"

"I don't think that's a yield sign," replies the commissioner.

"Yep, it's a yield," I say.

"Yah," pipes up the farmer with the snapshots. "They switched the stop sign to a yield sign down there years ago so the school bus didn't have to stop if there was no traffic coming. They did it because the bus kept burning up brake pads."

Well, we can look into that, says the commissioner. Then he suggests that I contact the township and ask that we be put on a priority plowing list, so the plows would come to our hill first. I explain that the issue isn't about the *amount* of snow, since the hill becomes too slippery to climb after only an inch of accumulation. In other words, long before the plows can be—or should be—reasonably dispatched. Furthermore—and this the commissioner doesn't know—because I run in certain key social circles, I now and then have occasion to hang out with some of the plow operators, and hear regularly what sort of pressure they already face, and how many demands are put on them (in one recent case, by an angry preeminent citizen armed with an upraised shovel). I am also dying to expand upon the flummoxy notion of having to request increased services as a result of the road being *improved*, but nobody likes a nitpicking linguistics stickler, so for the moment I stow that sentiment somewhere down and to the left, just beyond the clutches of my spleen.

The discussion continues a few more minutes, with commission members asking questions and exploring options. When it becomes clear that the commissioner and I are failing to adequately convey the issues at hand while seated around a conference table, he suggests that the intersection be included as part of next month's annual road tour, so that the members

can stand right there and see for themselves. This seems eminently fair. The day of the tour is yet to be determined, and because I want to be sure I'll be home to attend in person, I give the commissioner my number and ask that he call me before setting the date. I'll be happy to do that, he says.

I gather up my papers, thank the committee as a whole, and like a student cut loose from his oral exams, tuck my head and beat feet for the door. Behind me the farmer has taken my place and is spreading his snapshots across the table while announcing that recent changes in the roadbed have left his driveway at an untenable angle.

Two weeks after the highway commission meeting, the commissioner calls. After a pleasant hello, he informs me that he and the committee members will be visiting our intersection on an upcoming weekday. I check the calendar. Anneliese has appointments scheduled with the children on that date, and I will be performing with my band at a festival three hours downstate. It's a paying job booked months ago.

"That day won't work for me," I say.

"Oh."

"You did say you were going to check the date with me first."

Nothing.

"I'd really feel better if I could be there," I say. I am thinking of all the difficulty I had trying to explain the situation to the board out of context.

"I understand your concerns," says the commissioner. "And I can do a good job of conveying them to the committee."

"No chance of rescheduling the stop for a day when I can be there?"

"I'm afraid we can't do that," he says. "But I do understand your concerns and will make sure the committee members do as well."

I am setting up gear for a reading and concert in Madison, Wisconsin, when the commissioner phones with an update. My phone is muted, so I don't get the message until after sound check. The commission has been out to look at the intersection, I hear him say, and we are happy with the proposed improvements.

"If need be," he says in conclusion, "we can revisit the issue in the spring."

Can't lie. My jaw is clenched and my face is flushed. I snap the phone open and press callback. No answer. I leave

a message requesting that the commissioner call me back at his earliest convenience. Then I head off to do the show.

The first time I told Tom about the planned changes to our road, he looked at me like it was *my* idea.

"Weeaahhll, that's *crazy*," he said. "You'll never get up that hill come winter!"

Since then, my evolving tête-à-tête with the highway commissioner has become a regular topic of conversation between the two of us. The initial discussion quickly devolves into anti-authoritarian commiseration. Basically, we sit at his kitchen table trading *hassle-the-man* stories. As you might expect, my stories are pretty weak tea compared to Tom's. I can do a decent five minutes on our state-mandated septic tank fee (my beef being with neither the fee nor the attempts to protect Mother Earth and my neighbor's drinking water, but rather with the verbiage of the accompanying letter, which casts the fee as a charitable means of protecting me from the "unnecessary economic burden" of fixing my septic tank should I fail to maintain it without the government's guiding hand), I can chef up a nice little riff on the unintentional but nonetheless disturbing top-down disconnects of bureaucracy (*We promise to collect only information necessary for each survey and census*, says the government website. "So are you the writer guy?" says the pleasant census taker on the phone, followed by "I'm

not supposed to ask you questions like that"), and if you really want to see me unhinged, inquire as to the environmentally and spiritually defeating wonders of recently mandated and profoundly misnomered "non-spill" fuel nozzles.

Tom, on the other hand, has a hearty repertoire. Several years back, he and Arlene took in a stray dog. Girlie, they named her. Hearing a commotion one day, the couple ran outside and found the new meter reader holding a Mace can and claiming Girlie had bit her. Tom claims the meter reader couldn't produce any sign of injury, but nonetheless, a sheriff's deputy showed up later that day to check the dog's rabies papers. They had expired two weeks previous. "Well, you'll have to pen that dog up, Tom," said the deputy.

Tom showed the deputy his empty brooder house and asked if he could keep the dog there. The deputy said that would be fine.

The following day a woman from the health department called and asked about the whereabouts of the dog. Tom told her the dog was penned up. You have to bring it down here so we can keep an eye on it, the woman said. That's not what the deputy told me, said Tom, and hung up.

The next day the woman called again and told Tom that if he didn't bring the dog in she'd get a court order and come out to confiscate it.

At this point in the story, Tom always plays both himself

and the woman. When he portrays the woman, he pitches his voice high and waves his hands around his face in a fluster: "I says, 'Lady, if you really want that dog, I'll bring it to ya,' And she says, 'Oh, you will?' And I says, 'Yeah, but first I'm gonna get the twelve-gauge and blow its head off.' And she says, 'Ooooh, don't do that! If you do that we'll never know if it had rabies or not!' And I told her, 'Exactly.'

"And she never called again."

Then there were the two unlucky fellows from the county zoning department who were driving the interstate when they spotted what appeared to be a trash dump on Tom's property. In truth, Tom's family had used the area as a dump for years. But what the zoning reps didn't know was that when the government put the interstate in, for purposes of access it took a permanent one-acre easement on the property, including the dump.

"So these two guys stop in," says Tom when you get him going, which doesn't take much. "They'd been drivin' down on the interstate, and they could see the tin cans."

As with so many of the Hartwigs' stories, this one is told in tandem, and right about now is when Arlene jumps in. "They came over here and started givin' *me* hell!" she says.

Tom resumes. "So they're sayin', 'You can't do that, you'll have to clean it up, *blah, blah, blah*.'"

"I said, 'That isn't even our land!'" says Arlene.

"'No,'" says Tom. "'It's *yours*! Now who's gonna clean it up?'"

The men got in their car, and Tom says he never heard from them again. Look, and you can still see the tin cans.

Of course in each of these stories one perceives the position of people just trying to do their job. Attempting to maintain some semblance of civil order in the face of behavior equivalent to that of an adolescent spitballing the substitute teacher. After all, I am the guy who once used *Govis2nosy* as my password when the state forced me to register my two-pig operation online with the Department of Agriculture, and Tom once filled out his entire U.S. Department of Agriculture Hog Census using a pencil held between his toes, just to make it tough to read. But why dampen the moment with apologetics? The joy—nay, the *health*—of sessions like these lies in the freewheeling release of grumbles and ire. No one gets hurt, and what better way to sprain your neck than by nodding in vigorous agreement with the genius across the table who understands the world is populated by stumblebums and ingrates, present company excepted.

I have crawled into burning buildings, I have bare-handed the drawers of a child who has propulsively pooped the cradle, and once on the school bus I rose up and in a firm falsetto told Boog Swenster to stop picking on my little

brother. In all other critical confrontations, however, I am by and large an equivocating wimp. Thus the moth-wing tickle flitting the underskirts of my liver as I flip open the cell phone that has been vibrating in my pocket and realize the county highway commissioner is returning my call. Truth be told, when the phone went off it never crossed my mind that it might be the commissioner. A couple of days had passed, I was splitting wood, and my head was utterly elsewhere. Now after killing the motor on the log splitter and putting the phone to my ear, I shift immediately from the sweaty happiness of physical labor to the skittish sweatiness of low-grade confrontation.

For a good quarter of an hour, we go round and round. The average eavesdropper might never guess we were in disagreement, as both of us are speaking in tones normally reserved for the anteroom of a funeral parlor. It's a quintessentially midwestern tug-of-war in which either side tries to win by ever so tentatively *pushing* the rope. I do manage to tell the commissioner I am not happy about the decision. I go through the same list of concerns I presented at the meeting and the commissioner bats them back, one by one. He keeps circling back to safety, and continually refers to the intersection "improvements" (at this point I am no longer able to hear the word without twitching). Once again he encourages me to call the township and ask that we be placed on a priority

plowing list. At another point he actually suggests that we'd have a better shot if we switched out our current vehicles for four-wheel-drive models. At this, I eye the log splitter, thinking what sweet relief it would be to lay my head on the rail and trip the lever. Instead, I sputter, "But-but, but up to now we've been making the hill with our *two-wheel* drives!" And then, just because I am in danger of aspirating on my own froth, I get officious: "Would you agree there is an inherent irony in us having a discussion in which you keep giving me suggestions on how to *overcome* these *improvements*?"

"Well, yes," he says, quietly. But we are fifteen minutes into the conversation and it is clear his position is staked. "We can revisit this in the spring," he says, for the third or fourth time. I pace in circles, toeing the wood chips and holding the phone so tight to my head it reddens my ear. My adrenaline surges when I realize that essentially he is saying he doesn't believe me.

"Yes, but what do we do this winter, when we can't get up the hill?"

"Well, I hope that's not the case."

"It's not a matter of *if*, but *when*."

"Well, like I said, we can revisit it in the spring."

I am beginning to taste the smoke of my own molars.

"And," he says, "we can make sure the plows get out there early . . ."

I thank him for his time and close the phone.

For a while I just stand there, feeling shaky and weak, my bones humming with unspent epinephrine. I've been known to do some flinging and stomping in my time, especially when I think no one is watching, but right now I just don't have it in me. There is the sensation that I just burned fifteen minutes of my life kickboxing a giant marshmallow.

It feels incumbent at this point that I calibrate my carping in order to distinguish disputation from self-pity (that most pernicious of pursuits). There are times when I get going and I suddenly realize my voice has assumed the same pitch as Dennis the Peasant in *Monty Python and the Holy Grail*. "I'm bein' repressed!" my tone implies, when in fact I'm being inconvenienced. The highway commissioner is responsible for the maintenance and construction of over 1,400 "lane miles" of road, including the interstate that passes through Tom's farm. Every Tupperware-sized pothole, every befuddling roundabout, every bit of paint and signage designed to keep us from turning each other into roadkill, right down to the reflective sparkles in the centerline paint. His days and nights are filled with people telling him how to do his job. While waiting to give my testimony I personally observed as

he dealt with complaints ranging from the long-term environmental impact of road salt to a person demanding that the county buy him a new muffler after his fell off when his car hit a bump in the road. Thus (and we're not even factoring in the world situation here), one understands the relevance and scale of one's grump list and does not wish to contribute to the so-called culture of complaint. And yet, one can polite oneself right out of contention. It would be disingenuous to wrap everything in *shucks* and roses—I am frankly peeved, and I suspect the commissioner has scrubbed me from his Christmas list as well.

Perhaps the secret lies somewhere in the idea of allowing oneself to be cranky but not vindictive. I can empathize with the fact that the man is just doing his job—although for the foreseeable future this empathy will function as an intellectual rather than an emotional construct. No one's going to have to call the sheriff on me, but for better or worse, once I sink my teeth into something I tend to gnaw it to bits. Backstage prior to the show the other night I was ranting about the commissioner's phone message before some poor cornered soul whose expression was that of someone who has accidentally wandered into the path of a haranguing street evangelist. When I paused to suck air, another man who was listening introduced himself as a lawyer and said he'd be willing to com-

pose a letter to the highway commissioner on my behalf, pro bono. For all my frustration, I had never considered engaging an attorney, and I demurred. As grumptious as I'm feeling about the whole deal I do want to keep a sense of scale, and I also know that pro bono or not, I'd be triggering a whole new level of involvement extending over years. I believe the commissioner is being stubborn in the face of facts, and I also acknowledge that at this stage of the game I have not been entirely successful at keeping this from feeling personal. Every time another old-timer asks me what the heck the county is thinking over there on Starkey Road, I think of how easily the commissioner dismissed this available knowledge and my systolic spikes. But I'm not looking to lawyer up. Pro bono does not mean "without cost."

Back when Tom was fighting the interstate, he did get himself a lawyer. A stout fellow by the name of D. W. Barnes. "Dee-dubya," Tom called him.

I am in the Hartwigs' dining room. On the table before Tom is a sheaf of large-format black-and-white photographs. Aerial shots, taken prior to and during the construction of the interstate. "When you file suit, you gotta be prepared

for anything they throw at ya," Tom says. "They even asked me on the stand what kind of foundations were under my buildings. The idea is to try and rattle ya. That's why we had these taken."

After all of Tom's stories about life on the farm before the interstate, it's fascinating to see the place as it was. He holds up the first photograph and points out three dark splotches. "Turtle ponds. This one here was quite long. My brother and I used to build a lot of sailboats, and when the wind was blowing north or south we'd let'em go in that long pond and when they got to the other end we'd pick'em up and run back and start'em all over again. As a kid I always wished I had a cannon so you could shoot at your boat!"

The pictures were taken in autumn. I can see shocked corn in one field, and a tree-lined cow path where the westbound lane of the interstate now lies. Tom spins another photo around so I can see it properly. Now the bulldozers have been at work. Twin white scars cut across the countryside in a broad parallel arc, and I can see where the 360-foot culvert has been laid. The turtle ponds have become mud spots. "When they put that roadbed through they changed the whole drainage pattern," says Tom. "They have no ear for these things. It's sterile on wildlife down there now. Those ponds, you always had frogs and turtles in'em, and when you had the frogs and turtles you also had herons and bitterns

and kingfishers . . ." He stops and waves one hand in the general direction of where the ponds used to be.

"Now there's nothin'."

Out the window, I can see the traffic humming along.

"I'd go down there to the state highway office sometimes, and they wouldn't see me," he says. "So I'd go downtown and see D.W. I'd say, 'I was just up at the state highway office, and they were giving me the ol' Mickey Mouse. The runaround.' And D.W. would get his hat and coat and say, 'C'mon.' So we'd go back. I'm puppy-doggin' in behind him—he was a big beefy guy—and he says 'I'm D. W. Barnes, Attorney at Law! I wanna see so-and-so.' And then it was all 'Oh, yessir, yessir,' and in we went."

When the state made its initial offer for his land, Tom felt it was much too low. "Where they git ya is they come through and appraise yer place assuming that you got a willing buyer and a willing seller. But what you've got is a willing buyer for a very unwilling seller. They also appraise your place as if today it's worth x number of dollars, and after the highway is through it's still going to be worth x number of dollars. Well a'course it isn't. And also, you can't sue for aesthetic values."

I'm thinking it's odd to hear Tom use the word *aesthetic*, and perhaps he takes my silence for confusion, because he adds, "Noise, and stink, and all that stuff."

So he and D.W. challenged the offer in court. The court sided with Tom, and he submitted a number he thought was fair. The state countered with yet another lowball offer. "I told D.W., 'Tell'em to go to hell. We beat'em the first time, we'll beat'em again.'"

And they did. Tom is always closemouthed and slightly conspiratorial about the specifics of the settlement ("They paid us what we wanted . . . I settled out of court so it ain't on the public record, and they can never come after me for capital gains"), but about his opinion of the parties involved, he is crystal clear: "Weasels!"

He lets that sink in a minute, then explains. "When we won our case they had sixty days to pay up or appeal. They knew very well they weren't going to appeal, but they made us stew, then on the fifty-ninth day, they paid . . . *minus interest*!

"I'll tell anybody who'll listen: The state of Wisconsin is the crookedest outfit I ever dealt with."

You can't blame a guy, I guess, for taking his pound of flesh. And maybe a little more. Tom shuffles back to the photo of the early construction, the one with the white scars. Points to where they put that culvert in. After it was set, they buried it beneath a gigantic sand berm intended to elevate the

roadway above the breadth of the creek bottom. Shortly after the berm was finished and seeded, a torrential rainstorm flushed the whole works into Tom's cornfield, leaving approximately two acres of cultivated bottomland covered in a foot of infertile sand.

"I told those state boys, if they'd give me a thousand bucks, I'd call it even," says Tom. The state refused, and instead hired a contractor to remove the sand.

"So the state sends Sweeney Brothers out here with a bulldozer and one of these earthmovers. And a'course they're billin' everything to the state. And I went down there with them and they said, 'We can scoop that sand up but where are we gonna put it?'" As he did with the dog story, Tom tells the tale in two voices, playing the roles of both himself and the contractor.

"I says, 'Well you can't put it by the crick, the Department of Natural Resources won't allow that. But I got a washout up there on the hill, can you get it up there?'

"'Oh yah, but we'll have to make a road up there first.'

"'Well. You do what you gotta do.'

"So they hauled it all, then he comes to me and says, 'Now I think we should sod it.'

"And I said, 'Oh, ab-so-*lutely*.'

"So they scraped sod from one of my fields and packed it up there on that side hill. Then he comes to me and he

says, 'Down there where we scalped that sod, I think we should reseed that.'

"And I said, 'Oh, ab-so-*lutely*.' And normally you sow grass seed at a rate of ten or twelve pounds to the acre. They put it on eighty pounds to the acre.

"So when it was all over, they paid this contractor tens of thousands, when they coulda just paid me one. And I wound up with great pasture, a patched washout, and all that free sand."

Now he pulls a smaller snapshot from the stack. You can tell the photograph was taken from some elevation, but much closer to the earth. Close enough that a white Leghorn chicken is visible on the ground, its shadow cast against the dirt. "This one's from the top of the silo," Tom says, and I realize that after years of hearing the story of the battle of the silo, I'm looking at actual documentation.

"We needed plenty of room to get the silage wagons in there. You can see the tracks—that's why we took the picture. To document it. If they had gone with the fence the way they originally planned, they'd have knocked the silo down and cut off a corner of the barn. And even when we got'em to leave the barn and silo alone, they still tried to cut that road so close there was no way to get through there with the equipment." After seeing where the surveyor's stakes were set, Tom and D.W. raised a ruckus, and the state prom-

ised to send out the condemnation committee. Before the group arrived, Tom set up the blower (a wheeled machine that transfers silage from the wagon and blows it up a tube and into the silo) and hooked a silage wagon to one of his Farmalls. "There was two farmers on that committee, and they were looking it over with the state's appraiser. Then I said, 'Okay, now whoever thinks he can back that wagon up to that blower without knockin' over a stake, do it.'

"Well, they couldn't."

For a long time, nothing changes at the bottom of Starkey Road. Apart from some spray-painted outlines, the intersection remains undisturbed. I hold the hope—futile though I know it is—that out of the blue the commissioner will call to say he's thought it over, that my concerns make eminent sense, and that the road will remain undisturbed. Instead the day arrives when I come around the corner and find the road crew peeling up the old blacktop and excavating a dip—a shallow moat of sorts—that blocks the straight approach to Starkey and will force vehicles to slow down and deviate into the new J-shaped approach. The next time the crews come through they have with them a paving machine, and when they depart the changes are sealed in asphalt.

That day after the commissioner called, I set the choke on the log splitter and then, before yanking the pull cord, I just stood there a minute. From across the valley came the sound of the interstate. Sometimes the atmosphere works like an audio equalizer, emphasizing certain tones over others. On that day I could hear no engine noises, only the sound of rubber lugs thrumming concrete. Each vehicle was playing its own hollow note, and although I could distinguish between them as they rose and fell, fading and shading between keys, the sound itself never broke the sustain. I thought of that sound running day and night for all these years now, and I thought of how worked up I'd gotten over a few square feet of blacktop, and I wondered, when those first dozers rattled the dishes and scared the cows, what prevented Tom from fetching a rifle.

One doesn't wish to be overdramatic. I am not about to wrap myself in the Gadsden flag and charge the Senate dining room (although this deserves regular consideration). And Tom has told me that he believes the interstate has saved lives and helped the country. But whether it is a letter putting a solicitous spin on septic tank fees, a phone call demanding the redundant confiscation of a dog, or the aiming of bulldozers by bureaucrats, the issue isn't that we are being made to take our medicine; the issue is that it is being prescribed from a distance under the assumption that

wisdom distilled on high will remain wisdom when mixed with dirt. That the intersection that is better in theory will be better in reality. Once on a country morning I carried a bag of feed through a gauntlet of five rude-snouted hogs, then drove away to the city, where in the learned evening a decidedly nonagricultural gentleman assured me that pigs are acutely intelligent and naturally clean. Yes, I said, but they would also love to get you down in the mud and eat your foot.

There is some anodyne, you see, to having your say in person. I can pretty much draw you a chart on how this whole intersection redesign is gonna pan out. I have lost, the commissioner isn't going to change it back, and we are going to spend some time hiking in the snow. But at least in my quixotic tilting I have the right and the opportunity to meet with the commissioner face-to-face and phone-to-phone. To—and this is small of me, but true—make him a little uncomfortable.

Today if you look quickly as you pass Tom Hartwig's farm, you'll note a slight jog in the interstate fence. Just enough room to allow passage of a silage wagon. I don't know what meant more to Tom: pushing that fence back, or making the state come and stand there beside him while he did it.

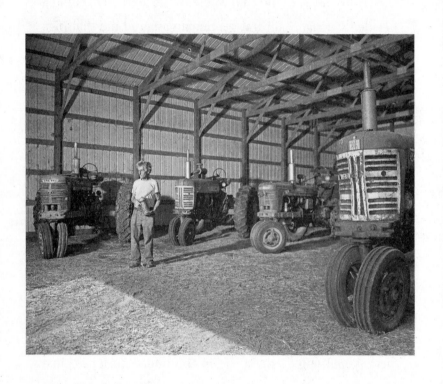

CHAPTER FOUR

The photographers have asked Tom to walk toward his silo, and he is doing that now, a little bowlegged from behind, stumping along as if it were just another thousandth trip to toss down silage for the cows. The wind has kicked up, and the shin-deep quack grass is waving all around him. The silo is painted white. Top to bottom, roof, chute, vent cap, the whole works, everything white but the four-pane window that used to overlook the path to Cotter Creek.

The silo is iconic to Tom's history, because it was the lever he used to pry the interstate southward. Only a few tens of yards, but a victory nonetheless.

You can see the silo is ringed with thirteen hoops. The hoops were added in 1988, twenty-one years after the interstate opened. It was the big trucks, Tom says. I'd be up there when it was freshly filled, and when two or three semis went by together, that whole thing shook. One morn-

ing about a week after we put up the silage I was bringing the cows in and I looked up, and, holy shit, that thing had opened up. I could stick my hand in. All winter it was like a sundial in there . . . you could mark the time by where the sunshine was hitting opposite the crack. In the spring, after we got the silage out, the silo company came. That boom truck would reach seventy feet. They didn't even unfold the elbow. They put them hoops on, a hunnerd bucks apiece. But they pulled that silo back together.

The female photographer stands just out of frame, watching the oncoming interstate traffic. Tom stands with his back to the camera, ready to walk. The success of this photograph will depend on timing. The photographers are trying to convey the proximity of the silo to the interstate by capturing Tom, the silo, and a semi rolling at highway speeds. Okay, Tom, go, she says, and he begins walking. An instant later a blue semi tractor pulling a tanker trailer zooms through. The other photographer tries to anticipate the truck, tries to thumb the plunger at just the right instant. In this the photographers do not have the digital privilege of instant review. You shoot, you hope.

In asking Tom to walk, the photographers are walking their own fine line of asking the subject to perform. The photographers have made a career out of quite the opposite. But even in the stillness of the photo they hope there

will be something implied by the evident motion of Tom walking one way, the truck rolling the other. They burn four or five of the precious sheets of film and move on, hoping there will be that moment in the darkroom when the chemicals reveal Tom, the silo, and the truck in perfect stop-motion triangulation.

You take one last look and think it would have been something to climb that silo and peek out the window before the interstate plowed through. To see the land un-broken. You are compelled, of course, to consider how the Ojibwe felt, returning to the campsites at Cotter Creek one day only to hear the sound of sawing and the lowing of oxen. Life will circle around on you. Also visible from the silo window is a gigantic billboard pointed at the interstate and advertising a casino owned by the Ojibwe. The bill-board says, WINNERS, 24/7.

THE FIELD CORN IS TALL and tasseled and the trees still green, but the grasses are beginning to slacken. It is September, and I am helping Tom Hartwig gather honey. I am trailing behind him as he pulls a flatbed trailer with one of his many Farmalls, this one a 1947 Model H.

Tom has six Farmalls, the youngest of which is sixty-

some years old, the oldest of which is a 1943 M. He also has one non-runner he bought for parts. He parks the tractors in a semicircle in his hay shed now that the hay shed no longer holds hay. There is a method to his multiple-tractor madness. "When I used to fill silo, I'd have one on the chopper, one on the blower, and one on the wagons. That way you didn't have to keep hookin' and unhookin'em." If you point out each of the aged red machines has a bit of the rattletrap about it, he won't be offended. This too is part of the plan. "I'd buy them old tractors cheap. If one broke down, I could just grab another one. No downtime. And by having all the same kind, I could swap parts around. And with my own shop, and because fixin' things is a hobby with me, why, I got by with a lot junkier class of machinery. Our neighbor, ol' Sally Johnson, she used to say I was about the only one she knew that could run with junk and get along just fine."

The careful observer will note there is one little item that belies this slacker ethos. The paint scheme of each of the Farmalls (except for the one we're using today, which is essentially straight-up rust tone) includes a fat white stripe running the length of the cowling. Viewed from a distance, one end of the stripe on each of Tom's tractors appears smudged with gray. Up close, you will see the smudge is actually a meticulously dense record of oil changes inscribed with a pencil. Three columns per tractor on average, span-

ning countless years in the literal sense, as the older col-
umns are faded to illegibility.

A man named Jerry has come to help with the honey
as well. We met only five minutes ago, but in that time I
have overheard enough of his conversation with Tom to
understand that the two have known each other for some
time, and once again I marvel at the radius of Tom's circle.

The hives are uphill from the house, tucked along either
side of a narrow hollow that also shelters Tom's vegetable gar-
den and melon patch. After parking the tractor and trailer,
Tom disappears into a small shed built into the hillside at the
low end of the holler, then reemerges with a bundle of bee-
keeping gear, which he spreads out on the trailer bed planks.
Slapping the worn wood, he says, "Built this forty years ago.
Out of a 1935 Chevy milk truck and a John Deere wire-tie
baler." Jerry and I have barely shared two words, but now
we shoot each other a grin. With Tom, if there's backstory,
you're gonna get it, and after eight decades, Tom is heavy on
backstory. If a tinge of boast creeps in now and then, it is dif-
fused by solid evidence, enduring function, and the boyish
smile. For purposes of compare and contrast, let us turn to
the world of academia and consider the comprehensive com-
position of your standard *curriculum vitae*.

Tom has also produced what appears to be a lopsided oil
can attached to a set of miniature leather-lunged bellows.

A logo imprinted on the device reads WOODMAN'S FAMOUS BEE-WARE BEE SMOKER. The smoker is a nicely crafted piece of equipment, the bellows paddles cut from wood and attached to the leather by a rim of carefully crimped and tacked tin. Producing a Bic lighter, Tom sparks a small tinder fire in the base of the combustion chamber, then packs it lightly with cubical bits of decaying wood punk. "Some guys use burlap, some guys use pine needles," he says, as he uses a miniature chisel to tamp the punk, which looks and feels like rust-colored insulation foam. "We've always used punk wood. You find a stump that's rotten and you can break it up by hand." When a wisp of gray rises from the chamber he wedges the spout back in place and coaxes the punk into reluctant combustion by working the bellows, *chuff-chuff . . . chuff-chuff . . . chuff-chuff*. The smoke that curls out the nozzle has a rich caramel scent. The upper edge of the bellows—where Tom squeezes the paddles to make the smoke puff out—is blackened and blistered in the manner of a hot dog left too long on the barbecue.

We're all wearing long-sleeved shirts with our cuffs and collars tightly buttoned. Tom hands Jerry and me each a beekeeper's hat and leather gauntlets. He, on the other hand, is wearing short-cuffed haying gloves and over the top of his flat-brimmed DeKalb seed corn cap he has draped a vintage mesh veil that is so frayed it appears to

have once been used to capture a very angry cat. I can't imagine how he will avoid being stung.

Tom's hives—*towers*, in the parlance—are weathered, their wood grain revealed in gradations of scuffed white paint, and here and there they are loose at the joints. The nail heads holding them together show through the remaining paint as dots of bled rust. The hive caps are held in place by old bricks and chunks of firewood. Approaching the first hive in line, Tom raises the cap, puts the snout of the smoker to the gap, gives it two puffs, and then lowers the cap again. "When bees get alarmed, they emit an odor, and that riles all the rest of'em up," says Tom, as if he's leading a class for the county extension office. "It's not that the smoke knocks'em out or calms them down, it's that they don't smell the others bein' alarmed. And then a'course it irritates'em and they start to move." Indeed, the bees are starting to emerge from the hive in a crawly yellow-orange cluster, like marmalade sliding down a wall. Shortly they are dropping in scatters to the grass, where they regroup on plantain leaves.

"Weeaahll, let's see," says Tom. "We'll have one of you guys start takin' out the supers and set'em up in front of the hive. I'll come along and blow'em out, and then the other guy set'em on the trailer." The hives are stacked in sections; the deeper sections are called bodies, and house the bees. The supers that Tom refers to are shallower sections contain-

ing the frames in which the bees build and fill their honey-combs. Many of the supers are glued to one another with dried honey. Tom pries them apart with the little chisel ("It's called a hive tool," he says when I ask.) and Jerry lifts them away and sets them on edge in the grass. "All right, I'm ready for that blower," Tom says, and I lug it over from the trailer. The machine consists of a gasoline engine attached to an enclosed fan connected to a vacuum hose. As with the trailer and pretty much everything else on this farm, it is cobbled together from spare parts and a story. "A guy who taught me some beekeeping had a factory job," says Tom. (What he's saying here is not that the man had a job in a factory but that the man had a factory-made blower.) "One winter I borrowed it and took it apart, then I just copied it." He points to the blower I've placed at his feet. "That hose is off a Sears Shop Vac. The engine is off a snowblower. That cost me fifty bucks. Then I made the two fans. The way you balance fans like that is you put a solid shaft through'em, then spin'em on a steel rail. If they always stop at the same place, you cut'em down or weld'em up for counterbalance." Before he pulls the starter cord, he says, "I only use this thing an hour a year, but I've used it for thirty years . . ."

At full throttle, the blower is a combination of baritone roar and wind-tunnel whoosh. While Jerry steadies the super on edge, Tom waves the tapered nozzle of the vacuum

hose back and forth over the gaps between the honeycomb frames, and bees come spitting out the other side. When he is satisfied that the majority of the bees have been blown clear, Tom nods. Jerry hands me the super, and I carry it to the trailer. There are twenty-two supers to be cleared, but between the three of us, the work goes quickly. From the moment Tom blows the first super out, we work in a cloud of bees. They whip wildly around us in an abstract tornado that reminds me of the way dollar bills blow around inside those Las Vegas money-grab booths. At one point I am stacking a super when a bee crawls across the mesh before my eyes and I freeze when I realize it is *inside*. Instinctively I reach to tug at the mesh, but then recall being warned during firefighting training some years ago about the same instinctive—and potentially fatal—urge to yank our face mask off if something goes wrong inside a burning building. Weighing the whirling swarm outside the mesh against the one lone bee inside, I reconsider, and he never does sting me.

When the last super is blown clear Tom switches off the blower engine. Instead of silence we are enclosed in the persistent mosquitoey whine of the bees—now clear of the smoke and flying in a mad swirl of reorientation—and, of course, the sound of highway traffic. Tom backs the trailer the short distance to the shed and we carry the supers inside. Tom will let them sit for two or three days while the last of the bees exit

the frames, then extract the honey. We shuck our beekeeping togs, and as he leaves the shed, Tom carefully secures the door. "Been a bear tearin' up the garden all summer long, and last week it took down one of the bird feeders," he says. "See that?" He's pointing to the window of the shed. Smack in the middle of the pane a smudged paw print is visible.

I am due to pack the car and head out on a road trip and Jerry is here to cut firewood, but the weather is pleasant, so we lean against the trailer for a bit and shoot the breeze. Tom says his honey production is way down this year, and some of the honeycombs have been sealed ("glued") before they were full. He blames this on two intensely rainy stretches we had this year—one in July, and one in August. "They don't fly in the rain . . . and when they aren't out workin', they make monkey business. They either glue everything down, or get to makin' swarms. I had five swarms this summer, and that's unusual, because they had plenty of room. And when they swarm, you cut your population in half because your old queen leaves with half the bees. Arlene and I were readin' the other day in the paper the average colony's got sixty thousand bees in and it can go as high as eighty. And they will fly a total of fifty thousand miles making one pound of honey." He rattles the numbers off like he's memorized them for a quiz, but by now I know his retention is such that if he's around and sharp ten years from

now he'll trot them out just as quickly. "Makes y'feel kinda guilty when you go up there and take it away from'em," he says, smiling in a way that tells you it clearly doesn't.

Beekeepers have been plagued with a sharp increase in colony collapse over the past decade, and over time I've heard Tom shift his speculation on the cause. When we first met, he figured it was cell phone towers. Later he figured it was mites. "The latest I've read is genetically modified crops," he says today. "These Frankenfoods. And it makes the most sense of any of'em yet, because in order to get it tolerant to some of these herbicides, they treat the seed with nicotine. And all the while that plant is growing it is secreting a little bit of nicotine. And nicotine is an insecticide. I think that makes the most sense yet. And the United States uses more genetically modified crops than anywhere in the world, and we've also got the highest incidence of colony collapse among the bees. And the butterflies are gettin' less, and the bumblebees . . . I didn't see very many bumblebees this year."

"Tom, you sound like a tree hugger," I say.

"Weeahhll, and another one, there's been a drastic decline in frogs. Now the latest link on them is atrazine. I don't know . . . And another one that's almost nonexistent, this summer I saw one snake. When I was a kid you always saw snakes. You'd find their skins, you don't see any of that anymore. Something is . . ."

He just lets it hang there. There is a swipe of honey on the trailer bed. It's covered in bees, doing all they can, I suppose, to salvage this thinnest trace of an entire season's work. "Hey, you guys go up there and pick out a couple watermelons," Tom says, ending the session and climbing to the seat of the Farmall. "When the curlicue is dry, the melon is ready," he hollers as Jerry and I step into the patch. Tom grinds the starter on the H. The engine spits and then catches, the old Farmall running with a fluttery purr, accented by the *ting-ting* of the hinged rain cap flapping atop the exhaust pipe. "Throw'em on the trailer," Tom says as Jerry and I return with our melons. The clutch on that H isn't the smoothest, and when the tractor lurches forward, my watermelon rolls off the back of the trailer and cracks open when it hits the ground. Down in the yard, I carefully place my split melon on the truck floor, then bid Jerry and Tom good-bye. I tell Tom I had hoped to help with the extraction, but won't be around. "Weeaahll," says Tom, "if I'm still around next year, you can help me then."

I fancy the phrase "on the road," as it conjures tumbleweed horizons, figurative artistic martyrdom, and muraled tour buses dieseling through the night. In fact, it's generally just

me in the family van with a box of books and a late check-in at the Janesville Super 8 after totally rocking the public library. Still, away is away, and as Jane and Amy and I sit on the steps eating Tom's watermelon and spitting seeds at the chickens before I pack the car to leave, I wonder if I am doing right by them. For better or worse, I decided a long time ago that it would be a mistake to plead apology for my absences, as that tack seems to send the subliminally confusing message that Dad is choosing to leave you behind in order to do something he would rather not. In fact, I love what I do, I'm grateful to do it, and in combination with Anneliese's work it adds up to a living (at least as of last Tuesday). I add the parenthetical not as a joke but as a nod to the realities of our chosen path of self-employment—last year's royalty checks added up to exactly one-eighth of our annual health insurance premium, a situation that left me gratefully flabbergasted that I should receive royalty checks at all while simultaneously prepping me for a recent e-mail in which a reader said I should be ashamed of myself for spending so much time away from my family and should instead stay at home and "live off your royalties." I heartily agree, and await further news. There is also the question of whether this person would send the same e-mail to my brother, telling him to stay home during planting season and live off the royalties in his corncrib.

But of course I wonder. The day I sat in the Hartwigs' kitchen and listened to the couple say they never left the kids behind, that has hung with me. The day Amy lost her first tooth, I was on the road. The day she went to the chicken coop and came dancing back to the house with our first egg, I was on the road. Once when Jane was an infant I was gone on a book tour for two weeks, and when I lifted her from the crib upon my return the change in her shape and weight stunned me. Always preternaturally tall, Amy is now grown lanky and her carriage is beginning to speak of womanhood. This summer she took swimming lessons at a nearby university, and one morning as I escorted her to the natatorium I caught a group of six college boys in a simultaneous head-turn. I wanted to take her straight home and never leave her side. But for the moment half our mortgage comes from "the road," and lucky us. Inevitably, our children come to see us as we are. Not as we wish we were, or even as we should be. Furthermore and as ever, our relatives serving in the trucking industry and military provide immediate perspective. So I sit with my girls here and work on accepting what we have: the melon, sweet and dribbly and good; the not-so-ladylike *p'tooey* sound of two girls learning to launch the seeds along the maximum arc, and the giggles as the chickens chase them down; the shared view of the valley below; the time at hand.

I am gone for three days, and when I return Tom is in the hospital.

Some time ago the minute hand on the Hartwigs' cuckoo clock spun loose and would no longer turn. Tom knew a fellow in Mondovi who repaired clocks, so he and Arlene got in the Crown Vic and drove that way. Arlene chewed on him a little during the trip, because he kept drifting the car leftward. They got the clock repaired, and then on the way out of Mondovi the town cop pulled Tom over. You were crossing over the centerline, sir, said the policeman. Then he gave Tom a warning and sent him on his way.

Back home the next day, Tom rode his bike out to get the mail. Standing astraddle the top bar, he reached for the mailbox and pitched headfirst into the asphalt. Picked himself up, got the mail, and rode back to the house. The following day, he took the Crown Vic. Stopped at the end of the driveway, opened the door, stepped out, and pitched headfirst into the corn. Had a heckuva time getting back up, he told Arlene.

That's it, said Arlene. We're going to the doctor. She called a neighbor, and he drove them to the clinic in Osseo. Early in the assessment, Tom admitted to the doctor

that he'd been having headaches for a month. The doctor ordered a scan, and the minute he saw the results, paged the ambulance. It's a twenty-five-mile run from the small Osseo hospital to the bigger hospital in Eau Claire. The interstate makes it a straight four-lane shot, and the crew ran the rig hot, siren wailing and lights flashing, Tom flat on his back and flying past his barn at maximum allowable speed. At the hospital in Eau Claire, they hustled him straight to surgery, shaved half his head, lifted a section of his skull, and relieved his brain of a good-sized bleed.

When Anneliese got the news, she called Arlene to arrange a food drop and offer rides to the hospital. Tom was doing real well, Arlene said. Their youngest daughter, Emmy, had taken her in to visit him, and several neighbors had called or dropped by with food.

Ever since we moved here and I joined the local fire department rescue service, I have figured one day the pager would go off and the dispatcher would give the Hartwigs' address. I can't say I dreaded it; I just knew it might be coming. What I did dread was not being home to help when that call did come in, and now it has. I'll go see Tom tomorrow, but tonight as I walk out to close up the chicken coop at dusk, I look out across the valley to the darkening ridgeline that overlooks the Hartwig house. I think of how it must have been the day they took him

in, the kitchen empty and still, Tom's honey jarred and on the shelf, Mister Bigshot curled in his fur, Cassidy flopped and snoozing by the door, and then the sound of that siren warping past. Maybe the cat twitched, or the dog raised an ear, and then everything shaded back as it was, just the interstate wash and the restored cuckoo clock ticking.

In the hospital he looks tiny against the white sheets. When I first poke my head around the corner he is drowsing against the raised head of the bed, and seeing him with his eyes closed catches me off guard. The privacy and vulnerability of someone asleep—I suddenly feel I am intruding, rather than visiting. I am withdrawing when his eyelids slowly rise. He looks drugged and disoriented. Then he registers me and his eyes open fully and brightly and as if he were pulling open the old familiar screen door he says, "Well, hello, Mike!"

"Tom . . . how y'doin?"

"I'm an airhead!"

He tells me the whole story then, beginning with the headaches and tipping over on the bike, and it's the same old Tom, animated and crinkling his eyes. The only obvious difference is cosmetic: the right hemisphere of his head has been shaved to the skin and inscribed with a semicircular staple-puckered scar roughly the diameter of a biscuit cutter. On the other side of his head, the hair remains as thick

as ever. It is as if someone began to give him a Mohawk and quit halfway through the job.

He describes the surgery dispassionately but in great technical detail. Quite the same, in fact, as he would describe a particularly tricky move on the lathe. He says they tried to relieve the pressure with burr holes first, but then had to lift a portion of skull and get right in there to scoop the curdled blood and stanch the bleed. You know he grilled the surgeon, because he's talking about the dimensions of the piece of skull removed, how the stapler worked, the parts list required for the repair. "I got three titanium plates, and each a'them has got four titanium screws. That's how they held the lid on. When I saw the X-ray, I said to Arlene, 'I thought they went to Kmart and got pop rivets!'"

In the end, he says, they got most of the blood out, but a little air bubble remains.

"So I'm an airhead!" he says again.

I am a registered nurse by training. Nearly twenty-five years have passed since I last worked in a hospital and I am terribly out of practice, but in my final position I cared for people who had suffered strokes and head injuries, so I retain a basic eye for the flickers and shadows of countenance that betray lingering effects. I watch closely, but see none of this in Tom. His gaze is direct and bright, the

impish glint is intact, and he is full of stories. With an eye toward his postsurgical weariness, I make a number of attempts to leave by backing slowly toward the door. Every time I get within reach of the handle and begin to excuse myself, he says, "No, and then there was the time . . ." Even this is a clue that Tom is running on all intellectual cylinders, because the use of "No, and then . . ." (pronounced as "No, an'nen") to extend (or reclaim!) a storytelling session is a colloquial conversational tic I grew up hearing around the counter at the feed mill and any number of kitchen tables and fall into regularly myself. ("Yah, and then . . ." also works, but it's the "Nah" construction you hear most often and that I find most intriguing on breakdown because of the odd non sequitur nature of giving oneself permission to speak by breaking silence with the word *no*.) So with each "No, and then . . ." Tom is telling me his faculties are functionally and stylistically intact.

Finally I move decisively for the door. "I'm gonna hit the road, Tom. You be sure to let us know if you need anything. Or Arlene. Anneliese has been checking in on her, and so have a lot of the other neighbors."

"Yep," says Tom, and rattles off the names of people who have called or stopped by, both here and at the house, and ticks off a list of what each came bearing. It's a mar-

vel how orderly he keeps his head. But as he recites the list, I detect a shadow note in his voice, a hint of thickness that betrays not a neurological impairment but rather a full heart.

"You've built up a lot of *social security*, Tom," I say.

"Yah!" he says, with a grateful chuckle. "Nah, and then . . ."

I'm still failing to make my exit when a woman and man my age arrive. "Hello, Emmy," Tom says, and I realize this is his youngest daughter. We've never met before. We exchange general greetings, then I take my leave. Behind me, as I exit the door, I hear Tom exclaim, "I'm an airhead!" I smile, realizing I have been present at the birth of a story to rival the crooked shovel handle. And the best part of this one? It travels with him, the punch line residing in his hairline.

Leaving Tom in the hospital, I head out on another glitzy mini-tour, my entire entourage sitting behind the steering wheel of my station wagon. When I realized this leg of the tour would take me through southern Wisconsin and right past the house of another old-timer who has long intrigued me, I arranged a visit, and am exiting the interstate toward his home now.

To clarify: I now and then describe Tom Hartwig as an "old-timer." As an octogenarian, he would certainly seem to qualify, but then again his mother lived sharply for twenty years beyond that and clearly there is more to becoming an old-timer than the accumulation of birthdays. My brother John, who is just now hitting his mid-forties, has comported himself as an old-timer since the age of three. I am two years John's senior but have always considered him the elder; while I spent high school focused mainly on trying to contain the quarterback option without messing up my hair, John was teaching himself taxidermy and trapping, reading Foxfire books, and assembling his own black-powder rifle. He is a man of broad practical skills and an evergreen appetite for knowledge that most recently led him to obtain his pilot's license, so keep an eye to the sky: That will be him at 750 feet in his 1964 Cessna 150, blaring along at 43 knots with his blinker on. Further cementing his accelerated old-timer status, he lives in a log cabin he built himself, owns his own sawmill, and recently—having obtained the plane and pilot's license—constructed a fully operational runway in his front yard using his own personal bulldozer. Sometimes I remind him that I am a really good typer.

Today's functional—as opposed to chronological—old-timer is roughly my age but could be an old-timer for his

name alone: Robert Frost, no joke. I have followed Rob from afar for a few years now as he blogs about his attempts to carve out a sustainable life in a suburban setting. Apart from greeting each other briefly after a book event once, we have never spent time together, but I feel both his approach (best described as gearhead meets greenie) and his operation are at least loosely relevant to some of the things we're trying to accomplish on our farm and so merit a closer look.

He greets me in the doorway of a house in a subdivision that looks like any other subdivision, and if not for a few homemade rain barrels out front or the dump truck load of mulch on the driveway, you'd figure it was the home of just another guy commuting to work in the big city and then back home to the vinyl siding—and indeed it is. If you follow Rob out back, however, you'll find that in between commutes, he and his wife, Meriah, have gone off the manicured lawn rails and deep into an alternate ecosystem. There are tiers of raised gardening beds, a hoop house, a large rack of serial compost bins, and various stands of uncommon foliage. Nearly every square foot serves a purpose, even when it looks deceptively otherwise. "This is our rain garden," he says, pointing to what looks like a nice little brushy patch. "Exclusively native plants, holds fifteen hundred gallons of runoff."

After a tour of the yard I help Rob distribute compost-

ing material obtained from a teardown of his methane midden, which is basically a hut-sized pile of chopped brush and other compostables piled over the top of two repurposed fifty-five-gallon drums and 290 feet of coiled garden hose. The intent here was to generate both heat and methane; the methane was to be captured in the barrels, the water in the hoses would carry heat to the house. (Continuing the theme of parallel old-timerism, the methane midden is to Rob Frost what the cannon is to Tom Hartwig—the neighbors find it unusual, hope no harm will come of it, and ultimately aren't sure what to think.) In its maiden run, the midden was a flop, although a qualified flop, because Rob devoted an entire blog post to all the lessons he learned in the failure. This is a signature move of his—laying it all out there. "Environmentalists need more critical thinking skills," he told me while we forked apart the experiment's dark brown remains. A true motor maven who once built street racing cars and exudes an enthusiast's love for tools and power, Rob has little patience for absolutists, and after being lectured for using a motorized tiller, has been known to take to the comment section of his blog to explain how much soil remediation can be accomplished with one cup of gas. And he isn't just throwing the term *cup* around. He really does track these things. He is a geek for specifics and minutiae, as evidenced by snippets and phrases from today's yard tour:

This is riddled with fungal mycelium . . . bioremediation . . . the heavy metals don't trace out real high . . . thermophilic bacteria . . . apex predators . . . I hear this talk and I hear echoes of Tom, especially since Rob is wearing dirty boots and working a pitchfork as he utters them. With his relative youth, heavy beard, and wrestler's build, Rob doesn't look like Tom, but you can *hear* a resemblance. "That's 'twelve-pack rock,'" he says, pointing to a large decorative stone in one corner of the garden, and while I'm trying to figure the geologic reference he says, "'Cause the guy charged me a twelve-pack to put it there." Hacking at a patch of backyard sorghum with a cabbage knife, he says, "A lot of my tools will be useful in a zombie invasion." My favorite grin comes when he introduces me to his ten-cubic-foot wheelbarrow, which looks large but unremarkable until you learn he has christened it *HUBRIS.* You can imagine he would applaud Tom's crooked-shovel routine.

In a final parallel between Tom and Rob, our entire afternoon is spent talking over the sound of howling traffic. Rob Frost's property butts against the very same interstate that slices through Tom's acreage four hours upstate from here. Rather than defeat Rob's spirit, the location seems to drive him. In addition to the hoop house and raised beds, the modest-sized yard is crowded with fruit trees and fruiting shrubs, and last year it yielded 150 pounds of

potatoes, 30 pounds of lettuce, and 800 pounds of food in all. In the process, he and his family make 3,000 pounds of compost per year, save 65,000 gallons of rainwater, and have created an ecosystem so vibrant it attracts prey and predators alike. From the kitchen window Rob's two children can see goldfinches in the prairie garden and red fox on the hunt.

Before I leave, Rob, Meriah, and their two children share dinner with me, a feast in which nearly everything—the potatoes, the tomatoes, the carrots, the squash, the sage, the thyme, and the oregano—come from the backyard. On the way out, Rob shows me his garage, which hasn't held a car for years and is appointed in a manner most similar to Tom's shop.

Back on the interstate, I turn on the radio, a mistake I rectify by snapping it right back off when the purple-faced politics pour forth—an experience akin to opening the garden window, only to be greeted by the rear end of an explosively diarrheic donkey. But the toxins are catalytic, and in the subsequent soothing sound of nothing but wheels, and with many miles to go, I pluck up a thread I've been teasing in my head and give it a think.

When I walked into Tom's hospital room, Fox News was playing on the television. The sound was down, so we were still able to visit as it flickered all Red, White, and Blue. I didn't think anything of it, because once when we were discussing television in general, Tom told me he only watched the History Channel and Discovery Channel. Then he added, "And I'm a conservative, so I watch Fox News."

You get into trouble pretty quickly when you start making broad declarations about the disenchantments of contemporary politics (and a quick review of how Cicero's whole deal went down will help reset the bar), but still: It struck me that we live in an age in which Tom's statement would be taken in some circles as reason to dismiss every word he uttered thereafter. In particular I was thinking of our discussion among the beehives when he described the decline of frogs and what it might signify, and the possibility that a large chemical manufacturer might be messing up his bees. When I called him a tree hugger that day I was shooting him a friendly little needle, but I was also thinking that our tendency to paint everyone in shrieking binaries really leads to some missing out. Sometimes Ray Wylie Hubbard sings about tattered angels; sometimes he sings, "Screw You, We're from Texas." Sometimes you gotta listen to one to get to the other.

I'm trying to trace this frayed thread of thought back toward Rob Frost and the idea of what it might take to keep this

country rolling in the long term. From our private conversations I can state with conviction that Rob and Tom don't spend much time marking the same side of the ballot. And so it follows that they would not choose the same leaders. But what of it? Neither is the sort to spend much time behind leaders anyway. The day Tom and I discussed the television I said, Yes, but, Tom, have you known a politician in all your life you liked? "Nope," he said, flatly and without hesitation. "They go in there with their big ideas . . . and no matter who you put in there, they're limited by the regulations and the money. And in politics you either scratch their backs or they scratch yers . . ." After a pause, he said, "But what's wrong now, there's too much antagonism against each other. Y'get *nothin'* done then."

When I think of Rob and Tom, I don't think left or right, I think git'er done, gonzo. I think of an avowed Republican who dares suggest that perhaps in regard to frogs and honeybees we ought to consider something other than the annual report, and I think of a green gearhead who dares suggest purity can be crippling and now and then we might need to augment that curlicue lightbulb with a modest gasoline chaser. I think if Rob showed up at Tom's place with one of his eco-friendly rocket stove gasifier contraptions that was in need of tweaking, you wouldn't see the two of them for a week, and all the sounds coming from that shop would be busy, happy sounds.

I think, more old-timers, please—whatever their bumper stickers, whatever their age.

Homebound on the final day of the mini-tour, and autumn is setting in. All along the highway the sun hits the hills at such an angle that every visible color begs to be accessorized by a pumpkin. The leaves are several shades of fire, even as the cool air implies you'd best get serious about what's coming. The chill edge is a friendly nudge, like a mother sweetly suggesting you go back upstairs and fetch a scarf, just in case.

Tom has been transferred to a nursing home now, doing a brief rehabilitation stint before they send him back home. The facility is located half a mile off my route, so I drop in. After asking for directions at the nurse's station, I work my way through a warren of halls until I locate Tom's room. The door is ajar and I can see him in bed, fully clothed and lying atop the sheets in his stocking feet. Again there is the slight shock at how small he seems. And seeing him supine on that bed, bootless in his familiar farming clothes, is somehow more jarring than was the sight of him wearing hospital garb. Perhaps hearing me, he turns his head.

"Well, hello, Mike!"

He looks a shade more hale than he did in the hospital.

"Howdy, Tom. How's it comin' along?"

"Oh, I'm a-doin'." He gives me a report on his therapy, how they're having him walk the halls and recover his balance.

"You going stir crazy in here?" He's still lying flat on his back as we visit.

"Nah, it's all right."

"I thought you'd be itchin' to go?"

"Weaahhll, yer here, no sense fussin' about it." When he says "yer," he's referring to himself, not me.

"I suppose."

"I sleep. It passes the time."

Throughout the exchange he is pleasantly matter-of-fact, betraying no hint of boredom, let alone depression. It's hard to square his pleasant acceptance of the situation with the resolutely independent man I know him to be, and I find myself wondering if he truly is that copacetic. If he really does have some ability to just put his independence in neutral. To go from the Tom I know who stumps around the yard and up to the garden and out to gather the honey-bee swarms to a guy who happily naps.

"You just kinda seem to be able to adjust, Tom."

"Weaaahhll . . ." He tails off into a shrug and a smile.

We visit awhile, then I take my leave, stepping back out into the autumnal sun. It's a short drive home from here,

and the final stretch takes me down the road along which little Tommy used to catch the school bus. Looking north, I can imaginarily backtrack his boyhood path from the road, across the field, down into the bottomlands, across Cotter Creek, and up the cut to home, where now—through a passing gap in the trees—I catch a glimpse of the red barn and white silo on their perch overlooking the interstate, the big trucks and little cars sweeping past nonstop while in his little room south of here, Tom waits in patience.

Or perhaps it isn't patience. Perhaps it's just cussedness disguised as patience. After Tom's surgery, his daughters Deb and Emmy were sitting with him and Arlene when Emmy asked him to rate his pain on a scale of one to ten.

"Ohhh, about a three," said Tom, his scalp puckered with over thirty-five staples. "It stings a little bit."

"How about the headaches you were having?"

"They were a nine."

"They were a *ten*!" hissed Arlene. "You would hold your head and say how it hurt!"

"Well, you both deserve a spanking for not saying anything for a whole month," said Emmy, and the talk turned to other things.

Cussedness. Patience. And somewhere in between, equanimity. There is this story Tom tells: He was working in

the yard when a car pulled in and two men got out. One was fresh-faced and young, the other appeared more seasoned. Insurance salesmen, as it turned out, pushing disability policies. Tom says he figured out pretty quickly the older guy was breaking in the new guy, showing him the tricks of the trade. The moment he stepped out of the car, the older agent straightened up and took a long, slow look all around the place, an expression of solemn appreciation on his face. Finally he said, "Nice farm you've got here."

"Yep," said Tom.

"Looks like you've put a lot of work into the place."

"Yep."

"Have you ever thought about what you would do if you got disabled and couldn't keep it all going?" asked the salesman, setting up the pitch.

"What would I do?" said Tom. "I'd sell the whole damn works and set on my ass, that's what I'd do!"

The first snow falls in October. Early, but not unheard of. It's thick and wet, plopping as much as falling. It clings to everything, turning the granary rooftop white and frosting the conical corncrib cap like a tin cupcake. The yard is

a frothy mix of white and green, the last of the grass still poking through.

I am on the road again, and Anneliese is teaching a class in town, so our friend Jaci comes to babysit. A veteran of the Starkey Road hill, she automatically does the turnaround trick at Fitzger's, but, forced to slow down to navigate the revised intersection, she makes it halfway up the grade before she spins out and slides backward. There are less than two inches of snow on the roadway, but it's enough. Heading back to Fitzger's, she gives it one more try, eking out a little more speed by crossing into the oncoming lane and then cheating across every inch of the gravel apron right up to the edge of the new mini-moat. This time she just makes it, spinning and inching over the crest and past our mailbox.

"What did they do to the road down there?" she says when she sees Anneliese.

Somewhere south of the Illinois state line I stop for gas and call home. Anneliese tells me about Jaci and the hill. As soon as I hang up I dial the commissioner. He doesn't answer—all for the best, really, considering my state of unbecoming petulance—so I leave a message, then resume driving across the heartland. I imagine those who pass me wonder what all the gesticulation is about, unaware as they

are that I am delivering ringing speeches to the dashboard in the oratorical manner of Lincoln/Douglas, minus the fine diction.

The commissioner never does return my call. I decide when I get home I will pay him a visit.

When it comes time to disperse my earthly possessions, the auctioneer will be rolling along, working his way through the precious (my scratched, dented, and loyal International pickup), the worthless (90 percent of the boxes stacked against the north wall of the shed), the odd (an inoperable antique hovercraft), and the mundane (four garden rakes, three with handles) when he will pause for a moment to contemplate a Vise-Grips pliers that is standard in all respects except for the fact that it has been welded to the grab hook from a logging chain. If you know auctioneers—and if he is one of the good ones—you know he won't pause for long, but will improvise a line something like "Here's a tool for all you amateur dentists out there . . ." A chuckle will eddy through the crowd, and then someone will bid it up to maybe two bucks, and the sale will move on.

This odd tool dates back to an evening last year when we went to visit Tom and Arlene for dinner. I cleared a space on the kitchen table and placed the Vise-Grips and the grab hook in careful arrangement (imagine the jaws of the Vise-Grips as

the jaws of a fish and the grab hook as the dorsal fin). I asked Tom if he could weld them together in that relationship. He picked the pieces up and examined them, scraping the Vise-Grips handle with his thumbnail, judging the nature of the steel. "Yah, I can do that," he said. Then he set the pieces on the counter and took his seat behind the table. I smiled then, because I recognized the moment for what it was. I spent my childhood and over half my adult life in an area where much of the lake property was owned by people from outside the area. These same folks (we called them "lakers") often hired my roughneck pals to cut trees and pull docks and do basic care-taking and maintenance. Invariably—especially if they were recently arrived—the lakers tried to establish a firm work schedule, often through persistent and increasingly queru-lous phone calls. In nearly all cases this triggered a reverse customer service model in which every follow-up call dropped them five places down the list. It wasn't that my friends didn't want—and in some cases desperately *need*—the work; it was that in a dynamic heavily weighted one way and with impli-cations of *hop to it*, my friends were maintaining dignity by controlling the one thing they could: their time.

So what Tom was doing here was letting me know the shop was closed for the day. *I can do it—but I ain't doin' it tonight.* Two days later Arlene called to say the tool was ready and I could pick it up anytime.

Now on a cool morning after Tom has returned home and the early October snow has melted away I rise before first light, don my camo togs, and sneak with my bow and arrows to a deer stand set in a ravine in the back corner of the farm. I intend to sit for just an hour or two, then get on with the day. Dawn comes in gray, and when the light is sufficient I pull my pocket copy of August Derleth's *Concord Rebel* and settle in for a read. This year's tree-stand reading list has included *Proust's Overcoat*, some C. S. Lewis (*The Great Divorce* in full, and then a partial attempt at the much chewier *Mere Christianity*), and one cowboy book. I have also worked on miscellaneous essays and book bits, and completed both the first draft and final revisions of the collaborative liner notes for a John Prine tribute album while sitting fourteen feet above the ground with my back against the trunk of a Norway pine in a cloud of Tink's #69 Doe-In-Rut Buck Lure (clearly a pinnacle artistic moment). Over my outdoor life countless creatures have been spared due to the distractions of literature. As hunters go, I am PETA's favorite.

An hour of Derleth and I have seen nothing. I rise to tuck the book in my hunting bag and gather my gear when I spy a small buck approaching. Quiet as I can, I finish stowing the book, take up the bow, and when the deer is near and presents itself in broadside, draw and shoot. It is a clean hit and the deer drops at the edge of a swampy patch.

After I gut and drag him from the woods and register him at the gas station in town, I back the pickup into the pole barn, where my deer skinner is set up. It's a homemade device operating on a snatch-block arrangement, with power supplied via a hand-cranked boat winch. Using a noose attached to a pulley system fixed high in the pole barn rafters, I raise the deer just above the ground and skin out the neck and forelegs. And then—from a shelf right near the skinner—I retrieve the Vise-Grips modified by Tom and clamp them on the deer's hide at the point where I've separated it from the nape of the neck. Once I'm satisfied the jaws have good purchase, I fix one end of a short chain to an anchor point on the floor and snug the other end into the grab hook Tom welded to the pliers. Then, by cranking the boat winch I simply ratchet the deer out of its skin. I am thrilled with how well it works, for I have fantasized about owning my own deer skinner for years. If this strikes you as unbearably medieval, imagine, if you will, my youth spent trying to pry the frozen hide from a stiff deer using nothing but smallish bare hands and numb fingers, and you will understand that my feelings for the skinner are equivalent to those of the Manhattan yogi for her brushed aluminum juicer. Plus, who wants breakfast sausage with its hair on?

After coming off the road I never feel like a better husband and father than when I am splitting and stacking the

last rack of firewood, or tossing the final forkful of oat straw into the chicken coop just before the big snowstorm hits. I feel like I am doing the things a man is duty-bound to do. (My head and the hovering countenances of several former nursing instructors suggest some consideration of gender roles and patriarchy might be in order, but in this case I am reporting straight from the heart and my head will have to just sit over there in the Corner of Unreconstruction for five minutes.) I hunt deer for reasons that are cultural, sentimental, and caveman-innate, but I draw the deepest satisfaction in this moment, when I am down here in the shed working to turn the animal into meat that will cross our table one meal at a time. I occasionally butcher a chicken, and sometimes a rabbit or grouse, but deer are the only animal I take fully from hoof to table on my own. When the lucky winner returns home from the auction that future day, perhaps he'll puzzle over the Vise-Grips a moment, then pitch it in a drawer or hang it on a nail, not realizing that what he has in his hands there is one of my dearest possessions: an original Hartwig, signed with a welder and existing as a literal and metaphorical link in the chain of family, food, and life lived in commerce with the finest sort of roughnecks.

I arrive at the highway department unannounced, and am perhaps beginning to emanate an aura of disturbing per-

sistence, because prior to sitting with me in the meeting room, the commissioner summons his patrol supervisor to join the conversation. The supervisor's name is Ron, and we shake hands across the table.

I begin with the standard recitation, reassuring the commissioner that I appreciate his position and intentions regarding the intersection. I still mean it, although I'm not sure he believes it, especially since he knows by now it is simply the preamble to a dissertation on all the reasons I think he did the wrong thing.

"That said, you know why I'm here," I say, trusting he has heard my voice mails even though he never called back. "We didn't even make it out of October before someone slid off the hill."

"I did say we would revisit this in the spring," says the commissioner.

"I'm not sure why we need to wait," I reply. "I mean, October . . ."

The commissioner embarks on *his* standard recitation: The rationale for the redesign, the people speeding off the hill, safety as the prime objective. As he talks, he sketches the intersection on a pad of paper. "See, traffic coming from this way is no big deal, but from this direction . . . an older person would have to crank their head around, and they just physically can't do that . . ."

"Here's where I'm getting frustrated," I say. "You keep telling me about these safety issues, but we've *created* a safety issue by not allowing people adequate speed to make the hill."

There is a long pause. We all three stare at the commissioner's doodle, as if it is some form of neutral ground.

"I don't know how else to put it," I say, after a while. "I'm not makin' it up. This woman . . . third week in October, she's comin' off the hill backwards, and she's a middle-aged teacher. She's not hot-roddin' . . . and she's been drivin' up that hill for ten years." I grew up dropping my gerunds, and have noticed that I tend to drop them even more aggressively in uncomfortable situations like these, perhaps as a result of some unconscious effort to convey a certain blue-jeans simpatico.

Now Ron speaks. "Well, one concern, if the township even made it out there to plow . . . I mean, if there's inches of slush and stuff on there, would going straight up help you to get up there with a car?"

My face remains relaxed, but I am clenching my figurative teeth, in part because we seem forever and ineluctably to veer back to the nonissue of plowing. There weren't "inches" of slush when Jaci missed the hill, and the benefit of going "straight up" has been central to my thesis from the get-go. In fairness, Ron hasn't heard my pitch before, so I review,

and also reiterate that the trouble begins long before there is accumulation sufficient for plowing, and therefore sending the plows out early is irrelevant. I'm filled with my usual liver flutters and the frustration creeps even more deeply into my speech patterns, which begin to sound like something blown from the overextended bellows of a one-note, comma-free accordion: "We didn't have to send them out early before and then it also makes me look bad because it makes me look like I'm in here complainin' that I want the plows out and my brother's a town guy up north and I know what you guys deal with plows, you got people callin' ya all the time sayin' 'where are ya!?' and I don't wanna be that guy."

"M-hm, m-hm," murmurs the commissioner, staring at his notepad and perhaps wondering just how long I've been on the meth.

"I'm saying we don't *need* any sort of special concern."

He rallies. "Well, any plows that would have to go out early would be township plows, so . . ."

I feel the accordion snap, then sag. My jaw follows.

Ron tries to reassure me. "I don't think anybody would look at it as you asking for special treatment . . . but if it's somethin' where it's easily maintained where the plow can go up it whether it is early or whatever it may be or it's one of the first roads on their route, then so be it. The thing of it is what we're tryin' to prevent is a safety issue."

Apparently my jaw muscles have now popped up like Ping-Pong balls, because Ron quickly presses on. "Yes, we may have created a winter issue. But during the summer, when we were out there building on the road, I wasn't the only person that seen somebody fly down that road and not even yield. Shoot right out in the intersection with the trees and stuff there. I wouldn't want my family coming around that corner and getting hit."

We are in the meeting room for over half an hour. The time doesn't really drag, because time doesn't drag during a fencing match. We are riding the same old conversational carousel: snow, safety, snowplows, snow, safety, snowplows. People "shooting" off the road every which way. At one point the commissioner says that the problem lies in the fact that whoever built the road all those distant decades ago cut it at an angle exceeding contemporary standards. "Nowadays, I don't know that it would even be permitted," he says. I must have twitched, because with some alacrity, he adds, "But that's not the point." In a change of course, and clearly seeking common ground, the commissioner describes his boyhood home. "My parents have a very steep approach to their driveway . . . and there were times, you know, you get six

inches of snow, and in a two-wheel-drive vehicle . . . you just
go like crazy and see if you can make it and if you can't, you
end up going any-which-way backwards."

Indeed.

"There were a number of times I just ended up parking
the truck down at the bottom of the driveway and walked
up and waited until we got the driveway plowed. *Then* I
drove up."

I am struggling with how to frame and fully express my
perception of this proposal—the suggestion that my wife
and children should abandon their vehicle beside the road
during a snowstorm and walk a few tenths of a mile up
a road designated as terribly dangerous because of all the
downward-careening cars—when again the commissioner
reads my thundercloud face and clarifies.

"My point is, I understand what you're saying about
needing to make a run for it."

We lapse into another gridlocked silence. I take a sur-
reptitious glance around the joint to see if the walls are
padded. Then, breaking the silence with a tone of polite
finality, the commissioner offers to call the township per-
sonally to ask if—*wait for it*—they might send the plows
out earlier.

"No," I say. "I'd rather face-to-face, I'm frustrated, I'm
not ang-ang . . ." I actually have some sort of laryngeal sei-

zure at this point that chokes me off for a second and re-sults in me performing an inadvertent but most credible imitation of Berkeley Breathed's late-lamented Bill the Cat.

I get my breath back and continue. "I am a little bit upset but I'm not a yeller and a ranter." Here I give a wan chuckle. "Maybe I'd be better off if I was."

"You've been very civil."

I wonder: Are you really civil if you're not *feeling* civil?

And then, believe it or not, we're off again. More dis-cussion of right-of-way issues, the width of the gravel apron, more on slip-siding cars and expanded landing areas. At one point Ron leans forward and points to the sketch on the pad of paper, right at the spot where the edge of the new roadway meets the fresh excavation—the mini-moat—preventing us from going straight up the hill. "If yer to look at fillin' in just a little bit of the edge . . . how much would you need? How many feet?" Then he catches himself. "I'm not telling you this is something I would do, because I wouldn't, and legally I would definitely not anyway."

"I can't give you feet," I say, "but whatever we need to basically keep the car straight."

"So maybe another car width?" asks the commissioner.

For a moment there is hope, but then the conversation derails right back into more discussion of cars launching Joie Chitwood–style into the maples, and miscellaneous

legal liabilities, and then I decide it really is time to wrap things up.

"You guys got work to do," I say. "I appreciate your time. I guess we'll just see how it goes."

"We're tryin' to . . . again it's . . . different things . . ." The commissioner trails off. It feels a little like breaking up in high school.

"And we definitely feel your situation," says Ron. "I got little kids, too."

I gather up my notes, the commissioner gathers his. Just before I leave, Ron speaks one more time.

"If we did add some gravel . . . or gravel *showed up there*, whatever . . . would that help?"

On the afternoon of Halloween, we take the girls trick-or-treating in the neighborhood, with the Hartwigs our last stop. Tom smiles broadly as he opens the door and sees Jane in her tiger whiskers and Amy dressed as a witch. Jane drags her stuffed tail off in search of Milk-Bones while the rest of us seat ourselves around the table. Tom looks good. His hair is thickly returned, the scar completely obscured, and any lingering weaknesses are gone. "You're doing okay then, Tom," I say. "Yah," he says. "I just went in for

my checkup and they said I'm doing fine. The air bubble is gone, everything looks fine." He runs his hand through his hair, over the spot where they lifted his scalp. "Only thing is, the part where they took out the piece of skull is lower than the rest. I told the doc he shoulda done some mud-jackin'!" It's a good little joke if you know that mudjacking is a process for elevating uneven concrete slabs.

We visit and catch up. "The bear that left that paw print on the honey shed window has been visiting again," Tom says.

"Tore the bird feeder down," says Arlene.

"Weaaahhll, he's gettin' ready for winter," says Tom. "Here a while back we had one hibernatin' in that big culvert they run under the interstate. It's a thirty-inch culvert, high as the table, and he filled that whole thing. And when I first found him, I went down and shined a flashlight in there, and there was them big ol' green eyes lookin' back at ya. I called the Department of Natural Resources and they told me if it was a female she'd have young ones in January and by February you'd hear those little ones squealing. Well I went down there in February and didn't hear anything and those green eyes were still lookin' back at me, but instead of filling that culvert out like he did at first, now you could see daylight past him, he had lost that much weight. The water started to run on the eighth of March that year,

and I went down and checked, and he was gone. He had gone the other way, and the guy that lived over there heard a commotion on the patio, and there was that big bear, two feet away. He told me, 'If I didn't have a heart attack that night, I never will!'"

Amy and Jane are listening with wide eyes. Arlene is beaming. I think of him small in that hospital bed and how good it is now, seeing him back in his corner, on his chair, telling his stories.

"Good to have him back, Arlene?" It's a dumb thing to say, I guess, but I said it.

"Tommy and I will be married fifty-nine years now, co-min' up," she says.

"Yah," he says. "Sixty years ago we were goin' together hot and heavy!"

"Thomas A.!"

Anneliese and I smile at each other. We know when Arlene calls Tom "Thomas A.!" she's acting happily aghast. It's good to see them ripping it up like this. We're being allowed a little peek back at the two young kids setting out on a date in that long-gone Chevy convertible.

On the way out the driveway, I hold Anneliese's hand. I don't believe they have yet perfected the genetic miracles that will be required if I am to share life with her for sixty years. But there is something about seeing Tom and Arlene

sparking at each other there that freshens my affection for my wife. When we reach the end of the driveway I turn my head to check for traffic and there, smack on the centerline, is the bear. I turn right instead of left and drive toward him, then pull to the shoulder in a place where the girls can watch as he meanders off the road and into the pines. We stay until he disappears into the brush, me squeezing my wife's hand while behind us the witch and tiger giggle at the sight of the bear's shiny black galumphing butt.

After the October snow, there is next to nothing. All the way through Thanksgiving the countryside lies uncovered. There are flurries, but the township trucks throw down gouts of brown sand and we climb the hill with no trouble. Still, you know it's coming.

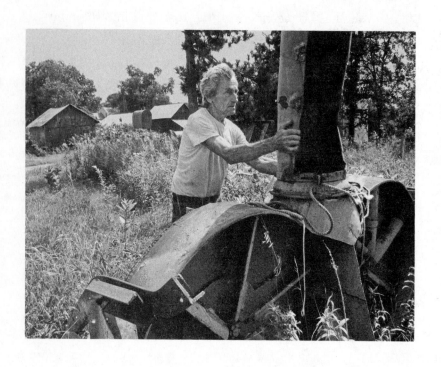

CHAPTER FIVE

There are stories even between the poses. As Tom leads the photographers from the silo to his sawmill, he stops to put his hand on the trunk of an oak tree. The trunk is the circumference of a patio table. When Tom was still a young boy one of the last of the local lumber barons visited the farm and talked about logging at the turn of the century. They had this idea, says Tom, that when they were done logging something, they should burn all the slashings and leave everything clean. When they burned those slashings they burned the little trees, too. He pats the oak, looks up at it. But they missed a strip of big oaks here. This is the last one.

The oaks, some of them were pretty good size. The state said if we stayed outta their way we could have the logs. Arlene's dad and I dragged logs for three days. We had three acres covered. The ones that were solid we picked out for saw logs, and we got 13,000 feet of lumber, and then

we had a firewood pile over 100 feet long. And that year I mixed I think it was twelve or thirteen pounds of gunpowder. Arlene's dad and my dad would go ahead and drill holes in those firewood chunks, and then we'd go along and load'em all with powder, and then we'd take the propane torch and go down the line, it was like giant corn poppin! Boom! Bang! Boom-boom!

Before the interstate went through, there weren't many big trees here. There were pines, hundreds of them, down in the creek bottom. Yah, I planted'em. When I was in high school. He holds out his hands, makes a saucer-sized circle. They were about this big. About sixteen feet high. Not quite big enough for pulpwood. They spent three weeks bulldozing and burnin'em.

They gave me sixteen cents a tree. At that time, I guarantee you, if you'd gone out on state land and cut a Christmas tree, it woulda cost you a minimum of fifty bucks.

But when you own it, well, then it's not worth much.

Today the only trees along the interstate fence are young Norway pines. Lately they've begun dying. All the exhaust, Tom figures. Or road salt.

Just beyond the oak is a gas tank elevated on a steel frame. The frame is mounted on wheels. Some'a them zoning people, they're picky about where you stick a gas tank. So I put it on wheels. If they don't like it here, I'll put it there. If they don't like it there, I'll put it here.

Near the gas tank, deep in the weeds, detached from the front end of the 1943 Farmall M tractor that will push it come winter sits Tom's homemade snowblower. He fashioned the thrower paddles from forty-inch lengths of three-inch well casing split in half and deployed in twin fan-blade arrangements that turn counter to each other. They spin on shafts and bearings taken from an old hammer mill, and the housing is made from the rims of a bull wheel from a grain binder. The chute—Tom calls it a spout—was constructed from blower pipe robbed from an old threshing machine. *I wanted it to throw snow fifty feet, he says, so I took a piece of string twenty-five feet long, pegged it at one end, and used it to draw a radius on the ground. Then I bent the spout to match the radius.*

That first year I powered it direct off the tractor. But whenever it'd start chewing through real deep snow, the engine would bog and the revolutions would drop and I'd

have to constantly step in the clutch and let it cure itself. The manner in which he employs the word cure *is a reminder that poetics are not strictly the purview of poets. To remedy the bogging issue, he fitted the blower with its own engine.*

Yah, it's a thirty-seven-horse Wisconsin. It was off a silage chopper. Got it for thirty-five bucks. The valves were stuck, so I pulled the heads and broke'em loose. When it was time to put'er back together I didn't have a new head gasket, so I painted the old one with aluminum paint. That was forty years ago, and it's still runnin'. I rigged it so I can reach the clutch and throttle from the tractor seat.

It's a horrifying machine close up. You can stretch both arms and not come close to spanning the intake. The uppermost reach of the paddles is nearly sternum high. You imagine a safety inspector from OSHA dropping in a dead faint atop his clipboard. In action, the paddles whirl invisibly fast, scooping the snow and hurling it up the chute to arc across the sky. It's fun when you get a nice overnight snow with a lot of ice crystals in it, *says Tom.* You blow that snow on a sunny morning, it looks like Ol' Faithful! *Once out and back, Tom says, nodding toward the driveway.* That's all it takes.

Up in one of the healthy Norway pines a jay scolds, his voice cutting through the sound of traffic, which, as ever,

runs steadily. Oughta be a toll road, Tom says as he turns away from the blower, and all's I wants is a penny per. That'd be a decent living.

Among the trespassers the interstate has delivered to Tom's door is included Death. Yah, within a mile of here we've had one, two, three . . . five fatal accidents. First one was to the south, two guys were haulin' a D8 bulldozer. During the night they must have fallen asleep and run up on the guardrail. The D8 broke loose and sheared the whole cab off. And then one year it was a bright sunny day in the afternoon, we had just finished haying, we were in the house having coffee. And there was a hell of a commotion out here and I ran out, and a semi went into the median and he crossed the other lane, drifted way over to those big oak trees on the far side, and he hit one of 'em and rolled the cab right under the trailer. Killed the driver. And when they dragged the guy out that was in the sleeper, he was alive, but his thighbone was stickin' out of his pants. Then up there by the overpass, an old guy had a heart attack, he was comin' eastbound, and he crossed the median and he ran into the fuel tanks of a semi that was hauling a full load of cheese and it caught fire. The black smoke just rolled, and the cheese ran all the way down to the county road.

He guides the photographers to his sawmill now, cut-

ting between the backside of the shed that stores the can-non and the woven wire fence establishing the boundary of the interstate right-of-way. Across the highway, a white cross is visible. It is fourteen feet tall and stands on Tom's property, just outside the state fence line. He points it out for the photographers. Yah, n'that cross over there, there was a woman state trooper killed over there. They wanted to put a memorial up for her but the state wouldn't allow a crucifix on public land. So they come to me, asked me if they could put it on my land. I said sure, on one condition: You make it big as you can.

EVEN THE GOLF BALL WON'T help me now.

"This one's gonna be a golf-ball job," my father would say while securing the hay baler power takeoff shaft in the shop vise prior to replacing the universal joint bearings—a real knuckle-busting spirit-warper of a job. We kids would grin because we knew Dad—a studiously nonprofane man—was referring to a long-standing joke he picked up from his last factory job: Before undertaking a difficult task you place a golf ball in your mouth to block the bad language. It's a perfect kid joke because it combines a goofy image with the illicit implications of naughty words.

Mounting the snowplow should not be a golf-ball job, but it is. As with many once-a-year tasks, I complete it with roughly 75 percent efficiency, and, boy, that other 25 percent is a real steam generator. Today I had already scuffed a knuckle and was only just managing to keep a lid on the fizz when I crossed behind the truck in frustrated haste and rang the trailer hitch with my shinbone, resulting in an impromptu performance piece I like to call the Howling Hopscotch of Rage. Only an asbestos-coated golf ball would have survived.

I am in haste because drifts are sifting through the gap beneath the pole barn door, and the steel roof is rattling with wind. It is the second week of December, and we are about to get a whomper. "Blizzard of the decade," said ol' Jay Moore in the Morning on Moose Country 106.7, and I have procrastinated mounting the plow until I saw the whites of the flakes. *Tut-tut*, say the strict calendarists among you, and fair enough, but then as the cut-rate Scandinavian Zen master Yogi Yorgesson famously never declared, "Who sniffs the rose before it blooms?"

I finally get the plow locked, climb into the cab, and nose out into the storm. The snow is no longer arriving in distinct flakes but rather sweeping across the windshield in a blur of stripes. I close and secure the pole barn doors, then plow my way up to the house. Our two pole barns are located downhill by the old barnyard; over our winters here

I've learned the hard way that because of prevailing winds, both pole barn doors often get socked in with several feet of snow, as does the narrow lane, so despite the availability of two roomy sheds, I park the truck on the upper level beside the old pumphouse, run an extension cord to the block heater, and head for the house. The chickens are fed and the coop battened down; the firewood is stacked tall beside the stove. This early on, there's not a lot to do except settle in and let it come. Anneliese calls Arlene to see if she and Tom are set for the storm, and Arlene says all is well and Tommy has his monster snowblower set to go.

At noon I start the truck and plow out the driveway, continuing all the way through to the bottom of the Starkey Road hill. Down on the county road, it appears the plow trucks may have made a pass, but it's hard to tell, as the snow is still flying unabated, and on the way back up the driveway my fresh plow cut is already beginning to drift in. At this point it will be all the county and township plows can do to keep the main arteries open. And the way this stuff is blowing in, it's even more likely they'll pull the plows in until there's a chance of keeping up. On a day like this the configuration of the intersection is a moot point. Ain't nobody goin' nowhere, and I only plowed as much as I did to keep a basic path in case I get an ambulance call

or we have a family emergency. I park the truck, plug it in again, and spend the afternoon up in my office, writing.

At suppertime there is still no sign of things letting up. Temperatures are due to dive once the snow stops, and Anneliese suggests I might want to plow everything out once before we head to bed so all the additional snow doesn't pack down and set up overnight. No sense in it, I tell her. It's coming down so fast it'll just fill right in behind me. "Okay," says Anneliese, and I think to myself, What a gift to have a wife so free of fuss and nag.

Someday, years down the road, I will instead think to myself, Hey, that "Okay" had the slightest little eyebrow lift right at the end of it, the same as the time I told her she was wrong about the wiring on the cattle waterer, that I didn't have to call the butcher ahead of time, and that we had more than enough firewood. Instead, I help tuck the girls into bed, bank the woodstove, and go gratefully to rest as the wind and snow bunt and tick against the windowpanes.

In the morning it is ten below, the iron earth hidden beneath snow carved and hardened by the night's unceasing wind. This is not snow that *blankets* the earth, it *enamels* the earth. The wind abates as the sun rises, but when I open

the woodstove door to the cold firebox I still hear the tubular swirl of air passing across the chimney top, as if some giant were piping it like a native flute. After kindling the fire—leaving the draft wide open and the door cracked until the flames are rushing—I layer up in flannel and Carhartts, draw a bucket of water for the chickens, and step outside. Detouring on the way to the coop, I stop by the plow truck to see if it will start. Twisting the key, I get not so much as a click. It's not the battery, because everything lights up fine. I trust the starter is frozen. Crawling under the truck, I rap it with a hammer a few times. When that doesn't do the trick, I move the magnetic heater from the oil pan to that part of the starter where the magic elves live (some call it the solenoid).

I stomp off to the chicken coop, not because I am upset but because that is the only way to walk in snow this solid. Rather than leave tracks, I punch holes. The morning sun is starkly bright, striking the earth at an angle that highlights the scoured contours of the yard: humps and scallops and backbone drifts that curl sharply around the downwind corners of the outbuildings. Steam wisps upward from the water bucket, and in the coop the chickens are shrugged and fluffed deep in their feathers.

After the chicken chores are done and before I try the truck again, I climb the ladder to the granary roof and clear the

photovoltaic panels, which are blindered beneath six solid inches of marzipan. It seems counterintuitive to be harvesting the sun at ten below zero, but the panels are actually more efficient in the cold, so I want to take advantage of the clear skies. While I am up here on the snowy peak I can provide a public service announcement of a sort: Although there are inherent advantages and cost savings to installing solar panels on an existing structure, if you live in country like ours, by the time you've made it through your first winter you'll find yourself thinking maybe you should have shelled out for the ground-level rack. My neighbor lent me a roof rake equipped with a special soft blade that won't damage the panels, but on a day like today, when the snow is as hard as this, there is nothing for it but to crawl up on the roof and push it loose. *But that's unsafe*, I can hear you saying, to which I reply, *Boy, is it ever.* Plus: *Electricity!* Now and then Anneliese peeks out the window, and I imagine her thumb hovering above the speed-dial, prepared—I'd like to think—to dial 911, although in fact she may very well be on the line with our insurance agent, Stan, bolstering the payout on my life insurance policy.

When the panels are clear and downloading the sun, I try the plow truck again and it starts. Thanks to the plowing I did yesterday, I make it out the driveway without much

trouble. But on the return trip, when I veer over to plow the blacktop apron before the garage, the blade hits with a *whump* and the truck stops dead, wheels spinning. I back off and hit it again, but gain only about a foot. Anneliese was right. I got so caught up in declaring the foolishness of plowing while the snow was still falling that I blithely loco-moted past the idea that this was the sort of blizzard that not only *dropped* snow, it packed it, jammed it, tromped it, carved it, and then froze it solid. Had I plowed out yester-day, I'd have a shot. As it is now, the snow simply will not be bladed. I will have to start the tractor and clear the whole works one scoop at a time. As I sit there staring at the im-permeable wall of snow off my front bumper and the reality of my day sinks in, I resist the urge to check the rearview mirror and see if Anneliese is watching now.

It takes me the better part of the day to get every-thing opened up. And here is the beautiful thing about my wife: She sees me out there on the tractor and knows very well what has transpired. And yet when I come in for lunch she doesn't say a thing. She knows right now I need to grunt and frown and work childishly hard at getting the thing done. Later—much, much later—I will find a way to mumble something about how maybe it turns out she was right. She is allowing me the blessed period of decompres-sion. By the time I get around to admitting that I really

should have pre-plowed, I will really mean it, and I won't mind saying it.

Sounds trivially silly, I suppose, but the payoff is immense. I often wish I was the brash, decisive type, able to impress my wife through definitive and timely action; that clearly not being the case, I can tell you that sleeping in the same bed with someone to whom you can admit your failings is a lasting comfort indeed. This is not about *mea culpa* as surrender, it is about *mea culpa* as mortar in binding together the uneven bricks of a human foundation.

Earlier, Anneliese called the Hartwigs again to be sure they were okay. Arlene answered and said Tom was out on the Farmall, blowing snow. In this, I am flat-out envious of him. I've always gotten by just fine with the truck blade and the tractor bucket, but in the time we've lived here we've never had snow this imperviously dense. It just can't be pushed. And while I am reduced to pecking away with my little loader bucket, Tom is across the valley with his homemade howling machine, blowing geysers to the sky, once out, once back.

Evening. Everything is plowed out, and we have taken dinner to the Hartwigs. Amy is draining a pot of potatoes in

the sink. The hot water hits the porcelain with a splatter, and steam mushrooms up to huff itself across the kitchen window. On the stove a skillet of sausages and sauerkraut is simmering, as is a saucepan of green beans. With help from our friend Mills, we ground and stuffed the sausages ourselves, combining our own homegrown pork and the venison I took last fall. In a small way, I like to think that sausage is a royalty paid on the deer skinner component Tom welded up for me. Anneliese made the sauerkraut, and she and Amy canned the green beans. The potatoes we dug as a family: me on the fork, Anneliese and Amy shifting the boxes, and Jane flinging angleworms. What you have here is your everyday Thanksgiving dinner.

The kitchen is warm and feels even warmer for all the food and the idea of the dark, snow-fixed land all around us. Arlene has her chair angled so she can direct operations. I am sitting with Jane on my knee, doing my best to keep her occupied as she has already stuffed Cassidy with Milk-Bones. Tom is in the other room rummaging in a drawer. When he returns he is holding what appears to be a miniature wooden doll with a protruding tongue and eyes and ears to match. He gathers the girls in close and unscrews the doll's cap, turning the figurine so that they can see that the head is hollow and studded with toothpick-sized pins that protrude inward. The pins are attached to

the tongue and eyes. "When we were kids, we'd catch a blowfly and stick him in there," he says. "Then when that fly would crawl around the eyes and tongue would come out and the ears would wiggle. We thought that was just hilarious."

Tom is also carrying a narrow-necked clear glass bottle. "This is my latest project," he says, and inside the bottle I can see a wooden chair, large enough that it had to have been constructed inside the bottle. "I did it in the evenings," he says. "I had to make these tools in order to do it." He holds out a pair of slim, oddly twisted forceps. "I could reach to the bottom of the bottle and pick up a toothpick with this." Then he proffers a lightweight rod with two tiny hooks he's forged at one end. "This I used to push and crowd things a little bit." As intriguing as his tools and handicraft are, I am as always fondest of his language, in this instance his use of the word *crowd*.

Tom hands me the bottle so I can study the contents more closely. "When I was a kid, you had to make your own playthings," he says. "And of course Dad didn't have power tools, but we were always welcome to use his tools. The only stipulation was that we put them back." I notice the chair has begun to dissemble. "*Aaacch*, I used Gorilla Glue," Tom says. "That's a mistake, because Gorilla Glue expands." Still, as he stands there with those delicate

homemade tools balanced on the palm of one hand and the bottle displayed in the other, he is beaming, and I am certain we are pretty much seeing little Tommy Hartwig at show-and-tell seventy-five years ago.

"I'm gonna make another one of these," he says, as he places them back in the other room. "I'm gonna make it a little heavier, put armrests on it, leather straps, and then a Christmas tree bulb with a plug-in. An electric chair!" When he comes back in the kitchen he can hardly deliver the punch line for grinning. "It'll either be modern art or morbid art!"

We are about to eat when Tom disappears and produces another bottle, this one filled with clear liquid. "Been runnin' the still," he says. I am teetotal, so he looks at Anneliese. "You wanna shot?"

"Just a taste," she says. Tom pours a sip in a shot glass and Anneliese tips it back.

"Hoo!" Her eyes are appreciatively wide.

"We had thirteen bottles of grape wine," says Tom. "They were bitter. I didn't wanna throw it away, so I decided to run it through the still. Then I figured that wasn't really enough to run through the still, so I went down and I bought some champagne yeast down there at the Cap-n-Cork. Champagne yeast will stand up to twenty percent alcohol and your ordinary wine yeast, it'll start killin'

out at about twelve, thirteen percent." When he gets go-
ing in moments like these, he is downright professorial. "I
took twelve pounds of sugar and eight quarts of water and
you heat it and make a syrup out of it and then we had
it in the fermentation jug over there by the dining room
table just burpin' away for about two months. Then I ran it
through the still and the first bottle that came out was one-
hundred-and-forty proof."

Anneliese looks at the shot glass, then says, "So if you
spit that out with a lighter in front of you . . ."

Tom's face lights up. "Ohhh . . . that'll burn with a nice
blue flame!"

I'm chuckling along when suddenly Anneliese's state-
ment registers. There is an implication of prior experience,
and I make a mental note to ask her later if she ever worked
in the circus.

"Then we got two of'em of a-hundred-and-thirty proof,
and one of about a hundred and ten," says Tom. "When it
gets down to forty proof we throw it out because that's the
end of it. But we mix'em all together, it's about sixty proof,
and you get six bottles. And that costs you about a dollar a
quart, and that's why the government frowns on it."

He pauses a moment.

"I don't like the stuff. Wine either. We give most of it
away."

"I'm seventy-eight years old, and I've never had a bottle'a beer," says Arlene. "Or a cigarette."

"I smoked a pipe for fifty years," says Tom. "I quit twelve years ago."

"Did you miss it?"

"For about a couple months. I used to smoke one of those cans in two weeks."

I've seen the cans he's referring to—fourteen-ounce Prince Albert Crimp Cut Long Burning Pipe and Cigarette Tobacco, each tin colored a nice deep red. They're scattered all around the shop, usually filled with bolts or old nails. There are also a lot of cigar boxes, filled with the same sort of items, but when I asked Tom once if he smoked the cigars he said, "Nah, I just use the boxes," and so it had never occurred to me that he might have smoked the Prince Albert.

"If I was doin' a lot of shop work, then the tobacco didn't last long, 'cause you had to have that pipe goin' to think," he says. "Weaaahhll, I went to the doctor and he said I had a little bit of emphysema. That did it." He put the pipe down and hasn't picked it up since.

"Yah," he says, "when I gave that up I told Arlene I had no more vices."

We eat then, knees to knees around the tiny table, the ever-present M&M jar pushed to the middle, where Jane

eyes it throughout the meal, waiting for that moment when Tom will unscrew the cap and tip it her way. I look at both girls now and wonder how much of this they are absorbing. The first time I came here with Amy, her head didn't clear the stovetop. Now she is shuffling pans on it, standing nearly as tall as her mother. With my late arrival, with my comings and goings, I am grateful my children will carry memories of people who have lived long and lived substantively. I am glad they will remember nights when we went *visiting*. I am glad they will remember their mother and me laughing and listening in the presence of *our* elders. Here at this table, in this moment, I feel as if I am in the middle of one long, slow exhalation.

The cocoon is breached later when we open the door to take our leave: first by the cold air, then by the sight of the interstate lights smearing past as we bundle into the van. Once we make the curve past the cannon, however, it's another cocoon, just our little family rolling out the driveway, the headlights illuminating the sheer walls of snow cut by Tom's howling blower during the bright day.

In the wake of the big blizzard, Starkey Hill is plowed wide open and deeply sanded. We come and go with no trouble.

Then, two days before Christmas, Anneliese and I join our friends Buffalo and Lori (Buffalo's parents were members of the *counterculture*) for dinner in town; their two young daughters have been spending the day at our place and will remain there with the babysitter this evening along with Amy and Jane. There are predictions for another storm, so at the last minute Anneliese and I take the plow truck. By the time we come out of the restaurant the air is twisting with snow and drifts are bridging the main roads, but when we turn up Starkey Road the shelter of the trees is such that less than an inch of snow has accumulated on the blacktop. I engage the four-wheel drive and we climb the hill easily. We are just pulling into the yard when my cell phone rings. It's Buffalo. His car spun out halfway up the hill. He and Lori slid down backward into the intersection and they are now sitting at the bottom of the hill. I tell him we'll bundle up the kids and deliver them with the truck. The evening ends with us at the side of the road in swirling snow and darkness—the worst possible time and place—transferring kids from one vehicle to another.

All the way back up the hill I deliver what has now become a rote soliloquy to the windshield, then go straight to my office, where I leave one more grumpy message on the commissioner's voice mail and request that he give me a call when he comes in.

The commissioner doesn't call. Then again, he had a blizzard to manage. While I was huffing into the phone receiver, he was overseeing the midnight maneuvers of over forty large plow trucks. I admit I left the message because there is a cranky part of me that just wants him to know I'm unhappy. There is also an element of *told ya so!* Additionally, I fire off e-mails to the township clerk and the president of the town board—they did not cause the problem, and in fact it is their conscientious sanding and plowing that has mitigated it thus far—but I am hoping they can bring some pressure to bear. I am not proud of how I am acting; then again, when I'm lugging kids up that hill I feel I have grounds.

After Christmas, we go to Colorado to visit Amy's father, a statement that sounds a little tricky on the face of it, but is blessedly unfreighted in the fact of the matter. Amy was three years old when we met. Her father, Dan, lives near Denver with his wife, Marie, and their two boys—Amy's younger brothers. We've never really gone in for the standard *half-* and *step-* prefixes. (My standard line has become that the term *stepdaughter* is perfectly sufficient for conveying the situation, but utterly insufficient in convey-

ing the heart, and above all I prefer the term lent me by a roughneck poet friend: my *given* daughter.) I have told the detailed story elsewhere, but the summary version is we are all grateful to say we are closing in on our first decade of getting along just fine. It helps that Amy's father and I are both tuned to the same humor frequency, which leads me to say the entire unusually happy situation is best summarized by the time Dan and I walked into the Denver children's museum with Amy between us holding our hands and a woman sighed and smiled at us with warm acceptance and Dan and I looked at each other and grinned, realizing we had just been benevolently—if inaccurately—outed.

Our trip to Colorado is not strictly for the holidays. Amy's dear Grammy Pat, a stately woman of nearly six feet who raised Amy's father and four other children on a Colorado farm after her husband was killed in a wreck when the youngest child was one year old, has gone several rounds with a virulent cancer. To anyone who hadn't known her previously, she would appear to be remarkably vibrant for her age, but the family can see certain new lines in her face, and there is concern that a recent remission may have been chimeric. One of the functional joys of our extended family (I prefer to misuse the term *extended* rather than the more euphemistic *blended*) is that we four grown-ups discuss things in quadruple and, following on these discus-

sions, we have agreed it is best that Amy have a fair sense of what might lie ahead. As such, she knows that Grammy has been gravely ill and may be again. Indeed, she knows that Grammy may not survive. On the other hand, we have also done our best to be clear that this visit does not constitute a wake. Grammy is in most ways very much herself.

Indeed, our time with Grammy is all we might hope for. She retains her elegant bearing and entertains the children by discussing the critical elements of wig selection in the wake of her chemotherapy. The house is wall to wall with relatives I have come to know by incalculable chance—not the sort of thing you would plan, but as I look around at children who have already grown a foot since I first met them, and at Amy's hard-charging younger brother who wasn't even born the first time I nervously met the family, and as I look at the grown-ups and realize we've now got shared history and stories and anecdotes, well, I realize at its best this world is happy in so many unpredictable ways. The children sit at Grammy's feet to open their delayed Christmas presents while we grown-ups update each other on the year passed, adding another layer of stories to our acquaintance. My favorite moments come in the evenings, when we all gather in the kitchen to prepare dinner and Dan and I wind up shoulder to shoulder, chopping vegetables and running sauté pans, while outside, the post-holiday

Christmas lights glow in white-framed silence, the season fading, the new year already under way.

Back in Wisconsin, Anneliese's mother, Donna, and her husband, Grant, are house-sitting and chicken-watching for us. It's natural enough, as they lived on the farm for the nine years prior to our residence. I call to check and see how things are going and learn that Anneliese's sister, who has been successfully navigating Starkey Road since she got her driver's license, was on her way down the hill when she slid straight into the newly excavated moat where the straight shot was removed. Neither she nor her passengers were injured, but they did have to exit the car and push her back onto the road before another car came down the hill. On another night, Donna and Grant hosted a get-together at the farm, and although there was less than an inch of snow on the road, a number of the guests had to leave their vehicles clustered at the bottom of the hill while Grant shuttled everyone back and forth with the four-wheel drive. Calling from Colorado, I leave another message with the commissioner, and use my laptop to send another e-mail to the town clerk. Later, looking at myself in the mirror as I brush my teeth, it does occur to me that if I were to enact this level of tenacity elsewhere in my life I might be able to *buy* the Starkey Road hill and configure it however I pleased.

We say good-bye to Grammy Pat as if it were any other Christmas, as it seems there is no other way. Then we depart for home with the car stuffed with gifts and our camera card filled with photographs of Grammy happy amongst her generations. On the interstate many hours later, in the darkness while Amy and Jane sleep, Anneliese tells me quietly that she was up in the middle of the night and found Grammy in the kitchen, racked with pain.

If, as a civilian around these parts, you attach a snowplow to your truck, you assume certain socio-moral-ethical responsibilities that you may or may not be able to meet. Last winter I set out for town after a particularly vicious blizzard only to discover Cotter Creek Road socked tight with a quarter-mile-long drift blown in like concrete. My approach was from atop a long hill: On the far end of the drift I could see stranded cars; on the near end I could see my neighbor pecking away with an old International tractor and a straight blade. In order to operate he had to push the snow into the ditch at an angle, back up, reposition, and carve off another slim slice. He was maybe an eighth of the way through and gaining only a few feet at a time. When he checked over his shoulder and saw

me coming, I flashed my lights and he backed off to one side. As my truck picked up speed, I couldn't help but feel sympathy for him, all bundled up on his old tractor, over-matched but doing the best he could. As I roared past, I gave him the nod, understood by a certain breed of men to convey mutual understanding and cool competence. At full velocity, I dropped the blade and angled it sharply for maximum snow displacement.

Some things I suppose you should see coming. But so caught up was I in humming the theme to *Underdog!* that it never occurred to me that the *snow* might displace the *truck*. The density of the drift was such that when the blade made impact, the angular force shunted the front of the vehicle violently aside, then spun it right around. I went from sixty to stuck in a split second and sat there poleaxed. The undercarriage of the truck was so jammed with snow that even in four-wheel drive it took me a while to rock it loose. When I finally backed meekly past my neighbor, he was apple-cheeked and grinning from his tractor seat. I didn't want to, but I rolled down the window. "You havin' fun?" he said.

"I did not see that coming," I said, and slunk home.

Another time Jane and I were on the way home from the feed mill when I spied a FedEx truck parked out by my neighbor's mailbox and the deliveryman jogging

a package down the long driveway, which was impass-
able with unplowed snow. My neighbor is on the road
even more than I, so I figured this was my chance to do
him a good turn. When Jane asked why we were turning
into Mr. Justin's yard, I grandly explained that by gosh
around these parts when we see the neighbor needs help
we don't wait for the call, we *act*. As the FedEx man
pulled clear, I lowered the blade and blasted a path to
the house, then turned around and blasted my way back
out. As we approached the road I had that Boy Scout
chest-swell sensation you get when you do a good deed,
until I checked the mirror and realized I had missed the
driveway by about six feet and was leaving in my wake
a sod-clodded snowbank garnished with lawn peelings.
On the way home I concluded the day's moral instruc-
tion by reminding Jane that nothing is more déclassé
than drawing attention to your own good deeds, so we'd
just keep this one to ourselves.

Throughout the course of winter the hill-fails accumu-
late. Neighbors coming to pick up Amy, sliding down the
hill backward with a car full of grade schoolers. A busi-
ness meeting canceled. A neighbor bringing her chil-
dren to visit forced to make a Y-turn in the middle of
the hill . . .

I track it all in a chart.

It's not the plowing. We've always been well served by the plow crews, but this winter the township has stepped up their activity noticeably, plowing early and often, and spreading sand so thickly it's like Daytona Beach out there. We frequently meet up with the plows in the turnaround, and I'm always worried that they've been warned about the guy up here who's been pitching a fit and demanding early plow-outs. I am especially paranoid because plowing is an often thankless job—they never get out soon enough to satisfy everyone, and the stories you are likeliest to hear are about how they creamed someone's mailbox, or sideswiped the garbage cans, or lurked around the corner until someone cleared their driveway before roaring out of nowhere to blast it shut again. So desperate am I to remain in their good graces, I often overwave when I see them. At one point I simply cut to the chase and stop by the town shop to leave cookies and a thank-you note.

I handed the cookies to the town clerk, who, much to her credit, didn't dive behind the counter when she saw me darkening the door. I had stopped peppering her with e-mails after she quite rightly pointed out that there really wasn't anything she could do at this point and that I should rather maintain communications with the county commissioner. The clerk's husband is a sheriff's

deputy on the graveyard shift and we sometimes wind up on scenes together. The other night, after we had helped load a patient and the ambulance siren was receding, I took him aside and apologized for my obsessiveness and said I hoped it was clear that my issue was with neither the town nor its plows, but rather with the commissioner's redesign, and that I hoped he would tell his wife so. He said he would and was as soothing as a large man with a gun can be.

Then the other night I attended my monthly first-responder training and found myself paired up with a fellow first responder and firefighter who moonlights as a snowplow operator assigned to our area. During a break between CPR certifications, we were standing next to the fire truck when I got up the gumption to tell him I hoped the crews knew I wasn't pushing for earlier plowing, and that in fact I was grateful for how much extra attention had been paid to the hill in the wake of the changes.

"Don't worry about it," he said, gruffly. "We know what's goin' on there."

This was an immense relief, and I thanked him for his understanding. Later that week, just to prove he didn't play favorites, he blasted my recycling bins so deep into the woods that they won't be available again until spring.

On another snowy afternoon, Anneliese calls Arlene and asks if we might come over with supper. Although Anneliese has known the Hartwigs since she was a child, we rarely ever drop in without first calling. You learn pretty quickly that the Hartwig farm—Tom's shop and Arlene's kitchen in particular—is a nexus of characters and conversation, and the couple won't be shy about letting you down if no reservations are available. No, not tonight, Arlene will say, the Schmidts are visiting. Yah, not this morning, Tom will say, Frank Henderson's comin' over and I'm gonna turn a bushing for his combine. And more than once I've called to verify that the coast was clear only to arrive and discover that someone else had showed up in the interim. If you like Tom and Arlene Hartwig, you will have to share them.

Tonight, though, their social calendar is open, and so we are at the kitchen table again, this time seated around the remnants of a baked chicken and salad. Tom has been telling stories about Chester and Lester and the oxcart. On the kitchen wall just above his head, there is a photo of a younger Tom on the cart with the two oxen in harness. A little boy is sitting beside him. It is either his nephew or his

grandson—he told me once and I can't remember, but I don't want to interrupt the story.

" . . . and a team of oxen pulling a small cart runs at an average speed of two miles an hour. How I know that is from here down to that overpass is a mile, and when I used to take them down there and back, if nobody stopped to talk to you, which wasn't very often, you'd be gone an hour."

Looking at that photo then, I'm curious about what kind of granddad Tom might have been. His grandsons are long grown and live many states away, so I have little to go on. With Jane and Amy he is friendly (and of course the first to offer Jane the M&Ms) and he'll show them things like his blowfly-powered doll, but he isn't a "gather round for story time, children" sort of guy. Even now he has switched gears from his own story to one he read in *Small Farmer's Journal* a while back about the woman who, along with her husband, two children, and their small scatter of cattle, joined a train of seventeen ox wagons in an emigration from Iowa to Oregon in 1847. "She kept a journal along the way," says Tom, "and in the eleven months it took to make the trip, she buried her husband and both children. The cattle lived."

He pauses, then says, "But, I mean . . . people don't realize the hardships."

Perfect, I think, that Tom's stories are not told *to* the children, or *for* the children. There is that meddling-parent part of me that wants to prep Amy prior to our visits (at this point, it's tough to get Jane to focus on the historical implications of anything other than the Milk-Bones and the M&Ms jar), tell her to be sure to pay close attention to all the wisdom and history, but I try not to harp on it. You can't cram these things down their necks. My dad never told me, C'mon, we're going to visit the Carlsons in their kitchen so you can learn something.

It's enough, really, just to let him go. When Amy picks up Oscar Underfoot and begins to pet him, Tom launches into a story about the time the cat brought a live chipmunk in the house and how it got to ripping through the curtains, and from there he segues into the story about the skunk in the basement, the one that dug a hole under the wall and hibernated all winter, until a warm spell in March, when it woke up and strolled up the stairs, through the kitchen, and out the door. Unable to pass within fifty yards of any animal without getting a case of the *awwws*, Amy is now paying close attention as she cradles Oscar.

"Yah, and when I was a schoolboy, I captured a crow," says Tom. Anneliese and I have heard this one a time or two, but the girls haven't.

"We didn't know whether it was a male or female, so

we named it Ginger. We kept him in a cage that first sum-
mer, and every time I'd go by I'd say hello. And that crow
would bow and he would say 'Hello' back, just as plain as
day. *'Hel-loow, Hel-loow.'* After that first summer we let it
go and it would sit out here in the trees, sayin' *'Hel-loow,
Hel-loow.'* Old Oscar Hibbard lived across the crick over
here, and he didn't know about that crow and they had a
big oak tree growin' by his barn, and one day after I told
him about Ginger, he said, 'By God I thought I was goin'
nuts! I'd come outta the barn in the morning and there was
a crow sittin' in the tree and he'd say hello to me! I didn't
say anything to anybody, and then one day my wife says,
"Do you see that big black bird that waits in the tree every
morning and says hello?"'

"The school was right over there, and that crow never
missed a noon or a recess. The kids would be hollerin'
and yellin' and he liked a lot of excitement. We had him
around for five years. He'd always roost in the woodshed
and the wild crows wouldn't have anything to do with
it I suppose because it smelled like Man. When he was
hungry he'd come and land in the window and he'd peck
the window. And you'd go out there with hamburger and
as fast as you'd hand it to him he'd take it, and when he
couldn't swallow any more, he'd start pouchin' it, like a
pelican.

"But anyway, when he was comin' or goin' from the school one day, someone shot'im."

"*Oh!*" says Amy.

Tom is sitting quietly, looking at his hands. *Reflecting on the memory*, I think. Turns out he's just mulling a tangent.

"I've observed that starlings can mimic other birdsongs, and I think if you got a starling young, you could teach it to talk."

Snowstorms big and little come and go, and time and time again we find ourselves out of our cars at the side of the road in the worst conditions, or leaving vehicles parked at the neighbor's house at the base of the hill so they won't be cluttering the shoulder. I have stopped calling the commissioner and instead just keep adding to my master list of incidents with an eye toward the review come spring.

Sometimes I fear I am turning into a ranting one-note loon, but recently I obtained backing from an unimpeachable source. The last time our farm was a fully operating dairy operation was in 1978, when the Starkey family sold out and moved to town. One of the Starkey boys (the "boy" is a grandfather) who grew up on the place still turkey

hunts out here (every year he kindly thanks Anneliese and me with a restaurant gift certificate and is thus responsible for roughly 50 percent of our annual dates), and when he told us his mom was still alive and living in town near the post office, we resolved to visit, mainly to introduce ourselves and satisfy our curiosity about some of the history of the farm. After welcoming us into her living room, she told us she moved to the farm in 1950 after marrying her husband, who was raised there from a boy. Mrs. Starkey was happily animated during our conversation, and it was fun to fill in the blanks as she reminisced and described how things were back in the day, allowing us to reset the scene in our minds. Toward the end, I indulged myself:

"You ever have any trouble gettin' up the road there?"

"Oh, ho, *ho!*" she said, in the jovial affirmative. "We used to go up to the corner and then fly up!"

Then she looked at me quizzically. "But you can't do that anymore, because they got that . . . that . . ."

"Yah," I said.

"Why did they ever do that? I couldn't believe it when I saw it. I'm glad they didn't do it while we lived there."

The conversation moved on then, to who used to live where and how the Starkeys were related to the Galdens and when it was they stopped using the windmill and the old well, but I might have missed some of it because I was

nursing up a little self-righteous fever over how we disregard the accumulated wisdom of the elders at our peril. First the farmer at the initial meeting, then Tom the first time he heard about it, and finally the woman who lived at the top of the hill for nearly thirty years—they all knew why the intersection needed to be straight, but then they had received no formal training in highway design and furthermore were not consulted.

Tread water in the seas of bitterness and you will eventually slip beneath the pinched and serrated waves, so thank goodness for a snow that fell like today's: softly, steadily, and lightly, stopping just as darkness arrived, so that the final visible image was the countryside tucked beneath a comforter. The steadiness of the precipitation meant that the hill was unattainable for most of the day, but any peeve I might have felt is at this moment evaporating in the warm roar of the pickup truck defroster as my daughters and I set out to clear the driveway.

Among the unanticipated joys of parenthood, snowplow time is a top-tenner. Amy sits belted beside me; Jane is strapped in her safety seat next to the door on the passenger side. We make the first pass out the driveway as if embarking on a grand adventure, coddled pioneers pushing through the untracked whiteness toward civilization, the

girls giggling giddily when the snow overflows the top of the plow and sweeps across the hood into the windshield, so Dad is temporarily driving blind. I let out with a theatrical "Noooo!" and tap the brakes so the snow reverses course. The audience claps and bounces, their smiles half-lit by the green glow of the dashboard lights. We jounce and scrape along, the snow rising off the canted blade to curl before the headlights like a perpetually surfable wave, falling to invisibility at the edge of darkness. When the long return run of the driveway is done, we switch to clearing the area before the garage, relishing the rambunctious back-and-forth bumper-car nature of bashing into snowbanks and reversing to make another pass.

It was during a snowplowing session that I first taught Amy to use the heel of her fist and tips of her fingers to make miniature footprints in window frost. It is during snowplowing sessions that I see her—teetering uneasily on the cusp of adolescence—happily back at being just a silly little girl. And it was on a night when all three of us were running in the plow truck that Jane spoke her first intentional word. It was her first winter, and she was on the verge of language. One evening I carried her with me to my office on an errand. The moon was bright, and I stopped to point it out. "Moon!" I said. She puzzled on it a bit, then said, "Mwooow." We practiced some, then went on our way. The

next day it snowed, and after supper the girls joined me to plow. We were bombing along and bouncing around when suddenly Jane began clapping her mittens and pointing excitedly. "Mwooow! Mwooow!" she said, and sure enough, right out her passenger window, there it was: the moon, rising over the ridge.

Nowadays she's full of jabber, and between the three of us we are having a fine old verbose time when I clear the last swatch of snow. Wanting to prolong the moment, I turn the truck around and we make one last touch-up pass out the driveway and back, the blade rumbling over the asphalt, the warm air blowing, the world beyond our headlights irrelevant, nothing else mattering but this shoulder-to-shoulder moment.

February 26. I am working in my office when an e-mail pings in. It's from a friend I haven't seen since college. A few weeks back, he writes, he was in the area and wanted to visit. He didn't have my phone number and it isn't in the book, but someone told him where we lived. He had driven out this way, but after sliding off the Starkey Road hill several times, he gave up. I open my ongoing Starkey Road file and add him to the list. His makes the fourteenth known

incident since October, and we haven't made March. *We can revisit it in the spring*, the commissioner told me back there when I was splitting the firewood we've mostly burned through by now. *Spring, schmring*, I think. If not for the gift of extra credit, I would have pulled a struggling C in my college statistics course, but I believe we have accumulated what the experts would call a representative sample. I go online and check the county website, then place the next highway committee meeting on my calendar.

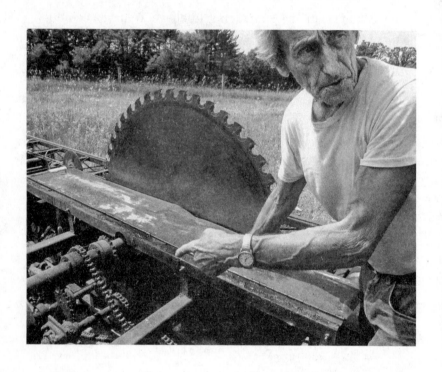

CHAPTER SIX

This is the most complicated thing I ever built, he says, hands on his hips as he stares at the sawmill. Took me two years. Two winters. We went out and looked at about twelve sawmills before we built this one. There's over a hunnerd pounds'a welding rods in that thing.

The sawmill is mounted on a set of old truck wheels and balanced by seven screw jacks distributed fore and aft. From tongue to tail it is forty-five feet long. A gangly boom projects out at a right angle and terminates over a pile of sawdust that has been swept there by the paddles on a droopy chain. The shine of the blade is dulled by a thin dusting of rust. Milkweed plants and ragweed are growing up through the slab rollers. The sun has been out just long enough to warm the surface of the slab pile, and you catch the scent of stale pitch.

Fella had some sawmill parts that had been lying in his iron pile for forty years and I gave him seventy-five dollars

for those. That included the arbor and the wheels. All the rest I built. He lifts away a hinged piece of sheet metal to reveal the guts of the mill, and now he's describing the minutiae, how he set up the clutching mechanism with sheets of Masonite and two truck tires that roll against each other, how he built the keyed hubs on his lathe, how the roller chain setup is intended to counter the negative effects of torque, how the push stick he uses to run the log carriage back and forth is hooked by means of an iron wheel to a setup that engages a Chevrolet transmission hooked to the rear end of a Ford Pinto, which in turn rotates a cable drum that pulls the log into the saw or runs it back when you throw the stick the other direction . . . You're trying to follow but all you see is a maze of shafts and bolts and roller chains and grease-caked bearings and flanges. In Tom's head, it's all laid out real clear.

Where I used to figure a lot of stuff like this out is while I was milkin'. I would visualize these projects. And then a lotta times at night you'd be out in the shop there and you almost had the idea of what you wanted but it wasn't quite there and finally you say the hell with it and go to bed, the next morning you'd get up, and you had it.

There was 250 pieces we cut and welded together on this frame. I used hollow tubes and trusses because I wanted a frame that was real rigid, but not heavy. 'Cause

you take heavy items, when the sun shines on there it's got a tendency to expand and then distort. He lets the sheet metal bang back into place. Yah, before I did this, I thought on it for six months. One mistake I made, I cut the grooves backward on that cable roller. Wound up havin' to take the cable off the bottom instead of the top and consequently had to raise the roller so it would clear.

So sometimes you just have to dive in, eh, Tom?

Yep. You can read all the books you want about how to ride a bicycle . . .

The photographers are positioning him so that the sawdust pile will appear over his shoulder.

When I had a hired man, we used to go out with the mill. The whole thing is portable. Takes about an hour or two to set it up, then another hour to get it level. You have to get it level. In the spring of 1982, we sawed 25,000 board feet in one sitting. In April of that year we went up by Allen with the mill and sawed another 15,000. But I never sawed very fast. I had a guy one time, he said, there's other sawyers a lot faster than you. We had a big ol' tree on the mill at the time. I told him, it took that tree a hundred years to grow to that size, I figure I can take my time to get the most out of it.

I don't saw much now. Just little piddly jobs. It's dropped way off because you've got a lot of these little

band-saw mills. The other thing that cut down on a lot of this home lumber sawing was pole sheds. Guys used to saw lumber and make a shed. Now it's just poles and tin.

WHEN THE FIRE CALL CAME in last night the fog lay thick as wool batts over the land, and despite the sound of sirens behind the radio chatter I was forced to drive at a crawl; even on low beam the headlights fixed themselves as pillars of haze just four feet off the bumper. I was on scene until 3 a.m., where with other first responders I helped treat and monitor worn-out firefighters before releasing them back to active duty. Now, after what seemed the briefest sort of nap, I am back on the road. It's just after 6 a.m., a fact verified not only by the dash clock but by the late Kate Smith, who is currently belting out the first verse of "God Bless America" on Moose Country 106.7. As long as Jay Moore is in the chair, every day begins with Kate. Then you get a Mac Wiseman song. After that, a country music single likely once available on an eight-track, and then your day is under way.

Visibility has improved, but the air is still heavily saturated with a headlight-blunting mist that hangs a halo around the neighbor's yard light. Although the tempera-

ture is above freezing, I'm driving in cold-weather posture, hunched inward and shivering, holding the bottom of the steering wheel in an underhanded grip, forearms pressed against my thighs, elbows pulled tight into my sides, all in an attempt to consolidate body heat until the car heater kicks in. The shivering is due partly to the cold seat and partly the lack of sleep, but above all it is nerves: I am driving through the predawn darkness to make another appearance before the highway committee. In short, I am feeling underpowered.

The road along this stretch meanders a ridge for several miles. Just before the turnoff that drops to lower altitudes, I round a curve and the horizon flares up in a great fog-fuzzed dome illuminated from below by acres and acres of parking lot lights. The lights stand on several square miles of black-top covering land that used to be a farm belonging to Tom Hartwig's grandmother. When the interstate came curving through, the writing was on the wall and the developers were knocking on the door. "We debated hangin' on to it," Tom told me once, "but by the time you woulda paid for the improvements and the roads they woulda had to build there . . . and you woulda got the tar taxed outta ya because it woulda been taxed on potential value. Plus we were pretty sour on trustin' anybody because of the dealings we had with the state, so in 1967 we sold it. Grandma died that year."

And so the farm became streets and subdivisions, apartments and office buildings, and—eventually—the site of a shopping mall. Up until very recently, the development stayed on the north side of the interstate. Then they installed a roundabout and put up a Gander Mountain on the south side. And now this year earthmoving equipment showed up in the farm field beside the Equity Livestock sale barn at the end of Cotter Creek Road and set to transforming the field into a maze of fresh blacktop cul-de-sacs, two-story apartments, and an illuminated waterfall installation anchored by a sign denoting the new development as "Prairie Park," continuing a time-honored tradition of naming things after what has been displaced. This is not an original observation, and in fact I have elsewhere noted that I grew up in Chippewa County, named after the Ojibwe tribe long ago sent packing, but I do think it would be a lovely kick to just once drive past a *faux* gold-leaf wood-carved sign welcoming you to Pulverized Pastures, Obliterated Pines, or Dozered Clover Drive. Now that the livestock sale barn stands adjacent to "Luxury Town Homes," I have to assume its life expectancy will depend evermore on cattle futures and the persistence of prevailing winds. None of this is a surprise—the land has been for sale for some time now—and because the location is less than a mile from the intersection of an

interstate and a four-lane state highway, it's frankly more surprising it has taken this long.

As I turn off the ridge road and descend into thickening fog, Mac Wiseman goes chopping off into "Rovin' Gambler," meaning the highway committee meeting begins in less than five minutes. The car is warming up but I'm still shivering.

I wish I had better known Tom Hartwig's mother. Her name was Olga, and I met her once, just before she died after breaking her pelvis at the age of 101. Anneliese had taken me up to Olga's little cottage behind the farmhouse and we visited briefly, Olga wearing sunglasses as impenetrably dark as the lens in a welding helmet. Later I learned she had a degenerative eye condition and wore the glasses inside and outside, and that the eye trouble was dispiriting for her as she was a retired schoolteacher (all of those years spent in a one-room schoolhouse) with an everlasting hunger for knowledge, and reading was her greatest source of comfort. When her eyes failed, Tom and Arlene set her up with an account for recorded books. "She wore out a half a dozen tape players," Tom told me once. "She never listened to fiction. One of her favorites was Stephen Hawking. And I

remember her being very intrigued with an autobiography of Winston Churchill."

It is difficult to overstate Olga's determination for intellectual self-improvement. In 1926, wanting to study European history at the source, she saved enough money to make her way from the Wisconsin farm to New York City and, after a ten-and-a-half-day third-class sea voyage (in her journal she described how her quarters pitched and tossed and smelled of creosote), she arrived in Oslo and began a three-month journey that would take her to Switzerland, Pompeii, and the ruins of the Roman Forum, where—again, according to her journal—she boosted a piece of marble. When filling out her official travel papers she described herself as having a long face and a Roman nose, and from our one visit I do recall that she and her son shared the same sharp features. I also spoke with her just long enough to get a sense of her responsibility—both genetic and instructive—for the omnivorous inquisitiveness so prevalent in Tom. Once when Tom was showing me a little distillery secret in a back room, he reached into the corner and pulled out a large telescope. "My ma bought this when she became interested in astronomy," he said. "She'd take us out and set it up and teach us the stars. We could see the craters on the moon, and some of the moons of Jupiter." Then, in a classic Tom coda, he chuckled and admitted that he also used it to spy on the neigh-

bor's cattle: "Course, in the telescope, the cows were all up-side down." (Tom's political ambiguity can also be traced to Olga, who so despised LBJ that she taped his photo to the underside of the outhouse toilet seat but also once named a voluble rooster Ronnie not only because his shiny black tail reminded her of Reagan's pomaded hair, but mainly, she said, because "he crows all day and says nothin'!")

Tom tells me that when his mother was a young girl, she used to climb the ridge out behind where the Office-Max is now and pick trailing arbutus. Over time the ridge has been shaved away a section at a time to make room for a Best Buy, a Michaels, another parking lot, another road, and a Buffalo Wild Wings, until now not much remains but a brushy knob overlooking the Borders turned Books-A-Million. The trailing arbutus is a flower that thrives in the presence of oak trees. I think of this whenever I see the exit sign for the Oakwood Mall.

When I enter the highway department meeting room I slide directly to my right and position myself behind the commissioner in the very chair I occupied while waiting to testify the first time. It's a small thing, but occupying the same seat provides me a measure of psychological orienta-tion. In pursuit of comfort we operate from habit at the earliest opportunity.

There is the standard call to order, the approval of previous minutes, and the review and auditing of bills. There is some discussion of how economic woes have affected sales tax revenues and possible negative effects on the department budget. There are doughnuts. And now the clerk is indicating it's my turn to speak.

In what could be a case of bringing a sledgehammer to a xylophone recital, I have prepared several copies of a neatly stapled seven-page report including a section titled SUMMARY OF PREVIOUS CONCERNS, a three-column table of INCIDENT DESCRIPTIONS (arranged in chronological order and including time stamp and relevant meteorological data), and a series of eight full-color photographs with explanatory captions appended. For the moment, however, I keep the reports in hand, on the hunch that if I pass them around everyone will be shuffling through the pages and not listening to me. With only five minutes to make my case, I figure an undiluted verbal tsunami is my best option. And so, after brief pleasantries, I try to ignore the hummingbirds in my chest, suck a deep breath, and—using one copy of the report for reference—dive straight in.

"In the last decade there were zero times that we couldn't make it up the hill. The number of known incidents that we've had on that hill in the five months since the road was changed is over fourteen. The minimum num-

ber of vehicles that we've had involved in the known inci-
dents is nine. I included that so you know I'm not talking
about one vehicle with bad tires or something."

I am already starting to suck wind, and so consider it a
favor when a committee member breaks in. "So it's not just
your wife having problems?"

"No, but that's why I'm here. This is not about me. I
could walk up that hill. It would do me some good. But I'm
on the road eighty, a hundred days a year and my wife is
stuck there alone."

I check the clock: over a minute gone already. Now I re-
ally get going, speaking almost without punctuation, trying
to cram as much into my five minutes as possible. I'm not
speaking rapidly, but steadily. I've also adopted a flat mono-
tone in a conscious effort to keep things in the lower register
and quaver-free—no Dennis the Peasant. Running one fin-
ger down the report, I begin ticking off specific incidents,
first describing the babysitter situation way back in October,
then recounting the night our friends Lori and Buffalo were
stranded at the bottom of the hill, then relating how my
sister-in-law wound up in the snowbank, and on down the
line. Now I am talking faster, and through the combination
of speed and nervousness I occasionally skip or swallow a
word. My mouth feels as if it is filled with spackle. I press the
report flat against the table so it won't vibrate in my hands

like a leaf trapped against an air conditioner intake. At one point I make a little joke about the loss of county sales tax as a result of a customer not being able to make it up the hill to buy one of my books and how this might affect the bridge-building budget, but it drops with all the reverberation of a ball of putty. Checking the clock on the wall and realizing I need to reserve time for the photographs, I go shorthand: "February 2nd carpooler woman came up, slid out, had to Y-turn, go back home . . . February 5th same deal . . . February 8th she just called from the base of the hill said I can't make it up the hill just come down . . . February 9th, carpooler, again, halfway up the hill Y-turn, slidin' down . . ." When I notice I'm nearing six minutes I cut myself off mid-sentence and switch to the visuals.

Above all I try to use the photos to drive home the point that the snow is only an inch to two inches deep when the road becomes impassable and snowplowing is not the problem. To illustrate this I supply pictures of my fingers stuck in the snow beside the spin-out marks. In one photo the snow is no deeper than my first knuckle; in another it falls just short of my wedding ring.

I close with the two shots taken early on a Sunday afternoon. We were returning from church when the van spun out halfway up the hill and slid sideways into the opposing lane. In the first photo, Anneliese is visible through the

windshield, walking up the hill, Amy just ahead of her and Jane in her puffy snow jacket, clinging to Mom's hand. The final photo is of my boot, shot from above to illustrate the fact that the slush was no more than half an inch in accumulation. To the right of my foot the spun-out tire tracks are visible. To the left, the much tinier footprints left by Jane as she hiked off uphill. I hold the photo up and address the commission as a whole: "The bottom line is, we can talk about safety, but that's my two-year-old, walkin' up the snow-covered slippery hill after church with who knows what comin' down the hill . . ."

I admit I'm probably—as my friend Frank often tells me—*peggin' the ol' wank-o-meter.* Really, all that's missing is a big-eyed kitten playing a blue violin. But if you've got an ace combo (a toddling child . . . tiny footprints in the snow . . . *after church*) well, shoot, you gotta flop those cards, especially in light of the commissioner's contention that the hill is regularly terrorized by tearaway racers.

I conclude by raising an issue that should have occurred to me long ago but hadn't struck me until I was slowpoking my way through the fog last night: What happens if we need an ambulance—or a sheriff's deputy, or a fire truck—on a snowy night and they can't make the hill? And then finally, as if disembodied, I hear myself say, "Those are my concerns, respectfully submitted."

Sitting there lightheaded and still trembling, my one coherent thought is: *Seriously, son . . . did you just say "respectfully submitted"?* It just kinda blurted out on the order of some guy who appears on *Judge Judy* to sue his ex for back rent and a set of speakers and drops a non sequitur legal term in an attempt to convey gravity.

The discussion that follows is wide-ranging. Much of it is consumed by the commissioner and me reexplaining our positions and logistics, especially for those members who haven't actually been to the intersection. The commissioner reiterates that the main reason for changing the intersection is to prevent people from coming down the hill and entering the intersection at reckless speeds. I counter by saying that if your primary concern is people speeding down the hill, then you don't want also to create a situation where people are regularly hung up or walking in the middle of that hill.

"Right," says one of the committee members. "But if there's only two families up there, then there aren't that many people coming down the hill."

Under pressure of extreme cognitive dissonance, my left eyeball nearly uncorks itself.

Another committee member—this one with a pronounced farmer tan—speaks. "It sounds like one of those cases where you look in the book and it tells you how to do

it, but maybe the book is not exactly right because of the situation involved." I want badly to dive over the table and hug him but that tan line suggests otherwise.

"Were there any accidents at that intersection before we changed it?" asks another member.

"I don't believe so," says the commissioner. Then once again he reiterates that the concern was people coming down the hill and not stopping.

I bring up the yield sign and suggest it be replaced with a stop sign. "If someone doesn't stop at that point," I say, "then they're just breakin' the law."

"Well a sign is a sign," says the commissioner. "It doesn't matter if it's a yield or a stop, they're gonna treat it the same usually."

This narrows my eyes some, and I feel the snappishness coming on. "Well, I would argue then, why do you bother putting up controlled intersections at *any* point?"

The commissioner pounces, in the tone of *A-ha!* "That's a very good question, because there have been some studies that found they are more safe without the sign."

I just stare at him, but inside my head Dennis the Peasant channels Jim Carrey: *"Re-hee-hee-heeaally!"*

In the commissioner's defense, I recently read an article posted on the website of the *Atlantic* magazine reporting that after traffic engineers in the Netherlands

experimented with removing the traffic lights, signs, curbs, and lane markings from certain urban intersections, safety and efficiency (between drivers, bikers, and pedestrians) actually improved. The commissioner is quite understandably trying to establish the fact that *Hey, I know something about this stuff. It's not all as obvious as you think*. And in this he has my sympathy. Anyone who operates at some level of esoteric knowledge—be it a nurse, a diesel mechanic, or a dancer—will recognize his frustration, which is triggered by a variation on the theme of mocking what we do not understand. *Why do you send all those fire trucks to a one-car accident?* say the bystanders, not realizing that several of the trucks are there to act as safety barriers for the vulnerable rescuers. *I can't believe you charge that much for a cup of coffee,* say uninitiated customers to my friend who owns a groovy coffee shop, not understanding he's not charging for coffee, he's charging for groovy. *I don't know why you shave your legs,* people used to tell me when I raced bicycles, *there's no way it helps you go that much faster,* not understanding that the shaving had nothing to do with speed and everything to do with the fact that after you hit the asphalt at 45 miles an hour, it's easier to clean and dress a wound that isn't matted with leg hair (it also had a tiny bit to do with how shaving helped your chiseled calves catch the sunlight, but let's not lose our focus . . .).

Still: The Dutch traffic idea has been tested mainly in cozy plazas and village squares—it's hard to conceive of its application on American highways and byways resulting in anything less than a charnel-fest on wheels. I suspect the commissioner's response is less a reflection of his forward-looking commitment to contemporary traffic management philosophy than his peevish belief that I am a persistently irritating human speed bump, and fair enough. For my part, I half form a retort suggesting that he put his money where his theory is and start yanking every stoplight in Eau Claire County, but I recognize this as testosterone-driven thinking powered by blood pressure and settle for pursing my lips like a skeptical three-year-old.

"I really would like to see something done," says a commission member at the far end of the table. "Even though it's not ideal as far as the highway engineers' manual."

The commissioner is looking a little strained.

"Well, I had agreed to look at it in the spring, and I plan to do that."

When I leave the meeting, I head directly to the aforementioned coffee shop, jonesing for a cup and a quiet place to write. I don't deal well with reality and am happiest within my own head. Events that pull me from the keyboard are always a reminder that while people like me float through

life ruminating and guessticating and pining and trying to *shape the narrative,* folks like the committee members around that table get out of bed at 5 a.m. to attend meetings on the behalf of the rest of us to discuss everything from bridge graffiti to guardrail-replacement policies, and to make decisions that rarely achieve notice unless somebody's not happy. Theirs is the plain, boring work of functional government, stratospheres removed from all the Technicolor barking of politics. My five-minute session was allowed to stretch well beyond fifteen minutes, and as I stood to leave, one of the more jocular committee members offered me a doughnut. I wouldn't be in there with my seven-page report if I didn't believe the commissioner had made a mistake, but I also wonder about the people around that table—the commissioner included—and if they see me as a needlessly obsessive yahoo throwing sand in the gears of the day.

In the middle of May I receive an e-mail from Amy's father, Dan. Grammy Pat is back in the hospital. Shortly thereafter he e-mails again to say she has returned home under the care of hospice. A week later the phone rings in the evening and it is Dan with the news that Grammy has died. Amy

is preparing for bed, and in light of her longtime tendency toward anxiousness at sundown, Anneliese and I opt to tell her the following afternoon in the full light of day. Thanks to Dan's regular communication, Amy has known this day was imminent, and when we sit with her in the living room filled with sunlight, she takes the news in stride. We buy plane tickets, leave Jane in the care of my parents, and fly to Colorado.

Everyone converges on Grammy's house and, truth be told, in between the necessary preparations we have a nice time, kids running every which way, adults cooking together in the kitchen and visiting. As the stories circulate, it is a chance for me to come to know Grammy quite literally by the numbers: Born in 1933 and married at the age of twenty-four, she taught school in Denver for three years before her first child arrived in 1960. In 1963 the young family moved to a farm and by 1970 the children numbered five. Then one night Grammy and her husband went out for a rare dinner with friends and on the way home their car was struck by a drunk driver. Grammy was badly injured and her husband—the man Amy would have known as Grandpa—was killed. Grammy Pat never remarried, and instead threw herself into running a farm and raising five children, all of whom wound up well educated and successful. After the children were launched, Grammy did not

slow down. This is not conjecture, because Grammy left lists, and we've been reading over them today: Over 270 musicals and other stage performances attended; 19,387 recipes attempted and only one classified as "a total failure"; 1,800 books read and neatly totted up in a journal, the final entry inscribed only weeks before her death. Somewhere in the neighborhood of thirty-five foreign countries visited, from Cancún to Croatia. And for those fatherless children, ninety-three birthday breakfasts served in bed. The family has put together photographs to be displayed on an easel in the foyer of the church, and what you see is a woman of nearly six feet who carried herself always with dignity, whether scrubbing vegetables for the county fair or giving her children in marriage one by one until the photographs became crowded with new smiling generations, including our Amy.

At the church, Dan and Marie and Anneliese and I arrange to sit together in the pews. Outside the church Amy has been running and playing in the sun with her cousins, and we are in the midst of the service before she finally crumples with tears and turns from the side of her fathers to the arms of her mother, a testament to the power of the feminine line. When finally she unburies her face from Anneliese's breast and turns her eyes to mine, I am crying and begin to avert my face. Then I think, *No*. She must

feel the strength of women and see the tears of men. Later, when we are together going through photo albums, including those documenting our visit in January, there is much laughter, and as I consider our situation and what it might have been as opposed to what it has become, it occurs to me that to all our other bonds our blended little bunch may now add grief.

Any reaction I might have to the appearance of apartments in a hayfield is tempered by the sight of a plumber's truck parked at one of the units under construction. That plumber has more than once come to our house on short notice and saved my incompetent bacon with quality work. He is a local fellow and a former classmate of Anneliese. More to the point, as a fellow self-employed person I can imagine it was welcome news the day he got the bid for the apartment job. Somewhere along the line we're all looking for some balance that will allow us to honor the past without strangling the future.

I have a desire to contain history that regularly drifts into the inane. Five years ago my father called and told me he was going to tear his silos down. I leapt into action, contacting barn restorers to see what the market might be for the remnants and recruiting my buddy Mills to assist in the salvage. These weren't your standard concrete-stave silos. They were

wooden, and marvelously constructed from laminated strips of lumber nailed together with thousands of meticulously placed nails and even more thousands of hammer blows. When I heard the silos were going down, the first memory to mind was of shoveling silage early mornings before deer hunting and seeing the fuzzy buttons of frost on each nail head. Dad used the silos only a couple of years. Mostly they stood empty, and we used to scare ourselves by climbing up inside them and then looking down from atop the pigeon poop– and bat guano–laden platform that joined them. The sense of vertigo was heightened by the fact that each had a five-foot-deep concrete-lined pit dug in at the base. The roof above the platform was very low, and if we crawled around up there during the day we'd hear the *gritch-gritch* of disturbed bats, which made us duck even lower.

Shortly after Dad called I drove to the farm and clambered up the cobwebbed ladders (hearing the bats squeak, I placed my hands on the rungs with care) and took digital photographs of everything I could: the handmade swinging silage doors, the patterned nails, the wobbly railing supposedly securing the platform, the concrete pits viewed from far above. By the time I shot the photos I knew the silos were coming down and the pixels would have to do for history. I had contacted a number of barn restoration and vintage lumber folks, but my initial rush of research

eventually tailed off against the perennial headwinds of finances and time. Dad was reroofing the barn, and because the silos were attached, they had their own roof, which was beginning to sag. Dad had done the numbers on rebuilding the roof and how much the extra square footage would inflate the shingle budget, and with the year's planting to be done and the roofers coming, opted instead to have my brother John stop by with his track-hoe. In a short hour or two he peeled the silos away from the barn, buried them in a significant hole, tamped everything down, and now there's just some grass there. Upon reflection (sadly, I often require extensive periods of reflection to recognize something I should have seen in the instant) I realized the greatest kindness here was that phone call from my father. A man of great practicality, he nonetheless knew of my soft spot, and spared me the shock of showing up one day to simply see the things gone. My brothers often do the same, calling me when they find some odd historical object and telling me I can pick it up behind the fuel tank or out in the shop. When my brother Jed was logging up north and discovered a vintage sign clasped deep within the wood of a white oak, he took the time to cut it out and haul it in from the woods, and now there it sits in my garage atop the plastic tub of old boots, waiting for some future auctioneer to dispose of it.

Now and then this time of year—when the first green grass is up and the trees are leafing out—my buddy Mills will take a load of logs over to Tom's place and we'll have a sawing day. We're over there now, and Mills has brought a batch of his fellow firefighters along. It has been entertaining to watch Tom surrounded by a posse of helpers from three to six decades younger than he, all of them (including me) struggling to keep up. It isn't the pace—Tom doesn't work quickly—but rather that we young ones lack the fluidity of memorized movement. Whether rolling a log from the rack to the carriage or dropping a dog ear on the saw log after flipping it, all of us amateur helpers invest reams of wasted motion. Even standing still, some of the guys look out of place, holding a cant hook like it's their first guitar.

I take my turn beside Tom on the log carriage. The pitchy buzz of the blade and the scent of the torn bark and sawdust evoke my childhood, when we logged all winter and in the spring the sawmill came. We were always excited to see what the rig would look like this time (in those days they were nearly all some homemade variation on a theme), and what sort of character the sawyer might be. I remember most clearly Pat, whom we knew as a hearty,

humorous giant bowing his head before grace at our lunchtime table but who—as we would learn later—was in the evenings a tavern brawler known to carry women about the bar on his shoulders. He hauled and powered his sawmill with a giant Case tractor featuring a set of repurposed front tires originally mounted on a commercial airliner. Another sawyer was a pastor whose saw was powered by a roaring 327 Chevy engine. The pastor took delight in sawing at full speed no matter the help or the heat, and took visible pleasure in overwhelming the stacker at the end of the saw, a cheapish trick that even in the eyes of a young child diluted the effect of the gospel tracts he passed around when we stopped for lemonade.

Here at Tom's I have more experience than the rest of the crew, but it is far distant, and the distance shows. At one point I am working the carriage beside Tom, struggling to drop the sharp iron hook (the previously mentioned "dog ear") that pins the log in place. This is a fairly simple process: You flip a lever that loosens a threaded stud, thus allowing the dog to drop by gravity down a rail and bite into the wood. Then you snug up the stud again and off the log goes to meet the blade. Tom does this in a single, smooth motion. I, on the other hand, am yanking and struggling and generally getting everything wedged sideways. At one point I look up, and there is Tom, hand resting on the han-

dle he'll throw to engage the saw as soon as I get done fid-
dling around. He is wearing a poker face, but in his stance
you can read an indulgent patience of the sort you might
adopt if charged with watching over a dim child attempting
to jam square pegs into round holes.

It's fun to work there, though, with the countryside
greening up and the air sunlit but cool, and everyone in
the spirit of big kids on a school field trip. We're all wear-
ing heavy gloves and hearing protection and safety glasses
while Tom is a full-blown OSHA DON'T poster as he stands
midway between the devouring blade and the whirling
truck wheels that spin against each other, rubber to rubber,
acting as gonzo clutch pads transferring power from one
rattling shaft connected to a roaring Farmall to another
attached to the saw itself. The exhaust blows, the blade
howls, and the sawdust flies, and there is Tom, barehanded
and placid at the center of it, wearing nary an earplug and
squinting against the flying wood chips.

He is in his element with an audience, especially once
the wood is sawn. After the slabs are pitched and the lum-
ber stacked, he stands surrounded by everyone, his blue
Stockman Farm Supply cap at a rapper's angle, telling the
story of the fellow who showed up with a beautiful set of
logs on his trailer.

"I asked him, 'Where'd you get them logs?'" says Tom.

"An' he says, 'I cut'em from my yard.' And I says, 'Well, I won't touch'em.'"

All sawyers and loggers are extremely loath to cut up a "yard tree," since they are often secretly studded with nails and lag screws and other saw-blade-busting surprises, usually the remnants of young adventurers building tree houses, or some long-ago farmer hanging a clothesline for Ma.

The man was insistent. As a matter of fact, the more Tom resisted, the more the man insisted, until it became evident that he felt Tom was impugning his logs.

"So I told him, 'A'right, I'll do it. But you see that saw blade there? If I hit somethin' and have to replace any of the teeth, I charge you a buck a tooth.'

"And his jaw was set right out there, and he says, 'That's fine.'"

The first slab peeled away without incident. Then, on the second pass, there came a shuddering iron clank. The saw powered through, and when the board fell to the rollers, Tom shut the mill down and assessed the damage: seventeen teeth destroyed.

"So I point to that one board, and I tell him, 'See that? That's a seventeen-dollar board. You want any more?' 'Oh, no, no!' he says."

He basks in the laughter that follows.

The best story of the day, however, is the one he tells on Mills. Mills is a world-class scavenger, always on the lookout for a good deal. Way back when he was barely out of his teens, he and a buddy spotted some downed pine trees in a farmer's woods. Mills had some woodworking projects in mind and was thrilled when the farmer said they could cut up the trees and take the logs for free. Mills says he should have been suspicious when all the bark fell away from the trees while he and his buddy handled them, and that he should have been even more suspicious of the fact that he and his buddy— youthful strength notwithstanding—were able to easily lift the solid eight-foot bolts and throw them into the truck bed. Instead, not knowing anything about lumber, he drove off for Fall Creek, where he heard some guy had a sawmill.

"Oh, he was proud of those logs when he backed up to the rack," Tom says, as Mills shakes his head. But before he even got all the way over to the truck, Tom was shaking his head. "I had my pipe goin' and I told him, 'Those logs don't look no good,'" says Tom. "I says, 'They're punky.'" Mills admits now that he had never heard the term before and wondered what type of connection Tom was trying to make with Punky Brewster.

Mills also admits that he didn't want to believe this guy, and Tom must have sensed it, because he went ahead and rolled one of the logs onto the carriage. After sawing a

couple of boards, he shut the mill down and showed Mills
and his friend the worm tracks and the punk that crum-
bled to touch. Won't even make good firewood, Tom told
the boys. Still, Mills had read an article about woodwork-
ers who made distressed furniture and he was convinced
this wood would be perfect for just such a project, and he
prevailed on Tom to continue sawing. Tom didn't say any-
thing after that. He sawed all but two logs, both of which
crumbled in the process of being rolled off the rack. When
it was all over Mills had about enough for maybe half a pic-
nic table and a smallish picture frame.

Mills has told me this story before, and he says the sweet
thing is that after Tom finished, he didn't have a bad thing
to say. In fact, Mills has always told me that he's pretty sure
Tom charged him about half of what he should have for all
that trouble and worthless wood.

Well, today we get proof, because Tom records all of his
sawing sessions in a dog-eared spiral-bound notepad. And
after fishing it out of his shirt pocket and tallying up today's
board feet, he flips backward through the pages until he
comes to a scribbled entry labeled with Mills's given name
and dated 1987. The entry in the notebook shows that Tom
charged him a grand total of twelve dollars, proving kind-
ness is available in various denominations. We all gather
around to look at the documentation. Mills rolls his eyes

and laughs. "Oh, I really thought I was rollin' up with some prime lumber there."

"Weeaahhll, we straightened him out," said Tom, addressing the crowd in general, " . . . but he got quite a lot of firewood in the process!"

When the two gigantic box elder trees just yards from our house died, I had the good sense to call on a professional tree trimmer to take them down. Although I have a chain saw, and although the state of our house is such that we dream of redecorating it with a bulldozer, dropping a sixty-foot tree through the upstairs window seems a drastic starting point. When the trees were safely down, I took over, sawing them up for firewood. I began at the top, trimming the branches, then blocking up the larger limbs and eventually the trunk. When I got to within about fifteen feet of the butt end of the tree, I paused with my saw in the air. *Yard tree*, I was thinking. *Don't do it*. I held the chain saw an inch above the trunk, while visions of my father and my brother and a parade of old-time sawyers—and of course Tom—slowly shook their heads. I eyed the distance to the stump again and figured I was still above the trouble zone.

The saw didn't kill immediately, thus allowing the chain to make enough revolutions that nearly all of the teeth were stripped. When I pulled the blade from the cut, there—about

an inch beneath the surface—was a fat chunk of steel, now brightly scarred by my disintegrated saw chain. I could see only the thinnest aspect of the object, but what I could see made clear that this was no bolt or nail—it was something of heft, like thick strap iron or a section of railroad track. I didn't carve it out, so I'll never know what it was, although I did entertain a vision of some unknown kid—now in his dotage, or long gone—shinning up the tree to stow a treasure some long-ago summer afternoon, or perhaps a hired hand setting some miscellaneous chunk of steel in the crook of the limb for just a moment while stopping to attend some task that distracted him forever. It is bitter in any event to run your saw chain into a chunk of steel; it is triply so when you have paused just prior to consult the memory of your elders.

Standing there with my toothless chain, I thought of the poor guy who insisted Tom saw his booby-trapped log, and felt we might form a small hangdog club. Some are called to carry forward the wisdom of the ages; some are called to *reinforce* the wisdom of the ages.

You take your entertainment where you can get it, so today we've packed up the kids and are headed north to watch my brother burn down his house.

For a decade or so now, my brother Jed has lived in the old Carlson farmhouse, where we used to visit the bachelors Art and Clarence. The house is an old beauty, square and solid—of the type writer Justin Isherwood so perfectly describes as a "white lady." It is also impossibly drafty, uninsulated, inconsistently remodeled, fitted with a basement reminiscent of a medieval dungeon, and generally in need of a major overhaul. So this year Jed and his wife have built a new house just across the yard, and now that they're all moved in, they've invited the local fire department—on which my brothers, my mother, my sister-in-law, and I have all served—to use the house for firefighting exercises that will end only when it is reduced to embers.

Leaving our farm, we make our way down the county road to where the new apartments have gone up and turn north. In short order we navigate the roundabout, pass over the interstate and past the exit for Oakwood Mall, where if you cast your eyes to the right you will see a large maple tree marooned in a tiny clump of land just off the Menards parking lot and within view of Sam's Club and Super Target. In a drawer in a cupboard in Tom and Arlene Hartwig's living room there is a photo of that tree taken in 1916, when it would have been suitable for a fishing pole and the factory smoke from the shores of the Eau Claire River six miles distant was the only hint of change to come. I set the

cruise control now, a tad over the limit but—one hopes—
not beyond the scope of grace. Barring the unexpected, we
will maintain this speed uninterrupted until we make the
New Auburn exit in thirty-five minutes. Until recently the
trip used to run through eight sets of stoplights and take up
to twenty minutes longer, depending on how many reds you
caught, but now we can skip that and run a new four-lane
bypass.

I was living up north during the years the bypass was
under its final mapping and construction and so I was
only vaguely aware of the specifics of its route. I was sur-
prised then, the first time we ran the new concrete, to
pass through a massive cut that left towering sandstone
cliffs on either side of the roadway and then suddenly
find we were paralleling Peterson Avenue—the county
road named after my great-grandfather. I glanced to my
left and sure enough, through a cluster of pine trees and
newer houses I spied Great-Grandpa's barn. Now my
memory compass swung into place, and it hit me that
we were tooling along at 68 miles per hour over the very
corner of the field where my cousin Wade and I would
sneak off from the family Fourth of July reunion to ram
around in a sand pit with Grandpa's three-wheeler. Just
over there, behind two new prefabs and a garage, were
the remnants of the apple orchard where cousin Markie

and I played with our dump trucks. As we passed into another sandstone gap the size of a federal office building, I realized it was blasted from a ridge we used to call Blueberry Bluff. I remember climbing up there with Wade when we were tots and telling him the bears were gonna get him.

In light of my usual maudlin inefficiencies and squishy antipathies, here's what caught me off guard that day: I wasn't that bothered. True enough, I had never known my great-grandfather. Had never seen the barn in use for anything other than storage. And by the time I had memories of the place there were already a few houses popping up here and there. In later years someone built a trailer court across the road from the farm, and by the time I was stopping to visit Grandma after Grandpa died, the original farmhouse was gone, replaced by two new houses, including the one Grandma lived in. But Blueberry Bluff had still stood as a bulwark against the city lights, and the old sand-burred field where Wade and I played had still been a sand-burred field. So I felt a pang of recognition, but it didn't even rise to the level of pang I felt when the town trimmed our trees, and it utterly failed to register in comparison to what I felt the day I saw the markers outlining the changes to Starkey Road.

I can only imagine the knots I would have tied in my-

self had I actually grown up on Great-grandpa's farm, or were I one of the folks still living along the new bypass route. What I would have felt had I been watching out my kitchen window as crews carved a gigantic missing tooth from Blueberry Bluff, or how I might feel were I standing next to cows in the little red barn while watching the traffic blasting back and forth. And yet today I am the traffic. And tonight on our return trip I'll take the bypass gladly, happy to get the family home twenty minutes faster. I find myself oddly detached about the whole thing, despite my memories tied to the transected property. I suppose the intimations here speak directly to the idea of having skin in the game. I stand beside Tom's barn and ponder the benign heedlessness of the people in the speeding cars, and here I am in the speeding car. In my heart I wish the bypass had never been built; in my car I never take the old way.

On the face of it, this is a glorious day—blue sky, bright sun—but the air is cool and cast even cooler by a pushy wind. Windy enough, in fact, that in light of this dry-bone spring the fire department will not be allowed to set the first flames before 6 p.m., when the air traditionally falls still. Nonetheless the trucks arrived at three in the afternoon, and when we show up at 5 p.m., the

crews have been training for several hours, rehearsing with everything but the fire and water. They hoist ladders and practice cutting vent holes in the roof, patching the squares with plywood when they're finished. Packed up in full gear, they play serious hide-and-seek, locating each other using the thermal imager that reveals the human body as a blob of heat. They practice search and rescue, knee-crawling and finding their way to the hidden dummy in full turnout gear. The dummy weighs only 165 pounds and the newbies are flabbergasted at how tough it is to drag the dead weight, and after struggling to do so, they stand in the yard and regard one another's beer guts in a whole different light. *Good luck with that*, as we like to say.

Over in Jed's old shop, a buffet is set up on sheets of plywood laid across sawhorses. Stacks of paper plates and disposable silverware, coolers of ice and pop, and on the other set of sawhorses, tubs of potato salad and coleslaw, bags of buns, and Nesco roasters brimming with beans and barbecue. There are also several sheets of bars—you simply do not hold a social event around these parts without *bars*—the clackety plastic clamshells of store-bought sugar cookies, and a pan of brownies. When the crews break for dinner, I take a final walk through the house, snapping photos

as I go. I have the usual melancholy, although it is a degree or two removed from what it would be if this had been the house of my childhood.

Stripped clean, the kitchen is a cube of hollow stillness. The emptiness charges the air with ghostly atmospherics. I imagine myself on my father's knee, the Carlson brothers at the table, the stories of that day's plowing or rainfall or corn prices registering and then disappearing into the folds of memory, only to resurface forty years later when I stepped across the Hartwig threshold.

Through the living room then, and to the foot of the stairs, marked by a banister post the head of which has been modestly adorned by a series of bevels. The geometrics are softened by layers and layers of paint, but there is just enough uncovered roughness and imperfection to suggest that the design was carved by someone using a standard handsaw. Having passed all the way through the house now, I step out to the front porch and immediately startle at the sight of a firefighter lying facedown with limbs twisted. My heart is already pounding in the split second it takes me to realize it's the training dummy, and I have a chuckle at my own expense. Recovering my pulse, I think of an object Jed saved for me from an upstairs closet in this house: a large framed photograph taken in the days when this house was proud. In the black-and-white image, Emma

and Gustav (parents of Art and Clarence, they were long passed by the time I arrived) are standing before this very porch. The visible trees are spindly and the lilac bushes right now towering beside the porch are two small puffs of shrub. Every window in the house is dressed—even the attic dormers are hung with lace. Gustav has his arms crossed over the bib of his overalls and Emma has her hands on her hips. They look less house-proud than just happy to be there, as I imagine they were after shipping over from Norway into the scrub-brush uncertainty of this place. From where they are standing they would have been looking down the driveway toward the dirt track that brought them here by buckboard, and I imagine Emma wiping her hands on her apron and following pint-sized Art and Clarence to the porch as they rushed out to see the first automobile the day it clattered past.

Of all my recurrent emotional afflictions the powerful longing for times irretrievably passed (along the lines of the Portuguese notion of *saudade*) is the most simultaneously delicious, devastating, and useless. Standing on the porch today, I can hear the easy ebb and flow of the firefighters in conversation around the corner and out of sight, and in the white pine boughs above, the sifted hush of wind through green needles. For whatever reason, the thing that floats over me through the stillness is this vague sense of what life

can be if we just have health and solitude. And by solitude, I mean, *leave each other alone.* Do no harm. At the very least, stop it with all the yelling. World peace is a concept far beyond my ken, but two minutes spent on a doomed farmhouse porch in silence renews my every scorched fuse.

I head back inside, take a few more photos. Many of the interior doors are missing. Jed invited me to pull them out of here several months ago and now they're leaned in a corner of my pole barn. They're the old heavy-style doors with see-through keyholes and knobs that rattle. I imagine putting them in a house of my own one day, when in fact they'll likely just clog the inevitable auction. With the doors gone, I can see into the room where my brother returned to bed alone after losing his wife of seven weeks in a car accident to which he was the first responder. I can also see the spot over near the chimney where he used to sit in the recliner after a long day of fieldwork or logging and cradle the son he had with his second wife only to lose the boy in a drowning. My *saudade* is an indulgence; for my brother and his wife it is a chilled steel blade to the heart. In the corner by the phone jack there is a pile of straw and kindling. Beside it lies a charged fire hose, the nozzle hissing with pent-up pressure. It is time to burn this house.

The first smoke emerges flat and listless from the upper edge of the topmost window before curling up around the shingles and into the sky. At the first sign of it the children point and squeal. Then a radio squawks, followed by the voice of a lieutenant somewhere inside the structure. "It's gonna be a little bit, because it's gotta build." Soon you have the odd sight of a procession of fully clad firefighters trooping into the house with armfuls of wood and old feed sacks to *stoke* the fire.

Once the fire takes, those of us not involved in the exercise back off and settle in to watch the show. The first thing I notice is the roofline of the house, dead straight against the blue sky. Like someone just struck it off with a level, not like it's been standing there through every sort of everything since 1895. My unbidden, unedited thought is, *the house did a good job.*

Now the flames are audible, snapping within. Flat strands of smoke seep out through the shingles, and the tar begins to loosen, melt, and run. Shortly thereafter comes the more vicious snap of hungrier, bigger flames, and then the firefighters arrange themselves along the hose, make an interior attack, and shut it all down. The cycle is repeated,

again and again, even as the countryside eases into a dusky half-light. No longer diluted by sunlight, the flames appear deeper orange, and fuller. All along the second story, pencil-sized flames send tendrils out the nail holes of the wooden siding, and before long, the fire infiltrates the structure to the point that it is no longer safe. There is more radio chatter, and firefighters begin spilling back out onto the yard. Then a voice over the radio: "Be advised, everybody's out." And now all that remains is to sit and watch the house burn to the ground.

The entire roof is steaming, and a hypnotizing 3-D whorl of flame is blowtorching out the vent hole cut several hours earlier. Along the upper eaves, soffits are falling, trailing smoke like downed fighter planes as they *wing-wing* to the ground like failed boomerangs. All around the yard I see firefighters and bystanders standing with cell-phone cameras raised before them, and naturally I think of the photo of Gustav and Emma, and what a stretch between those bookend images. Ten minutes pass, and the roof begins to fold in on itself. The firefighters have turned all their attention to protecting the surrounding trees and structures at this point, spraying everything down with fire-retardant foam. The scene is oddly wintry, the large white pines draped and dripping thick white bubbles and the ground covered as if we'd had a shaving cream bliz-

zard. In the living room area where Jed used to rock his son beside the woodstove, the main chimney—held in place by nothing but gravity—is still standing slim, tall, and soldier straight, a black line against the illumined billows of gray smoke that roil into the sky and drift with the wind over my parents' farm to the south, fading into the distance and darkness. On the porch the smoke is gathering in a layer next to the ceiling, pushing and thickening down, down, down. Fifteen years ago my brothers constructed a walk-in meat locker on the porch. The locker walls were made of pine boards sandwiched around foam insulation. They are snapping and popping with flames now, as I recall the finger-numbing trips in from the shop with venison haunches in those pre-deer-skinner days when we were still peeling the frozen hides by brute strength. The blazing cooler is creating a vortex of heat that sucks the descending layer of smoke out of the kitchen and into the devil's own slipstream, and now the whole works are roaring, the kitchen and all its history of visits vanishing in a blast furnace exorcism.

From my vantage point on the ground beside Amy and Jane and the other tots, my final view of the kitchen interior fire is framed by the front door I passed through for more than forty years. Earlier, when I stepped out the front after taking photos, I was caught by the sight of the

wooden threshold, which had matching indentations worn on either side by a sesquicentennial of footfalls. For an irrational moment I wanted to peel it out with a crowbar, but I settled for two snapshots and headed for the shop, where I stacked my paper plate with barbecue. I wish now I'd crowbarred that worn hunk of wood loose, taken it home, leaned it somewhere never to be used, if only because some of the sand that wore it down came in on my little green barn boots during one of those visits with Dad.

So much damage and yet the house is still in principle standing. The main walls won't fall even when the firefighters rock them with their pike poles, and that main chimney is still placidly anchoring the center of everything. It's late, though. Fully dark, and the kids are running laps and jabbering giddily, which any seasoned parent knows is not a sign of wakefulness but rather a predictor of trouble at 2 a.m. So we start loading up. I bid good-bye to some of my old firefighting pals, and to my mother, and to my brother, and we prepare for the drive home. Just as I am about to duck inside the car, I pause with a hand on the roof and, one final time, take in the scene: all the orange-glow faces, the firefighter silhouettes, the smoke ascending thinly into darkness. And then, at the periphery, a flicker catches my eye: the waning fire of the old house, reflected in the slid-

ing glass door of the new house, the flames dimly wavering, as if from within.

Coming to terms with my sentimentality is a long-term project of mine. There is this constant temptation to approach life as a preservation project, an understandable but largely futile notion. *I'd sell the whole damn works and set on my ass,* Tom said when the salesman tried to gull him into buying insurance to preserve things as they were, and I think I believe him, although sometimes when I see him happy at his lathe, I wonder. Dad tore the silos down because he didn't want to pay to roof them, but he also tore them down as part of a general decommissioning process. Nearing his seventies, Dad still logs in the winter and raises organic crops in the summer, but he has over the past several years been unwinding his farming operation. The milk cows were gone a long time ago, the sheep more recently (he kept a flock for forty-two years), and last year he held an auction and sold off a lot of his equipment. I appreciate the way he's done it, neither leaving his children to sort it out in his wake nor clearing everything out in one abrupt dump. As the sentimentalist of the family, this has afforded me the luxury of adjusting over time. Still, I wanted to be

at his equipment auction pretty badly. As it turned out, I was scheduled to speak at a national convention of college English honor students that same day and could not be present to bid. In fact this was fortunate, as there is no way my checking account could have kept pace with my heart. I did, however, arrange with my brother-in-law Mark beforehand to serve as my proxy bidder on one particular item: the running gear from one of Dad's legendary Oscar Knipfer hay wagons.

I was in touch with Mark by phone throughout the day. By utter coincidence, bidding on the running gear commenced just as I was being introduced before some one thousand or so bright faces in a very large conference hall attached to a Hyatt Regency in Minneapolis. And so, dear members of Sigma Tau Delta, it is with thanks and apologies that I explain: The reason I hunkered down behind the riser and clapped my phone to my ear immediately after concluding remarks on the state of rural literature in a postmodern age was to ask Mark, "Did we get it? Did we get it?"

"Yep," he said, and with a light heart, off I went to sign books.

Today the running gear is in service on our farm beneath a sporty new mobile chicken coop. It was built by my contractor cousin Ivan and is a real jim-dandy, with

four retractable chicken doors, two human doors, and a pair of trapdoors situated for strategic by-product removal and dispersal. In short it is a rolling chicken condo. Every time I move that coop I look back from the tractor seat and see that off-yellow-and-green running gear at work, and I think, this is an indulgence of sentimentality I can justify.

Just recently, Amy's pet guinea pig died. There were tears, and a small ceremony and shoe-box burial in the pine grove over past the woodshed. Some weeks later, Amy and I were walking down the driveway in the wake of losing both Grammy Pat and Mister Guinea (the latter much beloved and in residence for some five years, but we never really got around to naming him), when I asked her if she remembered Tom's story about the crow.

"Oh yes," said Amy. "It's my favorite."

"Well, I was thinking maybe that story would be some help to you when Mister Guinea died. You know, how Mr. Hartwig probably felt very sad when Ginger died, but he still smiles when he tells the story."

"Ye-eah . . . ," she said, and we walked quietly for a moment. *Kinda ham-fisted there, doofus,* I thought to myself, but then Amy spoke again. "It . . . it kind of helped me

understand how you can be sad but also that these things happen. And you can still tell the stories and have good memories, but you have to go on to the next thing."

For once I kept my mouth shut, and we walked on.

It is quite possible to reminisce oneself to death. To lose yourself in a hesternal funk. The night before the mobile coop was officially open for business, Amy and I spread our sleeping bags on the floor and camped there overnight. We giggled and imagined we were chickens. In the dark after Amy was asleep I smelled cool night air and kiln-dried pine, and I listened to her breathe, and I deemed the present sufficient indeed.

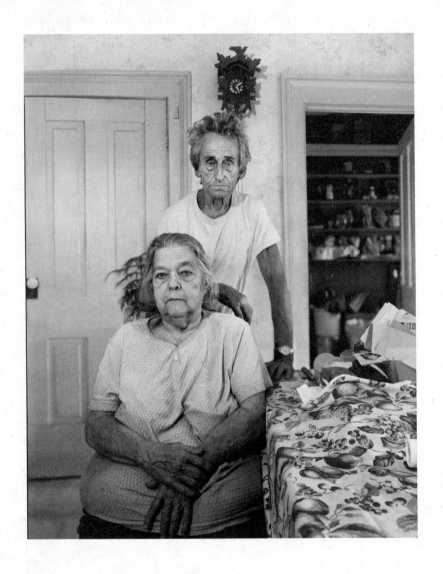

CHAPTER SEVEN

Well, let's go get a picture of that cannon.

The cannon is just a few steps away, in the steel shed across the drive. The barrel is visible, nearly poking out the open doors, but he leads the photographers right past it and deeper into a darker corner of the shed, over to a trailer upon which is mounted what appears to be an electric motor the size of a boar hog. This is another thing I built, he says. I gave a guy a hunnerd bucks for a DC generator and I built a portable welder out of it. This part here was left over from a John Deere hammer mill, the hitch was from a New Idea manure spreader, and the wheels were from an International truck. The generator weighs eighteen hundred pounds, so I left the springs and everything on there. You just take it right out into the field and run it off the tractor. It's just as smooth as paintin' with a brush!

You see, I've got two manure spreaders in here. One breaks on a cold winter day, you've got another one! And

that old silage chopper there, we had a bad hailstorm in 1964 and the only way you could salvage any of the corn was to chop it. So I bought that junky old chopper and blower, and, oh, guys teased me about that. But I had the last laugh on'em. I filled my silo with that for twenty-nine years!

Finally he moves to the cannon, pats the barrel. The blackened iron is dusty and speckled with sparrow droppings. Mid-barrel, a larger bird has left a whitewash splash centered around a dried gray turd. This is roughly a three-fifths scale replica of a French twelve-pounder, he says. From Napoleon's era. You can tell the rough date of a cannon by lookin' at the carriage. You got twin tails here . . . all the world's armies used twin tails until 1840, when they went to a single beam. This barrel weighs about three hundred pounds. That's only a third of what it should weigh for that diameter of bore. He grins, impishly. That's why it jumps so, when you shoot it!

Did those old cannons ever fly apart, Tom? The photographers are looking a little leery. Oh, absolutely, he says. A lot of'em would blow off the muzzle, or they'd even blow up by the breech. But they were cast iron. Cast iron is only about half as strong as steel. He pats the barrel again. This is seven layers of steel. Toward the last, I'd have to get Arlene out there to help me lift it up on the lathe.

When I first built it, I wanted to make sure it was safe. I took it back of the hill up there and I loaded it up with fourteen ounces of powder. Then I rammed in two tin soup cans filled with concrete. They weighed two pounds apiece. And then I had a dynamite fuse about two and a half feet long. I lit it and then I ran down into the field and stood there waitin' to see if a whole winter's work was gonna go up!

He stops to laugh, as if nothing would have been more entertaining than that cannon flinging shrapnel every which way. Instead, he says, it jumped back six feet and blew a wad of fire the size of a red fox. Using a hand mirror, Tom shone sunlight up the barrel and had a look. There were no cracks, no distortion. I knew then, he says, that it was perfectly safe for four or five ounces of powder.

The photographers and the young girl help Tom roll the cannon into daylight. The steel rims grind in the sand and ping against the gravel. That's good, he says, when the cannon is in the middle of the driveway. I shoot from here so nobody accidentally drives through right about the time I light the fuse.

He fetches the rammer, a six-and-a-half-foot wooden rod capped with a wooden plunger the size of a forty-ounce beer can. But then he rams it in handle-end first. Makin' sure there's no mouse nest in there, he says. Once I got it all loaded and there was a mouse nest in there and I couldn't

get it to fire. So I packed a dynamite cap in there and lit the fuse. Oh, it went.

He makes a trip back to the shed, returning with a plastic five-gallon bucket in one hand and a Dinty Moore beef stew can in the other. The stew can has been filled with concrete. This is our cannonball, he says. Now he fishes around in the plastic bucket and pulls out a shot glass. Then he fishes again and produces a roll of Reynolds Wrap, tears off a square, and shapes it around the shot glass. After it is formed to his satisfaction, he hands the tinfoil husk to the female photographer and places the shot glass back in the bucket, trading it for a plastic screw-top quart milk jug. Removing the cap, he tips the jug so the mouth is over the tinfoil receptacle and then taps it as if he is peppering a steak, and soft gray powder spills out. A fluid ounce of whiskey equals about four dry ounces of black powder, he says.

When he is satisfied with the amount of powder, he folds the foil into a neat packet and places it inside the barrel. Then he introduces the rammer, fat end first, and runs it gently in until he meets resistance. Removing the rammer, he picks up the Dinty Moore can and palms it into the fluted muzzle, then takes up the rammer again and drives it inward until the projectile is seated. Throughout, he stands wide-legged and holds the rammer in two hands parallel to his stance. If something should go wrong, if the

powder were to ignite, he might get some slivers, but slivers beat a rammer through the liver.

Sometimes at this point Tom will ask a newcomer to help him wad up an old newspaper. As he tamps the wads, he'll ask, Y'know what the newspaper is for? There are a few guesses. He just smiles at each one, says, Nope, nope, nope. Finally, his face cracking into the young-kid grin you've come to expect, he'll say, It's for nothin'—it just looks good when she blows!

No newspaper today, as the confetti would be a photographic distraction. Rather, the next object out of the bucket is a Skippy peanut butter jar. Removing the blue cap, Tom draws out a length of fuse. It looks like a fat piece of stiff blue string. He inserts it into the touchhole. That'll penetrate the tinfoil and go into the powder, he says. Now he kneels behind the cannon, sighting along the top of the barrel, wiggle-waggling the twin tails and using a bead welded above the butt end to help him align with the target. Now he twists the elevator screw to fine-tune the range. He admits the odds of hitting the red bull's-eye on the far hillside is quite literally a long shot. The cannonballs tumble, he says. The air deflects them. When they do hit the target, half of them go through sideways.

Everything's ready now. The photographers are poised, hoping to catch a muzzle flash, or at least some smoke.

Even with your hands over your ears, you hear the traffic just the other side of the shed. Sealed in their linear world, they have no idea they are sliding past live weaponry. Using a charcoal lighter, Tom touches a flame to the fuse. The fuse sputters and twists to ash.

Fire in the hole, he says.

And then nothing happens. Tom waits a good minute, then reaches in the bucket and pulls out an old-fashioned hand drill, inserts the bit in the touchhole, and reams it out. Back in war times, he says, if they were gonna lose a gun and didn't want it to fall in enemy hands, they carried a thing like a large cotter pin they could slip down the touchhole. Then they'd beat on it and it would spread and the enemy couldn't fire it until they got it drilled out.

He tries a second fuse.

Nothing.

I think some'a them fuses have got a break in'em, he says. Again he reams the touchhole. Threads a third fuse and lights it.

The sound is hollow and solid at once. The boom you'd expect, but with a note of a cork popping. The cannon rolls backward two feet. At this proximity the sound has a concussive physical presence, and what strikes you is the split-second suddenness of it, the irretrievable nature of the instant. The shot flies high and to the right, snapping off bits

of greenery before lodging in the hillside. Tom reloads, re-aims, and touches off another round. If you look across the field rather than stare at the muzzle, you can actually see the split-second swipe of the stew can flung through its flat arc. Naturally you imagine the field of battle and the horrifying idea of a projectile slow enough to see but too fast to dodge. This one misses the bull's-eye but blasts a hole through the outer edge of the white plywood. Everyone whoops.

TODAY I LOOKED OUT FROM my window above the garage and saw more than I deserve: a green valley, a populous chicken coop, a pink plastic tricycle. Yesterday Anneliese snipped a fistful of garlic scapes from our garden and used them in a pesto that is even now refurbishing those parts of me tainted by Zebra Cakes and sloth. There is a ring on her finger symbolizing the fact that despite a blizzard of torn tickets, I finally won the hapless bachelor lottery and ought to act like it. My *wife*—even now I sometimes pull up short at the word, so unexpected is it still—my *wife*, and her eyes so blue they still have the power to pull the breath from me across the proverbial crowded room. She has brought forth two daughters, each with the selfsame blue eyes, and when they hold my hand and call me Dad I feel simultaneously princely and lumpy.

Now it is bedtime. "What should we read tonight?" I ask Jane as I enter her bedroom for story time. "*Why Things!*" she exclaims, reaching into the stack and pulling out *Where the Wild Things Are*. We go in stretches of reading the same book for up to a week straight. We read in a rocking chair, and far from fearing the monsters on the page, the tot on my lap points them out with fascination, and comments on Max's state of mind based on his changing expressions. During the wild rumpus, we bounce and rock the book so Max and the monsters can march and boogie and swing from the trees.

When the book is closed, I lower her to the bed and tuck the covers under her chin, a great comfort I remember from the perspective of my own childhood. When I lean down to kiss her brow, she takes my face in her hands and studies it with a frown.

"Daddy getting old?" she says. Not so long ago she did a similar thing, staring at the top of my head, then saying, "Daddy's hair fell down!" Our children are mirrors that will not serve vanity.

"Yes," I chuckle. "Daddy's getting old."

She flops down and rolls to her side. Around her thumb, she says, "I can have a scratchbacker?"

"Scratchbacker," I say, and begin the back-scratch routine.

"Tell me about my day," she says, and I do. This too is an echo of comfort because I remember while drifting off as a child I would review my day from beginning to end and it was a calming thing, a way to put everything in order for storage. For Jane, the review invariably begins with "You woke up, you had breakfast . . ." and goes from there. Depending on the hour or how tired Daddy is, I sometimes go a little CliffsNotes on the whole deal. But I'm still not off the hook, because the moment I finish she says, "Tell me about a *funny* day," which means I am now to tell a story that begins, "I woke up, I had breakfast . . ." but then must unspool from the viewpoint of some mystery person or creature, until she pegs it. "I woke up, I had breakfast, I started pecking at worms, I . . ."

"A chicken's day!" Giggles all around.

"I woke up, I had breakfast, I combed my big beard, I started my bulldozer . . ."

"Uncle John!"

And then I kiss her one more time, and it is off to dreamland.

Of course not. There is the sippy cup to top off, the clock-radio classical music station to switch on (in the pickup truck it's classic country . . . at bedtime it's just classical), the night-light to adjust, the fan to run, the crack of the door to fine-tune . . .

But finally she does go to sleep, and I have that moment where I stand there in the night-light glow looking at the tiny figure and feeling at once overwhelming love and overwhelming fear that I won't get it right. Your heart quakes, even as it swells so large your breath is tight. In the next room Amy is preparing to sleep as well, and I utter a little existential prayer that tonight there will be no anxiousness. When the last light in the house has been switched off and all is settling to silence, I lie in bed reviewing my own day, wondering—when it comes time to tell kitchen table stories of their own—how my children will cast the character of their father. I reach for Anneliese's hand, and it is there.

Very recently there has been talk of developing the land adjacent to ours. It's all very tentative, and zoning requires that the plots be limited to one house per thirty-five acres, so it's not as if there will be pawnshops and a Zumba franchise alongside the pigpen, but our property lines and topography are such that if the project moves forward we will most likely see a new roadway carved twenty yards from the garlic patch, and forty yards from the granary door. There would be two or three new houses in view. As recently as two or

three years ago, this news would have had me up at night. I'd have been chewing it over and over. I'm not happy about it, and I hope it doesn't happen, but over time—and thanks in no small part to five years getting to know Tom Hartwig—I'm learning something about how to face change, especially in light of finite time and limited resources.

I'm on my way to visit Tom now. On a tractor, which means I get to use *road gear*. If you grew up a farm kid, nothing beat road gear. Road gear was the highest available gear selection on the tractor, intended—as the term implies—for use on the road. Whatever you were doing—raking hay, harrowing, cultivating corn—you always looked forward to road gear. Road gear meant the work was done. Road gear meant you raised the plow and dropped the hammer, the wheels spinning clots of mud into the air until the tire lugs cleaned themselves. The little tractor I'm driving today doesn't really have a road gear; it's just got a pedal you push to make it go faster, and somehow the thrill isn't quite the same, but it'll have to do.

The tractor and the brush hog attached to it actually belong to my mother-in-law. It's a real nice rig, although when my brother Jed the farmer saw me on it he smiled like it was just the cutest thing ever. I've been using the brush hog (basically a monstrous mower) to clear trails and the brush around the pigpen, and it has developed a crack in the housing, so I'm

taking it over to Tom so he can weld it up. I look forward to all trips to Tom's but this one especially because I'm commuting on a tractor and also my brother John is over there today. Tom is teaching him how to pound a sawmill blade.

Over time a sawmill blade will get knocked out of true. A little fat here, a little skinny there. Nothing visible to the naked eye, but it can create a terminal wobble. I've watched Tom pound the blade on his sawmill, and basically it's an esoteric art involving a large hammer. He lays a metal straightedge across the blade and marks the high spots with a piece of chalk. Then, using the hammer on one side and a heavy chunk of steel as a backstop on the other, he pounds the chalky patches until the blade is flat and true.

I take it easy going out the driveway so I don't shake the brush hog loose what with all the potholes, and I take it easy going down the Starkey Road hill so the tractor doesn't get away from me, and I slow but don't stop—it's a *yield* sign, after all—as I pass through the new blankety-blank intersection, but when I hit the county road, I push the throttle fully forward and let the tractor run.

We've been here five years now, and although we're still newcomers, we've accumulated some neighborly history along the route to Tom's place. Behind me at the base of Starkey Road is a pile of sawdust where the Zack brothers and I made firewood using their old buzz saw and the logs left after the town-

ship trimmed the road. Denny Zack and his wife run up the hill to tend our chickens when we're gone, and sometimes I take the girls down to throw food in their goldfish pond. A bit farther down the road is Farmer Jerry's place, where we get milk. I don't know a lot about the couple who live around the next curve except that they are in their nineties and the man still goes bowling. Another mile and I'm passing the homestead of the neighbor with whom I trade haying help for plowing help. The husband and wife who live in the house on the next corner both taught Anneliese in high school; sometimes they buy eggs from us. The next family along the road has two little boys; we often trade babysitting, the husband built us a set of shelves, and last year I brought the tractor down here to till their garden. Afterward we played kickball with the kids until dark.

I don't know what we'll do if the development comes. Maybe stay. Maybe pick up and move back to my hometown of New Auburn, currently population 562. Maybe spend a year in Panama. Anneliese and I have discussed it, and if someone showed up with a check one day that would allow us to pay off the banker and make a clean move to a smaller, more manageable place, there's a pretty good shot we'd sign. There is some irony in this, as I had reservations about moving to this spot in the first place and have just recently begun to feel I could be happy here for the long haul. I have always defined myself— and probably always will—by sense of place, in particular six

square miles including my hometown of New Auburn, and my parents' farm. I could be content within that little block forever. To this day when I hit the interstate exit up there I feel the longing. But lately I've been second-guessing the whole idea of *place*. Not in a negative way, but in a ruminative way. I am lately considering the idea of attachment as a confining indulgence. Confining in that there is so much world and so little time; indulgent, in that dithering over where one might best park one's hinder is the greatest of luxuries in light of humanity's travails. I keep the tractor pedal flat, getting all the road gear out of this toy that I can, but I can't escape the idea that just as we've established all of these neighborly connections we may be bound to sever them.

By the time I pass by the cannon and pull into the yard, Tom has already pounded the blade, and he and John, and John's father-in-law, Jim (a man who owns a dragline and a gravel pit, making him a magnate from where I hail), are standing in the door of the shop. Seeing me on the little green machine, they all grin in a way that makes me feel like I am piloting a pedal toy in flowered short pants. I back the brush hog up to the shop, and when I switch the engine off, I hear Tom in full anecdotal stride, right in the middle of a

familiar story about the farmer down by Fairchild who had a fire that burned the barn to the ground but left the silo standing. "The insurance company wanted that silo down," he is saying, "so we took two cannons down there and started shootin'." John's face lights up. After all, my brother is a man who once blocked a shotgun barrel, tied a long string to the trigger, and then fired it just to see if it would explode (it did). "It was a twelve-by-thirty-six Madison stave," says Tom, of the silo. "Took us a while, but it came down like a tree."

I say hello to Tom and he nods, but keeps going. "Yah, on that cannon now, a lotta people think that's illegal, but the Gun Act of 1968 exempted antique weapons and replicas. So you can own as big a muzzle-loading cannon as you can afford powder for." His sly grin crept in right around the phrase "muzzle-loading cannon" and lingers as he completes the thought: "Course, what you do with it, that's maybe another question . . ."

"Were you shooting yesterday, Tom?" I ask. "I heard a pretty good *boom* right around noon."

"You can hear it up there, huh?" he says, with a proud papa smile. Then John asks a question about ballistics and Tom begins to describe his process for manufacturing black powder. Although the materials are basic, the process is complex and furthermore eases over into the shady corners of endeavor some classify as "extralegal," so let us remain vague.

Correspondingly, when Tom showed up at the local emergency room with facial burns a few years back, his explanation ("I was welding on a gas tank") may have been "extrafactual." In a favorite visual image I never actually witnessed, Tom once told me how he tested a new batch of powder in his mother's kitchen. "I brought a little in and tossed it on the hot stove to see how fast it flashed," he said. "That went over real well!"

"Yah, when I started messin' with those cannons, my ma used to shake her head and say, 'When the donkey has it good he dances on thin ice.'"

There is talk of shooting the cannon today, but John and Jim are on a parts run and the store is due to close at noon, so they are beginning to edge toward their pickup. Sensing this, Tom shuffles his set list on the fly and hits his closing number in stride, easing back to the far corner of the shop to pull out the shovel with the curved handle. Today after the punch line, he even adds a bit I haven't heard before, about how the highway crews are getting new uniform shirts with one pocket sewn on upside down. "That way they don't even need to use their hands—they just stick the shovel handle in that pocket and lean away," he says.

Everyone is enjoying the laugh when I notice John fishing around in his pocket. "What do I owe you?" he asks Tom. (Actually, he pronounces it as one word: *WhaddoIoweya?*) "Oh, twenty bucks should do it," says Tom, and when John

hands the twenty over I see a five folded over it. It's a real smooth move, like he's greasing the Hyatt Regency doorman to turn a blind eye to his Escalade in the no-parking zone. And in an even smoother move, Tom doesn't even check the bills—he just slides them into his pocket, sparing everyone the discomfort of frank currency exchange.

"Well, whaddya got here?" Tom asks as John and Jim drive away. I show him where the iron in one corner of the mower arbor has cracked and separated. In order to provide access to the crack, I had to detach the brush hog from the tractor. "We gotta get it up off the ground if I'm gonna get in there," Tom says, and starts ratcheting away with a rickety car jack—one of those shinbone-looking things you'd find in the trunk of your '72 Buick—he pulled from somewhere on the floor of the shop. The jack teeters and yaws and I run around desperately stuffing wooden blocks beneath the brush hog wherever I can. At one point the jack collapses and Tom stumbles backward as the steel lip of the brush hog bites into the earth just short of his toes. "Bitch!" says Tom, addressing the jack as it lies in the grass. He goes into the shop and returns with a hydraulic bottle jack. This works much better, and shortly we have the mower propped safely aloft.

After using his torch to debride the cracked and fatigued steel, Tom cuts a section of strap iron roughly the size of the resulting gap. Using the press to bend it at an

angle that matches the shape of the arbor, he leaves it to me to grind the edges until I achieve a snug fit. In the meantime we've discovered a crack on the other side of the brush hog, so while I'm grinding and fitting the patch and working at clamping it in place, Tom drags his cables around to weld the second crack. I'm lying on my back and working overhead when I notice a tingling in my arm. I've had issues with numbness in that arm for some time now and even as a young man couldn't work with my arms raised for long before I got pins and needles, so I ignore it and keep working. But the tingling gets more and more insistent, and eventually I realize it's happening in sync with the futz of Tom's welder. Naturally, when I tell Tom I'm sucking up his stray voltage, he acts like it's the funniest thing he's heard all morning. But when he comes back over to my side and sees I have the patch fitted and clamped, he says, "Yah, that'll work," and I feel like the kid who won the spelling bee. He kneels down, flips his mask in place, and strikes an arc, the 6011 rod sparking and sputtering until in short order the brush hog is patched up and good to go.

I help him stow the tools and welder, and we lower the brush hog and reattach it to the tractor. Then I say, "Well, Tom, *whaddoIoweya*?"

"Fifteen," he says. "That'll cover it."

I reach into my pocket and blanch. Check my other

pocket. I've done it again. Nothing. I think of John, and how smoothly he palmed the cash and a little something extra, and how that moment compared to this, what with there being zero lag time between the price and the payment.

I cop to my penury, and right on cue the stories begin: Frank Thurston, the Buford boys, the eagle shitting . . . I squirm through the entire litany, the sickly grin in place, gone from the winner of the spelling bee to the knucklehead who forgot his homework. Still, the discomfort is predicated on a history of neighborliness, and although I can't get that tractor into road gear fast enough, I'm smiling as I do it.

When Jane achieved potty-training last year, there was a hitch: She couldn't reach the bathroom light switch, so one of us still had to make the trip with her. As a remedy, our friend Lori made her a "Light Angel"—a thin two-foot strip of wood with a hole and a scallop cut in one end. Jane quickly learned to use the scallop to push the switch to "on" and the hole to pull it to "off." As a father, I found this a liberating development because now she truly could go to the bathroom by herself, and I didn't have to shift my lard. Then came the night not so long ago when Jane disappeared into the bathroom and then—after an extended interlude—

hollered, "Daddy, I have a *sur-PRIZE* for you!" Talk about your daunting summons. Because the poor dear may read this one day (and because I may one day require her to assist me in a similar manner), I'll go light on the details other than to say you just never know when that fire department hazmat training is going to save the day. But the real emotional kneecapper came as we were leaving the bathroom. I instinctively reached for the light switch and Jane scooted in front of me, blocking my way. "No, Daddy, no—I want to show you!" And with that she rose up on her tippy-tiptoes, stretched her hand as far as she could, and with one tiny little finger, flipped the switch and cut the light.

I felt my heart split.

Oh, I knelt and hugged her, and told her we were proud of her, and that she was our big girl, and she beamed, but as I wandered back to find Anneliese and share the news, I felt as if I had stepped off a ledge and into a vacuum where I was falling and fruitlessly trying to grab armfuls of time. How odd that a happy moment would permute into such hollow helplessness, and how silly to be pitched there by the click of a switch. And yet in that one unpremeditated instant, my daughter—already in the other room and jabbering at a plastic horse—inflicted me with a case of emotional hiccups.

It is natural, when from the mushy island of middle age you watch your toddling daughter or study the lined face of

your octogenarian neighbor, to wonder just how long one will be (as I heard a caller to Moose Country 106.7 put it recently) "upright and taking nourishment." I asked Tom once after his stroke if he had worried about dying when he was in the hospital. "Nah, not really," he said, raising both hands and his eyebrows as if to say, *Whadd'ya gonna do?* "I had a good friend in high school, Bart Miskey. He was six feet five, like a beanpole, and the year after we got outta high school I remember we were shootin' the breeze one night, talkin' about how old we were gonna get. And I remember tellin' him if I didn't make it to be eighty, I'd be disappointed. He thought that was hilarious. And then he says, 'I'll never see thirty.' And he didn't. He drowned when he was twenty-five."

"So you're two years into bonus time," I said. "Yah, I guess so," said Tom, after a small laugh. "And I just bought a brand-new wire-feed welder—I'm either an optimist or an idiot!"

I cannot imagine I will live to be an old man. I have had neither visions nor premonitions. I'm not laying money either way; I simply can't *imagine* it. I feel too vulnerable. Anneliese, who is ten years my junior and of the "what you think about you bring about" persuasion, knits her brow

when I talk this way, and I am never quite successful when I try to explain I'm not being fatalistic, I'm being okay with it. Two-plus decades of making fire and rescue calls have tinted my glasses in this respect. You simply never know when you're going to step off the mortal curb. Furthermore, I was reading Montaigne again last night, and after quoting Horatio to the effect that even the cautious man can never foresee the danger that may befall him, Montaigne rattles off a list of acquaintances who were crushed in a crowd, killed at a tilting, choked with a grapestone, hit in the head by a turtle, and fatally smacked with a tennis ball. Because I no longer require one, I will likely escape dying in the manner of Montaigne's emperor felled by the scratch of a comb, but as a guy who raises his own bacon I did take very seriously his invocation of the ancestor of King Henry II who died "by jostle of a hog." Conversely, in the department of Something to Shoot For, Montaigne does cite no fewer than six men (including a pope) who perished "betwixt the very thighs of women."

Lately I see my grandfather's lines in my face. From the time I first remember him, Grandpa's chin was bracketed by twin furrows, one running from either corner of his mouth at a slightly widening angle down to his jawline. The effect was to make it appear as if his lower lip and chin were of a unit separate from the rest of his visage, in the

nature of the *Nutcracker* prince or a ventriloquist's dummy. To the grave, Grandpa kept himself in trim, but the lines nonetheless lent him a set of jowls. If I stand before a mirror beneath the bathroom light and flex my face into an expression of pursed-lips disapproval, those very same lines form. For now I have to force them up with a grimace, but with each passing year they appear more readily. Recently I saw myself on television, and there they were. They are joined by other signs, of course: the old-man ears, slowly expanding in relation to the rest of my head; an earlobe inscribed with the cursed cardiac crease purportedly linked to heart disease; the standard follicular shifts (baldness, yes, but also sproutings too off-putting to scrutinize in this space), including my single eyebrow profusing into an obscurantist hedgeworks evermore threaded with white and requiring regular hacking back; a change in the alignment of a toe; and finally the ever more pervasive musculoskeletal creaks, cracks, and pinches. Twenty-plus years of all-nighters spent slumped before a screen (well, for the first five or so it was a ribbon and a platen) or blear-eyed behind a steering wheel while fueled by truck stop coffee and cellophane-wrapped gas station treats have certainly lowered my trade-in value. In addition to the chin lines, I note I am well on my way to a matching set of Grandpa's baggy eyes, and the two vertical scowl lines above the bridge of my nose are etched for the duration. In

this my forty-sixth year I am compelled to admit I may be composed of something other than mystery and light.

There are times when I look at my daughters—especially Jane, who is only now forming solid memories—and wonder if she will always think of her daddy as an old man. When my father was my age he had already seen me out of college. There are moments at forty-six that I feel irredeemably spent. Bald and worn out. Other days I feel not a whit removed from eighteen, although both of these states are tied more to my psyche than my physique.

Last year a dear friend turned fifty. He got to moping on it. I am five years his junior, and find him to be remarkably well preserved. He has thick hair, a trim figure, and still plays league hockey. "I don't know what he's complaining about," I told Anneliese. "He looks younger than *I* do."

"Yes he does," she said.

A hesitation of point-five seconds would have been a reasonable kindness, don't you think?

We have reached the season of fireflies.

Much is made of the year's first robin, and fair enough. Although the celebrated red breast is actually dull orange, when viewed in the context of brown sod and remain-

dered slush the bird does provide a reliable emotional boost. But the first firefly! Through the deciduous declension of autumn, after the crystalline stricture of winter, and into the *yes-no-maybe* spring, it is possible to forget that such an insect—easily more magical than your standard unicorn—even exists. Then come the blue-green blinks, furtive in the grass. Doling out love by the lumen; is anything so naturally fantastic as a firefly's butt? It is as if star seeds cruise the earth. I spotted this year's first just two weeks ago while crossing the yard after dark to perform the nightly ritual of securing the chicken coop for the evening. Perhaps young firefly damsels swoon when they see my headlamp afloat, believing it to be the most fantastic butt of all.

Now the fireflies have grown profuse, and last night, when I made the evening chicken rounds after toothbrushing and bedtime stories and tuck-ins, I was so overcome with the phosphorescent countryside that I returned to the house and pried the children back out of bed. I snatched a few bugs from the air and we held them loosely in our fists as the light pulsed from between our fingers. Then we released them and stood quietly hand in hand, marveling at the terrestrial Milky Way stretching from our very feet and lavishly beyond to the valley below. The hills were stroboscopic with love.

Another day has passed into another night, and I am standing at my desk considering a cardboard packet. It's slim, but has some heft and is of portrait dimensions. Within is a sheaf of prints from the day Tom led the photographers around his place. The packet has been on my desk for quite a while. I've been coming and going, on and off the road, on and off deadline, hoarding shards of time in between for farm and family. I began to cut into the packet the day it arrived but then remembered Tom at the sawmill, and the customer who complained that he didn't saw fast enough. *I figure I can take my time to get the most out of it*, Tom had said, and I felt the same about the photographs in the packet. I understood the work that went into them: carefully framed and shot, developed by hand, everything one by one. I didn't want to flip through each image and then rush on to the next thing. I wanted to study them without constraint. See if they might reveal something more about Tom or life itself. That last bit sounds grandiose, but have we a more elementary responsibility? I placed the packet aside until such time as I might absorb the contents more deeply. Now, after dark, with the children abed and a high wind

blowing a storm that never seems to arrive, I believe this is that time. Although it is late, I go to the room above the garage, make coffee, put on music, and pull the pictures from the packet.

During my first pass through, I have trouble getting beyond a browse. There are a multitude of shots—Tom seated on the running board of the Model A; Tom beside his cannon, standing with the rammer upright like a soldier caught midway between attention and parade rest; Tom stabbing his palm with his index finger in the midst of emphasizing a point. Each image triggers a rush of recall extending far beyond anything captured in the flat replication, and the more associative aspects take over: When I see Tom's hands cradling the knurled boring bar holder, I recall the dirt-grease scent of the cluttered shop; when I see him standing before his sawmill, I hear the scolding of a jay from a windblown Norway pine; when I see him backlit in the haymow, I feel the soft crunch of ancient chaff beneath my feet; and of course, implied in every image, the nonstop traffic soundtrack.

Then I come to a straight-on head shot of Tom, and my attention fixes. His face and shoulders fill the bulk of the frame. The predominant light is directed against his left side. His eyes are deep-set beneath black eyebrows.

His gaze is utterly direct, but to characterize it as *piercing* would be overdramatic. The photographers have not asked him to smile, and he holds his mouth evenly. The creases across all aspects of his face are riverine, each a record of repetitive expression, set and baked by wind and sun. His hair is longer than I have ever seen it, sweeping back over his ears almost as if it were blown and feathered. Atop his head it stands in a muss. Caught at the far end of a haircut, Tom's look is less the Samuel Beckett I have previously described and more Keith Richards *sans* the seedy leer.

In so many ways—the wrinkles, the graying hair, even the tattered collar—this is a portrait of wear and tear. Of seasoning. And yet my first thought when I peer beyond the superficial physiognomy is of Tom the boy. It remains visible in him. It helps, I suppose, that even in this staid pose I can summon kitchen table Tom, the Tom with the stories about gathering arrowheads and running across the bridge to school, or searching the sky for Ginger the crow. The way he tells those tales, it is as if he has managed to bring that little boy with him, and I suppose he has. One night when Anneliese and the girls and I were at dinner in the kitchen Tom got to rattling off the pranks he and his schoolboy buddies pulled—killing the school bus by packing snow up the tailpipe; blocking the axle on Art Brackett's '37 Ford so when Art stumbled from the tavern and tried

to drive off he just sat there spinning his wheels; playing hooky to go hitchhiking, only to be undone when the first car that stopped was driven by the school principal—and what I saw wasn't an old man gone wistful but rather an old man still resonating to the glee of a young heart.

For all his stories of the past, you rarely get the sense that Tom is operating out of reminiscence. Rather more, he simply enjoys a good story and its telling. I have seen him sentimental only twice. Once was when he admitted to the photographers that he kept the cows because he liked how they looked in the field. The other came during a kitchen table visit when he got to talking about his father and the community-owned threshing machine.

"My dad ran the steam engine for that threshin' rig. The neighbors all owned it but my dad ran it for thirty-three years. And as kids we used to get so darned excited when you'd hear that engine, he'd toot the whistle when he turned in the driveway, and we'd hear that thing chuggin' away and we'd run over the ridge to watch it come marchin' on up . . ."

He paused in reverie, looking out the window.

Then he returned. "That engine's still goin.' It's in a museum up at Edgar."

What I am unprepared for is how even the few months passed have imbued the image of Tom's face with a figurative historicity. It is as if the darkroom fixer, rather than

merely stopping time, has deepened it. The pictures are microscopically detailed, utterly unretouched, and yet Tom seems someone other than Tom. He is rendered intimately unrecognizable. There is some remove at play, as if I am viewing him through a binocular turned backward.

The portrait of Tom and Arlene together was taken in the dining room. Arlene is seated beside the table, and Tom stands behind her, his forearm resting on her chair back. The cuckoo clock is prominent on the wall above Tom's head, *tick-tick-ticking* the whole time. The door leading to the living room is visible in the background, and down in its lower left quadrant the flash has cast the handle of Arlene's oxygen tank in silhouette. She removed the cannula for the shoot, and the clustered tubing is visible as a shadowy wad.

Arlene was talkative that day. "Those eight days that I was in the hospital, I'd look at the clock, and I'd see two of'em!" she said, as the photographers set their gear. "The first night the doctor said to Tom, 'I don't know if she's gonna make it through the night.' But I guess I'm still here.

"I had one of those four-wheel walkers," she said, then gave a dismissive wave. "You go out in the driveway and you hit potholes, and it goes like this . . ." She mimed the walker tipping forward. "I do *not* want to fall down. I don't want to

cause any more trouble. Thomas says, 'You gotta get out.' So we go grocery shopping, but there I use the cart."

She paused, then spoke again, tapping each syllable into the table with her index finger.

"I tell myself: It. All. Could. Be. Worse."

It took the photographers a while to get the shot of Tom and Arlene. Their antique equipment required persnickety setup and left no room for error. "You have to go through this every time you want to take a picture?" Arlene asked, raising her eyebrows and shaking her head in mock horror. Then the photographer said, "Okay, hold still now, and don't move a muscle," and in the silence before the shutter snapped, I could hear Cassidy's tail swishing against a brown paper shopping bag, the muffled traffic beyond the barn, and—from somewhere in the room—an odd, barely audible grinding sound, which I eventually tracked down to a rotating crystal sun-catcher attached to the dining room window with a suction cup. "Our nephew gave us that," said Tom. "It's solar-powered." By the sound of the gears it wasn't long for this world, but as the crystal slowly spun it refracted the sunlight, swabbing the room with a rainbow blob. Just below the windowsill, Tom's fermentation jug was bubbling another batch of wine. Beside that stood a milk can decorated with a hand-painted portrait of Chester

and Lester—a gift from a lady in Pennsylvania, Tom told the photographers. A miniature cannon rested on the sideboard. None of these things appear in the portrait, but they inform my perception of the image.

If Tom's appearance in the solo portrait was disorienting, in this portrait it is startling. To my eye, he is rendered alarmingly vulnerable and undersized. It is Tom, for sure, down to the last leather-pecan wrinkle. But his eyes appear timeworn, and it looks like he is leaning on the chair for support, when in fact I know that in the moments before and after the shutter snapped he was gibing and joking and he had just spent the afternoon nimbly touring us through his farm and life.

Last month Anneliese was sorting through some boxes and came across some snapshots taken on the Hartwig farm during her hay crew days, and they were a revelation. There was Arlene, dark-haired and laughing in her kitchen, peeling tinfoil from a pie plate. There she was at a graduation party, laughing again. And there she was perched high on the seat of one of the Farmalls, her grip strong on the steering wheel, as she drew a 14T John Deere baler down the windrow. In the tractor snapshot she was tanned and hale,

sporting a pastel sun visor and looking down into the camera with her cheeks bunched up into a smile.

And there was Tom, same face, same lean frame, but with a fashion-catalogue jauntiness to his posture, and—these were the days when he still had vices—his corncob pipe clamped in his teeth. In some of the photos, taken when Anneliese was home visiting from college, Tom is wearing a sky-blue snap shirt and a coal-black handlebar mustache wider than his face, which has the effect of making him look like a slightly screwball card shark.

So: photos of Arlene pulling the hay baler, but none of Tom cooking for the hay crew. "You'd have been in tough shape without Arlene," I said during a recent visit, mildly calling him on it.

"Oh, absolutely," Tom replied, pressing one palm down on the table as if for emphasis. "I depended through the years very heavily on her. She helped me hay, she helped me milk cows . . . when I needed parts she'd go and get'em. And a'course the implement dealers couldn't pull the wool over her eyes because she used to go out there and help me take the tractors apart."

Arlene was watching him talk, using one of her hands to smooth the tablecloth. "Tommy and I will be married sixty years now, comin' up," she said, echoing what she said last winter. "I can still see him . . . I'd be up in that office

building and there he'd go, down the main drag in that white convertible and wearing that red shirt—so he'd *stick out*, you know!"

The last happy little jab there, coming right after Arlene was getting wistful, got a good laugh from Tom. Then she narrowed her eyes and squinted at him. "You weren't always so hunky-dory like you make out you were."

Tom clasped his hands and squeezed his forearms together on his lap, rocking forward and grinning like a kid.

Arlene looked at him again and shook her head. "He was *differnt* . . ."

I thought about that little exchange a lot in the months that followed, and whether or not there was any rancor beneath the teasing, or what sort of history it might have been based upon. Even in the best circumstances, I don't doubt that over the course of six decades, *differnt* occasionally lost some of its appeal. Whenever I hear someone described as "quite a character" I wonder how the home-based reviews might compare. The perspective shift from observation to cohabitation can be clarifying. My own grumpiness has long been a point of humor in our family, but it hangs on more than a thread of truth. Recently, after I issued some parental edict, Amy waited until I had gone off to my room above the garage, then confided in Anneliese that she was afraid to talk to me because I was

so irritable. This rightly jolted me. From the day I met her Amy has been a delicate spirit, prone to anxiety and nocturnal weeping on behalf of the world in general, and I found myself wondering if in my sullen clomping around I might already have rent some fabric not easily mended.

I think, too, of all my literal and figurative ramblings, of how many times I was off somewhere telling my tales of raising chickens, pigs, and babies while Anneliese was right here raising the chickens, pigs, and babies . . . and gardening, and canning, and dealing with the leaky basement, and teaching yoga, and holding down stints as a freelance Spanish translator and an instructor with the foreign language department of the local university. When I am on the road I develop teen-level absence crushes on Anneliese. I send her notes and call her to say sweet things I fail to say when I'm actually home and sharing the same square footage. I pull out of the gray parking lot of some early-morning truck stop, jaw set and chin quivering, imagining myself a lonesome rider at the gates of dawn; meanwhile, she is back at home dealing with piano lessons and doctor appointments and the kitchen drain and lesson plans, and has oddly scheduled exactly zero minutes for pensive gazing. Or for taking maudlin phone calls from a situationally lovelorn husband sitting in a distant bookstore parking lot with a Starbucks and some free time.

I am ten years older than Anneliese, but she is the grown-up in this relationship. People chuckle when I say that, but I'm not going for a laugh. When you're lucky you should just say so. And then write yourself a stern reminder not to fall back on that luck. There is this male tendency to believe that somehow the initial two weeks of snappy dressing, full eye contact, and best behavior will balance out thirty years of holey underwear, mumbling, and anatomic decline. It is one thing to be a work in progress, quite another to be a work in regress. Familiarity is no excuse for lowering your standards. Or so I said to myself last week while standing saggily before the bathroom mirror in my holey underwear.

The last time Arlene had a spell, I got a call from Emmy. Tom had phoned saying Arlene was weak and not talking sense. Emmy was at work and wondered if I might run over and check on her mom. I wasn't home, and it sounded like maybe a stroke, so Emmy rang off and had an ambulance sent. Had I been home I would have been paged to the call. For the second time now, I was out of range when the Hartwigs needed help. However, by chance I was in town and only blocks from the hospital and so I drove over and was waiting in the ER when the rig arrived. After the paramedics

wheeled Arlene to her room—she was barely conscious—I left to let the nurses do their work and waited in the hall for Tom, who had followed at a safe pace in the Crown Vic.

When he came ambling around the corner and started toward me, I was struck again at how the frame—be it provided by a camera lens or the vanishing perspective of a gleaming hospital hallway—informs the image. How the Tom I knew—the fellow holding forth from his chair in the kitchen corner, or expounding on the explosive properties of box elder–based black powder, or setting the lathe to turn a shaft—suddenly appeared as a slightly bewildered old man finding his way across the icy-smooth tiles.

He drew fairly near before recognizing me. The door to Arlene's room was closed, so I escorted him just around the corner to a family waiting alcove and we sat down. After he matter-of-factly described Arlene's symptoms I got him to talking about his honeybees, and this seemed to mitigate the surroundings. Shortly the nurse appeared and ushered us into the room. Arlene looked terribly gray, and was lying motionless with her eyes closed. As Tom approached the bed Arlene's eyes opened, made contact with his, and then closed again.

A phlebotomist arrived and drew a curtain around the bed, so Tom and I moved back to the hall and stood together outside the door and visited with Emmy, who had just arrived. Although he looked out of place, Tom con-

veyed no distress. The phlebotomist departed and shortly afterward Emmy and I were in conversation when we realized Tom had slipped back into the room.

We peeked, and he was at the bedside again. As we watched, Tom drew off his cap and brought his face close to Arlene's. "How you doin', Ma?" he said, in a voice so gentle it seemed another man's. As before, Arlene's eyes opened, met his, and closed again. Cap dangling in one hand, he reached out with the other—that same hand I've watched at the welder, at the torch, at the lathe—and ever so carefully caressed her brow. "We gotta get you better, Ma," he said, his voice earnest, but still soft. "We had a goal, remember? Sixty years together."

The hand was still now, resting on her hair.

"We're almost there, Ma . . ."

It turned out Arlene hadn't had a stroke but rather a severe systemic infection. She recovered in short order and came back home. I'm still not sure what the "hunky-dory" comment alluded to, and I likely never will. Not my business, not my place. I don't imagine you do sixty years as a flawless skate. I talked to Emmy about what we saw in the hospital room that day, and she says her father's tenderness

took some time in coming. That for all of her childhood it was the farm first, always the farm. That she's not sure he would have touched Arlene's brow twenty or thirty years ago. But here in these later years, she says, there has been a shift. Toward tenderness, yes, but also—this just in the last year—toward frying his own eggs.

It is important, now and then, that overgrown boys be called to account. Recently a woman who had seen me perform a humorous monologue approached Anneliese and said, "Your husband is *so funny!*"

"Yes he is," said Anneliese, without hesitation. Then, demonstrating impeccable timing of her own, she added, " . . . on*stage.*"

Rimbaud wrote of *"the friend neither ardent nor weak."* I do believe I found her.

As did Tom.

I return once more to the portrait of Tom and Arlene together. Again I am focusing on the contrast between the Tom who opens the screen door or fires up the torch or slaps his hands at a funny story and the Tom I see on the one-dimensional prints. Now I turn to the simple head shot again. The one taken so close to his face. Just Tom, look-

ing into the camera. "Your head is a container," he told me once. "It can only hold so much." His forehead is tall and square above his narrow face, framed above and to both sides by his brushy hairline. It occurs to me now that the photograph was taken only a few weeks prior to his craniotomy. Even as the shutter snapped, the bleed that would send him pitching into the corn was incipient. And now I am thinking of him looking so unexpectedly tiny in the hospital bedsheets. The low-level shock I felt at seeing him that way and the way I feel at seeing him in these photographs are echoes of a sort. The Tom I carry with me is the Tom of action: Tom behind the welding mask; Tom blowing bees from the honey supers; Tom fired up over long-lost highway battles. The Tom I know best is the Tom of rawhide, of strap steel, of the quickening glint. Posed before his sawmill, he looks curmudgeonly; posed beside his cannon, he looks dour; posed in his own parlor, he looks waifish.

When I talked with Tom in the nursing home, I was surprised that he wasn't fidgeting for home, or feeling bereft. That he was simply occupying the moment as it was offered him—and catching up on his sleep. I go back to the pictures again, and his eyes, and slowly I see a shift. What I saw as worn and weary, I now see as something closer to placidity. Patience. Both he and Arlene are simply looking at the camera and waiting. Surely this is the rarest of ex-

pressions in this instant-message world. We are not used to seeing patience and may therefore be slow—or unable—to identify it. Seeing placidity, we mistake it for disconnection. In the time it took the photographers to shoot those photos, a few thousand vehicles swished past on the interstate. You wonder how many—if any—of the people within those vehicles were accepting the moment. Instead you have the image of white knuckles on the wheel, clenched guts, feet and fingers tapping. The drivers and their passengers have reached the impotent outer limits of human capability, which so far allows us to project ourselves anywhere immediately with the ironic exception that our actual cell-based selves remain constrained by the rules of physics, which, even at ten miles over the limit, will prevent us from getting to Milwaukee any faster than the coffee-soaked Cheeto crumbs at the bottom of the cup holder.

There is vulnerability in these black-and-white photographs, and why not: One day you fall off your bike and cannot locate the mailbox. But the eyes, I think I'm homing in on that now. Who looks you in the eyes these days? We are either checking our phones or checking for what's next. Tom's eyes are checking for what's now. What *is*. And how to live within it.

Then again, perhaps I'm trying too hard. Searching for something that isn't there. I have now and then overtly plumbed Tom for certain introspections, and it rarely pans

out. It seems he reserves his periods of reflection for the purposes of sussing out a means of designing a reverse-threaded cable reel. After Arlene came home from the hospital I dropped in one day to see how things were going. We were in our customary places at the dining room table again, the cats and dog flopped here and there, a sunbeam refracting through the fermentation jar and glinting off the barrel of the miniature cannon on the sideboard. The conversation meandered from general catch-up to hog-raising tips ("four pounds of grain for one pound of gain," Tom says) to a review of typographical and historical errors Tom has marked in the previous day's edition of the local newspaper ("That should be FDR, not Teddy—they got the wrong Roosevelt!). He was also pleased when I noticed his crisp new copy of *The Practical Pyromaniac* peeking out from beneath a *National Geographic.*

It was a nice little visit, the kind you tuck away and cherish for its very comfy informality. And yet I was also thinking of how on any given day these visits might come to an end, and was hungering for some deeper wisdom. I waited until the time seemed right, and then:

"All these years, Tom—you have any regrets?"

"Well, sure," he said.

And then nothing more.

 ✧ ✧ ✧

Once when we were still a family of three, Anneliese and Amy and I were hiking in rural Panama when we happened upon a sculpture garden open to the public. Amy skipped eagerly from piece to piece as we followed. At one point the trail passed through a tunnel-like arbor. Amy was running ahead when I raised the camera and snapped a photo. The shutter caught her mid-stride with one leg pushing off, one leg reaching forward, her hair frozen in a jounce, and her body leaning toward the light at the far end of the arbor. The image delivered a metaphorical whack that even today leaves me afloat.

Then today I look up from my desk in time to see Jane run barefoot up from the pole barn where she has been adventuring, her braid bouncing as she leans into the turn up the sidewalk toward the house. She too is bent forward in a headlong posture, and just as her face passes from view I freeze-frame her in the same position as her sister in Panama those years before. In all cases we view our children along a vanishing perspective, an obvious truism that not unimportantly nudges us to, as the writer Jim Harrison has put it, view *ourselves* walking away.

And so it is, if forced to choose only one portrait of Thomas A. Hartwig, it would be that in which he is departing the camera. He is diminutive in the composition, stumping shin-deep through a sea of crabgrass that

anchors the bottom third of the image. This is a color photograph, and by the pale green blades you can tell summer is waning. In the way they twist, you can see the wind is up and hectic. Tom is ambulating toward his silo, visible as a whitewashed concrete column standing bulwark against a thin-clouded sky. The camera was set beneath the surviving giant oak tree; a few blurry branches drape leafily into the upper foreground, establishing a sense of depth and pointing generally toward Tom in his position just off center and to the left. You can see the crack that nearly felled the silo—it runs from the ground to the eaves—but the thirteen hoops are all snugged tight, and you get the sense it'll stand as long as man and tectonics allow.

The semi is shooting out from behind the silo, the blue blur of the cab conveying speed even as it is held frozen on film. It's a tanker truck, the fifty-foot flying cylinder of the trailer zooming at a counterpoint right angle to the silo, which stands stolid on a foundation sunk twelve feet in the ground. The roadbed is set just slightly lower than the crabgrass plain, so that the semi-tractor wheels are obscured by fence-line brush and the sleeper cab rises over the near horizon like a predatory dorsal fin, the effect being that of a shark nosing through the kelp shallows.

Tom is simply walking. A little bowlegged, his arms

loosely hung, elbows everted. And in this shot he looks sturdy. As if he could last. As he has.

All told, the state took fifteen acres from Tom and Arlene Hartwig, although you might as well call it thirty-seven once you count the landlocked patch on the far side of the concrete. "It did more to ruin this place than anything," Tom says. "Before, we were half a mile from the nearest neighbor. Peace and quiet. They wound up takin' it by eminent domain. You think you own something? You have the *use* of it . . . but if it comes right down to nitty-gritty, you don't own it." One day when I took Tom a copy of the *Eau Claire Leader* describing the interstate opening ceremonies, I asked him what it was like that first day when the traffic came through. "To tell you the truth, I really didn't notice it that much," he said. "As far as the noise, well, you'd had two years of construction here, so you were pretty well tuned to the noise." Then a smile began to work its way across his face. "I did always say I woulda loved to have taken a big manure spreader up there to the overpass and when the politicians went through, just back up and let 'er rip!" Later, Anneliese asked Tom if he ever got hotheaded about what was being done. "Nah," he said. "You got to

adjust, because you can't change it." I take another look at Tom's eyes in the solo portrait. I see resignation and resolve in cohabitation, and no contradiction in it. I see more than a little of my old friend Montaigne, as well, specifically in terms of what Sarah Bakewell writes of Montaigne's commitment to *"amor fati*: the cheerful acceptance of whatever happens."* Twenty-three thousand cars a day is a drag, but, hey—you got a free broom and a pocketful of stories. Tom Hartwig has not only transcended the intrusion of the highway, he has transcended the intrusion of bitterness.

Back again, now, to the photo of Tom with his back to the camera. The man, the truck, the silo: That's your story, right there in a picture. The man lost, the truck won, the silo is a battlefield monument.

And yet the man marched on.

I studied the photos for a long, long time. At midnight I stepped outside and a firefly split the air above my hair with such velocity I thought it was a tracer round. Spasmodically, I ducked. He was on a freight-train flight, poor fellow, borne on the bum-rush brunt of a pummeling wind and propelled at such a clip that his amorous beaconing lingered on my retinas not as blinks but as extrusions of neon. You wonder if his message was readable. You think of the sensible lady firefly discreetly glowing from the

safety of the grass below, raising one skeptical antenna at the hot-rod tearaway before turning her attention to the windbreak edges of the lawn, where the lower lights go bobbing along.

Or perhaps—just maybe—she longed to join him.

At two in the morning I awakened and realized I forgot to secure the chicken coop. Crossing the yard in my rubber boots and cotton undershorts, I saw blinks in the weeds, which caused me to wonder where the windblown firefly wound up, and how it all worked out for him. The wind had calmed, although high above a ragged tissue of cloud scraped the face of a gibbous moon. The lunar glow was just sufficient to drape a milky wash over the shoulders of the land before me, but the far valley lay as a gulf of darkness. I closed the coop, then walked farther out the ridge until I could see the running lights of the semis slipping to and fro across the bottomlands, throttling through their all-night runs with a softly audible thrum. Down in the shelter of the semicircling ridge I knew Tom and Arlene were sleeping—as they have since the highway opened— above the tremor of heavy wheels.

For reasons both chemical and banal as well as foolish in the face of good fortune, I regularly descend into quasi-clinical funks during which my gyroscope goes wobbly and

my soul assumes the character of a rain-wet corn husk. When I am at my worst, I have found two things help immensely: the arms of my wife, whose capacity for acceptance exceeds my ability to comprehend it, and coming to this ridge where I might stand beneath the infinite galactic spray and (Montaigne again) look narrowly into my own bosom.

The other morning I ran into my barkeeper friend Nolte at the local coffee shop. I told him how I had been walking out to worry beneath the stars, and I told him about Tom, and how I had come to believe Tom's life was a testament to equanimity, and that I was working on that. Nolte said, Perry, I think you've got the equanimity thing figured; it's your equilibrium that needs attention.

Recently a friend gave me a listen to a song he's been working on, and out there on the starry ridge that night it came to me. The first verse is unsparing, with lyrics that describe a man failing himself shamefully and—this is what bloodlets the soul—failing others. The song builds in such a manner that you feel yourself rising from your body, higher, ever higher, into the thinnest wintry air until you reach an atmosphere at which you can visualize your life adhering in transparence over the very curve of the earth. Just as you achieve weightlessness there arrives the lyric: *And at once I knew . . . I was not magnificent.*

And so it is I am soothed by the impossibility of all those stars. This is the universe suggesting that it is quite capable of absorbing my wobbles, and that if need be, it can spare the bulk of an entire galaxy to do the job. In the meantime, back on earth, I should keep plugging away. A great weight lifts, and the message beaming back from endless billions of howling, earth-dwarfing gas balls is that infinity resides also in the smallest speck of light.

I think of that firefly up there at altitude, swept along by forces he cannot control, appropriately bug-eyed, legs flailing, wings furiously fanning, and yet even in the midst of it all, still tending the hopeful glow of love. I think of Tom, weaving bulbs and wires through the spokes of that Harley, roaring into town and up and down the sidewalk, trying to catch Arlene's eye with his spinning, flashing lights. I think of his hand, reaching for her brow. I think of Anneliese's blue eyes, and when my floundering and flubbing leads to darkest hours how I long to look into them for the universe they hold. I think of my children, and what I owe them, and where that account might stand.

The light of a firefly is the size of a teardrop. We cannot defeat the cosmic wind. We are not magnificent.

But, by God, we try.

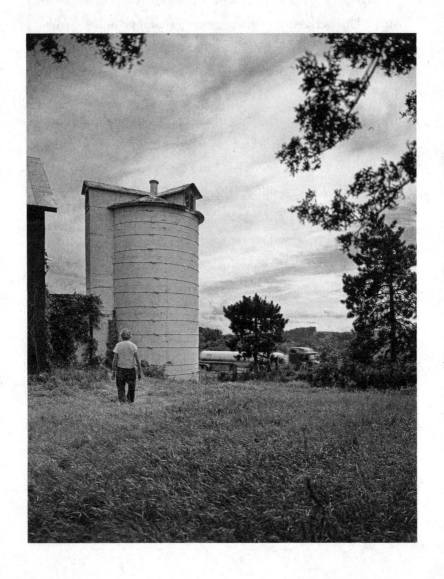

EPILOGUE

Somewhere in the universe the cannon shot still reverberates. The photographers are stowing their gear in the Rambler. Tom is back in the kitchen with Arlene. She is frustrated that she couldn't get around out there. *It makes me mad,* she says. *Since that last bout, I have no steam. I'm always tired.*

From your chair you can see the traffic passing through a bracket formed by the barn and the casement of the kitchen window. The cars go dot, dot, dot, the semis are dashes. The RVs are somewhere in between. Someone drifts to the rumble strip, raising a serrated moan. The sunbeam crosses Cassidy the dog at a late-afternoon angle. An elongated strip of orange passes betwixt the brackets. *Schneider National,* says Tom. *Out of Green Bay.* You can feel the tremor through your boot soles.

We were told they would never be allowed to come in the house to use the phone, says Arlene. Her elbows

rest on the walker. There is the faint hiss of the oxygen through the tube. That's what they told us. But every time they wanted cement hauled down to the culvert they'd come up here. They'd use our driveway, and they'd use our phone . . .

If I had it to do over again, nothing would be allowed except with a court order, says Tom. Fight'em all the way, right from the beginning. Be the meanest S.O.B. goin'. He is in his familiar stance, legs crossed, wrists crossed, eyes cast at the floor. Now he looks up, says, And then you pay me.

Arlene chuckles. All we got was a push broom . . . and that was wore out! They're both grinning now. Rueful, sure, but with a twinkle.

Weaahhl, we were too trusting, says Tom.

Yah, says Arlene.

They stop now, considering. In the parlor a rainbow dot slides across the plaster, thrown by the little geegaw turning. You hear the cuckoo clock ticking, the pendulum squeaking. The dog shifting, snuffling, rolling her belly hopefully to the sky. The rubber thrumming on concrete. The oceanic wash: Whoosh. Whoosh. Whish, whoosh. Whoosh.

You cannot tell if they hear it. It is not possible to say if it registers.

We are suckers for final scenes. The neat package, the knot-ted ribbon, the credits rolling over nothing but an echo. If you leave right now, the room will fix itself in black and white and stay that way forever.

But you linger. Listen to the clock, listen to the cars, listen to the ringing phone.

Tom lifts the handset, passes it to Arlene. Hello, Arlene says. Ahh, he is, just one minute. She passes the handset back to Tom. He listens a bit. A keyway? Yah, I can do it. Yah, I have that. Nah, just bring it on over.

WHEN THE PAGER WENT OFF this morning I threw my kit in the pickup truck and drove jouncing out the driveway past the PIRVATE DRIVE sign. At the top of Starkey Road I pointed the bumper downhill and accelerated. Right around NO PAIN, NO GAIN I got off the gas and tapped the brakes a bit lest the commissioner be hiding in the weeds. At the yield sign I checked both directions, then got back on the foot-feed. As I maneuvered the grump-making chi-cane, something outside the driver's-side window caught my eye: a change in contour, an earth-tone flash.

I swiveled my head. Fresh gravel, freshly graded. Swiveling my head back, I ducked and checked the mirror. The moat is partially filled, the apron widened to a car's width.

It ain't the straight shot, but it's a shot.

I'll tell Tom, next visit.

ACKNOWLEDGMENTS

FIRST AND FOREMOST, TO MY parents—anything decent is because of them; anything else is not their fault.

Anneliese, who walked me to Tom and Arlene and is walking with me still. Amy and Jane, forever in the cozy kitchen of my heart.

John and Julie, for the focus. Mills, for friendship. Our Fall Creek neighbors, for being neighborly. Alissa, for reminders. Blakeley for the road. Karen for math with a heart. Krister for pixel panics, Dave for mainlining our onlining. Carissa, in the spirit of pink ponies. Jay Moore for the mornings. Jennifer Barth for cutting but not running. Lisa B. for goodness sakes, how long now? Jason Sack and Dan Kirschen. Scranton crew. Rob and Meriah Frost and family. Emmy and Deb, with respect and thanks. The people along the road who have given me and my family shelter and quiet—the names are adding up, and you know who you are. Dan and Lisa for the shack in the woods. The

Long Beds for sharing the stage, Dean Bakopoulos for sharing the terrors. Racy's and Mister Happy for key privileges. Matt Marion because he hangs in there with me. Ben in Ohio, always on duty. TFD and Emergicare, for letting me carry a pager and visit the ditches.

Brad and Donna for support and the view from here.

Our Colorado blendeds and extendeds. Gene and Paula, because you're always here even so far away.

Anthony Shadid, who wrote things that mattered.

And because we never forget the old school: Frank, the Joynt and kitchen table crew, Mags, and the place some call Nobbern.

If I missed you on the page, I got you in my heart.

And hey: Vern.

ABOUT THE AUTHOR

MICHAEL PERRY is an amateur pig farmer, an active member of the local rescue service, and a contributing editor to *Men's Health*. He lives in rural Wisconsin with his wife and two daughters, and can be found online at www.sneezingcow.com.

ABOUT THE PHOTOGRAPHERS

JOHN SHIMON AND JULIE LINDEMANN have been my friends since the day we met in prison. I hope you will go to www.shimonlindemann.com and learn more about their work.

Insights,
Interviews
& More . . .

About the author

About the book

Read on

Meet Michael Perry

MICHAEL PERRY is a humorist and *New York Times* bestselling author of *Truck: A Love Story*; *Coop: A Family, a Farm, and the Pursuit of One Good Egg*; *Visiting Tom: A Man, a Highway, and the Road to Roughneck Grace*; and the essay collection *Off Main Street: Barnstormers, Prophets & Gatemouth's Gator*. He has performed and produced several live-audience recordings, including *The Clodhopper Monologues* and *Never Stand Behind a Sneezing Cow*. Perry lives in rural Wisconsin, where he remains active as a first responder with the local volunteer fire department. He can be found online at www.sneezingcow.com.

Raised on a small dairy farm, Perry equates his writing career to cleaning calf pens—just keep shoveling, and eventually you've got a pile so big, someone will notice. Perry prepared for the writing life by reading every Louis L'Amour cowboy book he could get his hands on—most of them twice. He then worked for five summers on a real ranch in Wyoming, but his career was cut short by his fear of horses and an incident in which he almost avoided a charging bull. According to a series of informal conversations he held around the ol' branding fire, Perry still holds the record for being the only working cowboy in all of Wyoming to attend nursing school, from which he graduated in 1987 after giving the commencement address in a hairdo that combined mousse spikes on top, a mullet in back,

and a mustache up front—otherwise known as the bad hair trifecta. Recently Perry has begun to lose his hair, and although his current classification varies depending on the lighting, he is definitely Bald Man Walking.

Perry has run a forklift, operated a backhoe, driven a truck, worked as a proofreader and a physical therapy aide, and distinguished himself as a licensed cycle rider by careening into a concrete bridge completely unassisted. He has worked for a surgeon, answered a suicide hotline, picked rock in the rain with an alcoholic transvestite, been a country music roadie in Switzerland, and worked as a roller-skating Snoopy. He can run a pitchfork, milk a cow in the dark, and say "I don't understand" in French, Greek, and Norwegian. He has never been bucked off a horse, and contends that falling off doesn't count. He is utterly unable to polka. ∿

Writing *Visiting Tom*

How did the idea for your book originate?

I visit Tom when I need a piece of iron cut, bent, or welded. Sometimes I stop by just to drop off a dozen eggs. Sometimes my wife and our two daughters bring food and stay for supper and Tom's endless supply of stories. Sometimes I visit just to visit. Tom is not my mentor or my guru. We are simply neighbors. And yet what fascinates me (and drove me to write this book) is how much I can learn from someone like Tom, whether he is running a cutting torch or—in tandem with Arlene—telling silly chicken stories at the kitchen table.

Originally I wanted to write about Tom because he is a vanishing breed: a well-read, largely self-educated curmudgeonly polymath who is capable of driving a team of oxen, harvesting wild honey, and using his one-hundred-year-old lathe to turn out parts for his neighbor's $300,000 combine and fabricate cannons, and who also possesses a multitude of other talents. The more time I spent with him, however, the more I realized that rather than teaching me how to "do stuff," Tom was teaching me how to achieve equanimity in the face of life's imperfections.

The book incorporates my own experiences in hapless battle with the local highway commissioner (over the rerouting of a local road), as a longtime bachelor turned father of two daughters

(Tom and Arlene also raised two girls and are closing in on their sixtieth anniversary), and as an inept knucklehead (Tom built his own sawmill; I finish off my woodshop projects by shooting them with a .44 Magnum revolver) while I searched Tom's life for clues to how I could best comport myself as a husband, father, and citizen.

What if I'm not interested in cannons and old-timers?

Ultimately this book is a love story. When Tom was courting Arlene, he tried to get her attention by weaving green and red electric lights into the spokes of his 1948 Harley-Davidson motorcycle. She refused to ride in his sidecar, but when he showed up later wearing a bright red shirt and driving a white convertible, she said yes. Now Arlene says it is her dream to celebrate sixty years of marriage. She is less than a year from that goal, but her health is poor, and it's not clear if she'll make it—this lends a poignant undercurrent to the book. Humorous scenes of the couple bantering (as only a long-married couple can) culminate in a scene weaving together a million fireflies, the colored lights on Tom's Harley-Davidson, and song lyrics by recent Grammy-winning band Bon Iver. So it's not all good ol' boys talkin' tools.

In short, my time with Tom has drawn me to more deeply appreciate the love of my wife, what I might owe my children, and where both accounts stand. ▶

Writing *Visiting Tom* (*continued*)

Also, I spend a lot of time writing about my own dunderheadery, including the fact that the minute I mount a snowplow on my pickup truck I become a danger to myself and others.

***You have written four books set in rural Wisconsin. Has the area changed since you wrote* Population: 485?**

Yes. My hometown of New Auburn is now Population: 562. Clearly a case of urban sprawl. Also, as explained in *Coop*, I moved to a farm some forty minutes away near Fall Creek, Wisconsin, but I still get home for Jamboree Days most years and help out at the bratwurst stand.

The country is always changing. In fact, parts of *Population: 485* are devoted to describing the many changes that had swept through the little town over the first one hundred years of its existence, and those changes continue. Right now the village is at the epicenter of a sand mining boom—there are two new factories along the rail sidings, and more to come. Naturally this has roiled emotions, but apart from how we might feel about the issue, it also bears out the point: In *Population: 485* I suggested New Auburn might best be described by the phrase "the train doesn't stop here anymore." Now—again—they stop all the time. In *Visiting Tom* I write of how Tom's ancestors displaced the Ojibwe tribe, and then the interstate displaced Tom. And now when you're on the

interstate right where Tom's barnyard used to be, you can see a giant billboard advertising a casino owned by the Ojibwe. Change tends to trace an ellipse.

Why do you think your books are popular beyond the Midwest?

Well, there is no question I have been known to lay some 'Sconnie references between the lines for my cheesehead readers. But among the unexpected privileges of this writing life I stumbled into (basically while wearing barn boots and a nursing cap), I cherish most highly the opportunity to travel the United States and shoot the breeze with people from all walks of life and all corners of geography, and the conclusion I've reached is this: the only things that vary are the accents and the number on the population sign. *Visiting Tom* is about an unusual Wisconsin fellow, sure, but it's also about a human being trying to make the best of a diminished situation and find some love to boot. Who can't relate? I could make some grand statement about the unity of humanity, but how about this: In *Population: 485* I write of my fellow volunteer firefighter and friend Bob, the severely cross-eyed butcher. I was signing books somewhere in the South when a fellow approached the table, leaned in close, pointed first at the volunteer fire department patch on his jacket and then at his severely crossed eye, and in a deep Southern drawl announced, *"And*, I'm a *butcher!"* ▸

Writing *Visiting Tom* *(continued)*

We shook hands and I felt right at home. That's how I hope folks feel when they read my books.

Finally, what do you think potential readers might miss about the book if they see only the cover and title?

I write a lot about trying to be a good dad. I have two daughters. The younger is three and the older is ten. Someone told me I don't have a family, I have a sorority. I write about the delights of bombing down dusty country roads or plowing through blizzards in a pickup with my daughters as copilots, I write about the joys of knocking off work early so we can go down to dance in the creek, and I also write how I am clearly overmatched, even—*especially*—by the three-year-old, who comports herself as some combination of trial lawyer and bulldozer operator. "I sure hope you aren't sticking your tongue out," I told her recently after catching her in the act. "I'b dot!" she said, brightly. "I'm saying *aaahh* so you can *check* my tongue, and that's a *good* thing!" ❧

Have You Read?
More by Michael Perry

COOP: A FAMILY, A FARM, AND THE PURSUIT OF ONE GOOD EGG

Last seen sleeping off his wedding night in the back of a 1951 International Harvester pickup, Michael Perry is now living in a rickety Wisconsin farmhouse. Faced with thirty-seven acres of fallen fences and overgrown fields and informed by his pregnant wife that she intends to deliver their baby at home, Perry plumbs his unorthodox childhood—his city-bred parents took in sixty-some foster children while running a ramshackle dairy farm— for clues to how to proceed as a farmer, a husband, and a father. And when his daughter Amy starts asking about God, Perry is called upon to answer questions for which he's not quite prepared.

While sharing his travails with the humor readers have come to expect, Perry also writes from the quieter corners of his heart, chronicling experiences as joyful as the birth of his child and as devastating as the death of a dear friend. Alternately hilarious, tender, and as real as pigs in mud, *Coop* is suffused with a contemporary desire to reconnect with the earth, with neighbors, with meaning . . . and with chickens.

Have You Read? *(continued)*

"An enjoyable visit to a rural homestead alongside an amiable and benignly quirky companion."
—*San Francisco Chronicle*

"Perry can take comfort in the power of his writing, his ability to pull readers from all corners onto his Wisconsin spread and make them feel right at home among the chickens." —*Seattle Times*

"All I wanted to do was fix my old pickup truck," says Michael Perry. "That, and plant my garden. Then I met this woman . . ." *Truck: A Love Story* recounts a year in which Perry struggles to grow his own food ("Seed catalogs are responsible for more unfulfilled fantasies than Enron and *Playboy* combined"), live peaceably with his neighbors (one test-fired his black powder rifle in the alley; another's best Sunday shirt reads "100 PERCENT WHUP-ASS"), and sort out his love life. But along the way, he sets his hair on fire, is attacked by wild turkeys, takes a date to the fire department chicken dinner, and proposes marriage to a woman in New Orleans. As with *Population: 485*, much of the spirit of *Truck: A Love Story* may be found in the characters Perry meets: a one-eyed land surveyor, a paraplegic biker who rigs a sidecar so that his quadriplegic pal can ride along, a bartender who refuses to sell light beer, an enchanting woman who never existed, and half the staff of National Public Radio.

By turns hilarious and heartfelt, a tale that begins on a pile of sheep manure, detours to the Whitney Museum of American Art, and returns to the deer-hunting swamps of northern Wisconsin, *Truck: A Love Story* becomes a testament to the surprising and unintended consequences of love.

Have You Read? *(continued)*

"A touching and very funny account. . . . Thoroughly engaging."
—*New York Times*

"*Truck: A Love Story* is a delightful, quirky account of a year in a mid-American life spent restoring a 1951 International Harvester, cultivating a garden, and falling in love."—*USA Today*

Welcome to New Auburn, Wisconsin (population: 485), where the local vigilante is a farmer's wife armed with a pistol and a Bible, the most senior member of the volunteer fire department is a cross-eyed butcher with one kidney and two ex-wives (both of whom work at the only gas station in town), and the back roads are haunted by the ghosts of children and farmers. Michael Perry loves this place. He grew up here, and now—after a decade away—he has returned.

Unable to polka or repair his own pickup, his farm boy hands gone soft after years of writing, Mike figures the best way to regain his credibility is to join the volunteer fire department. Against a backdrop of fires and tangled wrecks, bar fights and smelt feeds, he tells a frequently comic tale leavened with moments of heartbreaking delicacy and searing tragedy.

"Swells with unadorned heroism. He's the real thing." —*USA Today*

"Part portrait of a place, part rescue manual, and part rumination of life and death, *Population: 485* is a beautiful meditation on the things that matter."
 —*Seattle Times*

OFF MAIN STREET: BARNSTORMERS, PROPHETS & GATEMOUTH'S GATOR

Whether he's fighting fires, passing a kidney stone, hammering down I-80 in an eighteen-wheeler, or meditating on the relationship between cowboys and God, Michael Perry draws on his rural roots and footloose past to write from a perspective that merges the local with the global.

Prior to writing the beloved memoir *Population: 485*, freelance journalist Michael Perry wrote essays on such diverse topics as big-rig truck driving, country music, butchery, farming, nursing, and the many facets of small-town America. *Off Main Street: Barnstormers, Prophets & Gatemouth's Gator* is a collection of Perry's offbeat reporting, and is confirmation of his one-of-a-kind worldview and deeply personal and human insights.

In "Branding God," we witness Perry working on a cattle ranch and recalling time spent under the spell of a fire-and-brimstone preacher by the name of Brother Timothy. In "Rolling Thunder," Perry rides with a convoy of Vietnam veterans on their chopper-rigged march to the nation's capital. In such pieces as "A Way with Wings," "Swelter," and "Manure is Elemental," Perry reflects on his own boyhood spent in rural Wisconsin amid the everyday characters of the American Midwest.

Ranging across subjects as diverse as lot lizards, Klan wizards, and small-

town funerals, Perry's writing in this wise and witty collection of essays balances earthiness with poetry and kinetics with contemplation, and is regularly salted with his unique brand of humor.

"Michael Perry is like a sensitive, new-age Hemingway."　　　—Salon.com

Don't miss the next book by your favorite author. Sign up now for AuthorTracker by visiting www.AuthorTracker.com.